One Hundred *over* 100

One Hundred over 100

Moments with One Hundred North American Centenarians

Jim Heynen

Photographs by Paul Boyer

FULCRUM PUBLISHING
Golden, Colorado

Text copyright © 1990 Jim Heynen
Photographs copyright © 1990 Paul Boyer

Design by Hugh Anderson

Published simultaneously in Canada by Western Producer Prairie Books, Saskatoon, Saskatchewan

Library of Congress Cataloging-in-Publication Data
Heynen, Jim, 1940-
 One hundred over one hundred / Jim Heynen ; photographs by Paul
Boyer.
 p. cm.
 ISBN 1-55591-052-1
 1. Centenarians—United States—Interviews. I. Boyer, Paul,
1944- . II. Title.
HQ1060.5.H49 1990
305.26'0973—dc20 89-29600
 CIP

Printed in the United States of America
10 9 8 7 6 5 4 3 2

Fulcrum Publishing
350 Indiana Street
Golden, Colorado 80401

Table of Contents

Foreword

I warmly commend you upon a most interesting and challenging book—photographs and previous life histories of 100 people over 100 years of age. That is a magnificent collection of magnificent people. How wonderful it is for human beings to live beyond 100. What a great privilege they have enjoyed. The stunning thing about life today as compared to life in the past is the increasing life expectancy of people. If a child were born in 1900—the year I was born—that child had a life expectancy of 48 years. A child born now has a life expectancy of 75 years. A child born 50 years from now should have a life expectancy of 81 years, and yet you have brought forth in this beautiful book the photographs and life histories of people who have already lived over 100 years. I am told more than 125 thousand people in the United States have reached the age of 100. Let us hope that you and I, indeed, everybody, can someday look forward to that wonderful privilege.

Your beautiful book will encourage others to want to live to be 100 or more. Maybe it will encourage people to say what one man has reputed to have said when he discovered that he had reached 90 years of age. He said, "If I had known I would have lived so long, I would have taken better care of myself." Let's hope your exciting book will encourage all to take better care of themselves and they may celebrate this centennial of their own lives. We have done a lot to make life better for senior citizens, but we have much to do to fill their lives with the years, the life, health and happiness they so richly deserve.

Your book will make a great contribution to that end.

Claude Pepper
Congress of the United States
House of Representatives

Acknowledgments

With a little help from friends, it's possible to move mountains. Our friends have given us tremendous support in this project—from advice, directions, lodging, and meals, to airport transportation at very strange hours. We gratefully acknowledge these friends: Anita Cook, Janice Martin, Deborah Newquist, Joey Darrah, Terri Paré, Nancy Steele, Anne Pruitt Shough, Tim Vande Heide, Linda Hasselstrom, Lee Kline, Terry Lawhead, Herman Nibbelink, Dr. Sam Pobanz, Coppie Greene, Dr. Robert Colfelt, Dr. Richard Lynn, Scott Walker, James Hepworth, Jack Shoemaker, Barry Lopez, Diane McDevitt, Teresa Jordon, Jonathon Lazear, Muriel Nellis, Marvin Bell, John Rezmerski, Jim Anderson, Deborah Pearce, Mike Moore, Reneé Wilson, Lushia Worthington, Z and Dr. Bill Scheyer, Marilyn Hoyt and Danny Wharton, Mary Gray, the Quileute Tribal Council, Jim and Cynthia Mooney, Mae Sprenger, the Sorrento Hotel in Seattle, John and Anne Laskey, Kim Williams, Jim and Martha Anne Mooney, Bob Baron and Charlotte Foehner, Al Schoenfeld, Mark Schoenfeld, Dick and Betsy Armstrong, Casey McKinney, Dora Wakefield, Larry Montgomery, Steve Davis, James McKanna and Vivien Casagrande, Jeremiah Gorsline, Al and Lynn Zimmerman, Susan Yecies, Victor Budnik and Janie Hewson, Pat Frederick, Mary Ellen Berry, Kim Stafford, Hilbert and Alice Heynen, William and Joyce Heynen, Carol Bangs, Paco Mitchell, Linda Clifton, Bill Holm, Bill Ransom, Noreen and Dr. Jim McCarron, Steve Sanfield, Roger Amstutz, Linda Townsend, Diane Abshire, Michael Shopenn, Deirdre Czoberek, Mike Elwell, Rebecca Romine, Bruce and Thelma Boyer, Pia and Isabella Boyer, Sally Sprenger Boyer, Emily and Geoffrey Heynen, Anna Paine Williams, and Sarah Townsend Williams.

All photographs were taken at the time of the interviews.
Each written entry begins with vital data and ends with a final section that focuses
on the centenarian's response to the question, "How did you get so old?"
Dates of the interviews are listed at the back of the book.

Introduction

May this book diminish your fear of aging. Even though old age is becoming a more fashionable topic of conversation and the aging population a larger target for advertisers, there probably are still more books about very old cars, houses, paintings, and even dishes than about very old people. We seem to be squeamish about looking at the reality of aged human beings, almost as if we are terrified by what, if we are fortunate, will become of us. So great has been our fear of old age that one survey showed fewer than half of us want to live to 100. What an odd trick we play on ourselves when we try to stay healthy and yet dread old age, the natural consequence of good health. The stories of the 100 people you will meet here may invite your mind to roam in new directions, for much of what they say and who they are contradicts our negative attitudes toward longevity—and a change in attitude is long overdue.

Let these centenarians invite you to take a new look at old age, and in so doing, to take a new look at your own life, for they are what you are becoming with every passing day. They don't necessarily make old age look easy, but they do make it look worthwhile. You'll find here people who still go to work every day or who are as mentally and physically active as most people of 50 or 60. Living past 100 can become a time for reaping the rewards of a life well lived or for bringing families together with a renewed sense of hope for the future. Even those who are less physically able are not living meaningless lives. They have simply moved out of the work force and into the spirit force, creating goodwill among those around them with their simple, unadorned presence that says, "Behold, I have endured." Paul and I didn't meet anyone who was afraid to die, but we didn't meet anyone who was afraid to live either. Again and again, we left our visits with a great sense of peaceful excitement, inspired by what we had just seen and heard.

The fact that so many of today's centenarians live full and meaningful lives should make us wonder: If we must be terrified by old age, why not be terrified by its splendor, by the possibilities it allows the mind and spirit and even, sometimes, the body?

There is really nothing in this book that refutes what medical people have been telling us about longevity—how we live and who our parents are do make a difference. Still, no matter who you are, it will not be hard to find yourself in these pages, to find someone whose past resembles your present and possible future.

It's not true that only short, skinny people live to be old; several people here are over 6 feet tall and some have weighed 245 pounds most of their lives. It's not true that genetics is the sole determiner of who will live to be old; several people here are breaking all family records. It's not true that only the carefree nonworriers live to be old; some people here have always been worrywarts. There are health nuts who might be viewed as early pioneers in the field of life extension, but there are also a surprising number who are still addicted to tobacco. Retiring early because of a nervous breakdown? You're in here. Lonely and childless? You're in here in abundant numbers. Recovering from cancer? You have many partners in this book, some who have recovered from cancer three times. If you're someone who always puts work before pleasure, you're in here. If you're one of these lazy people who sneaks off to read while others do the work, you're here too. Salesman, artist, poet, nurse, teacher, waitress, department store manager, homemaker, minister, day laborer, maid, secretary, accountant, coal miner, farmer—you name it, you're here. Maybe you can't keep a spouse. There are people here who have undone their I-do's up to four times! Religious fanatic? Religious skeptic? You're both here. Homebodies and travelers. Everybody seems to be here. The variety of people should convince you that no one is exempt from the possibility of longevity. Once and for all, you should be assured there is no one formula, no single secret. As you will see, if there is one secret, there must be at least 100.

But in spite of the variety, isn't there one truth that holds for all 100? Perhaps there is. Whoever coined the term *tough love* could have been describing today's centenarians. If there is one feature they have in common, tough love is it. It's not exactly the kind of tough love parents might be asked to administer to recalcitrant children—it is more the unswerving focus that persists in a quiet kind of gusto, in a nonaggressive determination, or in a soft fortitude. If some of their senses are dimming, some other internal lights have been turned on bright. In one way or another, their tough love shows in their relentless involvement with life. And it always shows in a concern beyond themselves. I don't think there is one selfish person in this book. But there isn't one patsy either. Let's say, everyone here would give you whatever they have if you needed it, but there also isn't one here who wouldn't fight you if you were trying to hurt somebody.

I guess those who endure are neither ashamed to love nor to be tough, and it appears that the tough love can be directed almost anywhere—whether toward children, art, work, God, literature, a game of Scrabble, or a good laugh—so long as it is directed at something or someone other than oneself. One thing is for certain: the resulting personality is one we all could look to for creating meaning in our own lives.

Few people have been more helpful in initiating changes in our attitudes toward the aged than a man who lived out his own kind of tough love to the end—Congressman Claude Pepper. Shortly before his death at age 89 and after many years of dedication to the well-being of America's aging population, he read many of the entries and saw many of the photographs from this book. "How wonderful it is for human beings to live beyond 100," he wrote. "What a great privilege they have enjoyed. . . . Let us hope that. . . everybody can someday look forward to that wonderful privilege."

It is time we all celebrate the presence of the very old as honorable guests in the human community, giving them a more honored place in the present and ourselves a more honored place in the future. It is with Claude Pepper's celebration of life and his vision of the future that I introduce the following 100 over 100.

Jim Heynen

Thoughts Along the Way

Trust

Jim and I went to see Mary Wallace on a hot and humid Florida afternoon. It was so warm that I broke with my normal decorum and wore shorts instead of long pants. I'd be able—I told myself—to move faster and more comfortably in the heat, and I'd increase my chances of getting a good photograph.

Mary Wallace sat on the porch, in the shade, watching as children played in the dusty street, and neighbors worked on cars or walked up to the corner store. Mary Wallace is a tiny woman, but she dominates the neighborhood like a queen.

I photographed Mary Wallace while Jim asked questions. She was delightful and charming, speaking in accents that required careful listening. At one point she turned the tables on us and began asking her own questions. She wanted to know us. She looked down at me and asked, "You have cordwood cutters or parlor pets?" I puzzled over that for quite awhile—mostly because I couldn't make out the words, couldn't get past "polla pits."

When I finally made the connection, it was as though I had discovered one of the great truths about life—simple and pure. This woman wanted to know whether I had sons or daughters, and there were smiles all around as I announced that I had two parlor pets. At the height of good feeling that surrounded the moment, Mary Wallace looked at me and said, "Next time you come to visit, you wear long pants, or I'll take a switch to your bare legs." And then she smiled.

That smile is one of the treasures of this book, and she gave it as a gift. It was in that moment that I knew Jim and I were not doing a book about old people. We were doing a book about people crossing boundaries, people overcoming fears and ignorance, people reaching out to their fellow human beings. Mary Wallace could have been any age; I could have been any age. That smile and that moment crossed decades of human experience and forged a bond of understanding.

Jim Heynen and I felt that same immediacy time and time again throughout our work on this book. It sounds ludicrous to say that it's possible to experience 100 years in the short space of two hours; but it happened to us often enough that I can't really deny it. I feel it again when I look through my contact sheets and when I read Jim's prose. These people gave us their trust, and they revealed their lives openly and honestly. They let us probe with our questions and take over their homes with a trunkload of photographic equipment, and they got into the fun of it all.

The key word is trust.

Paul Boyer

Hands

I notice the hands first.

"The tip of that needle is still in here," says the seamstress. She holds up her finger, then puts my finger on the spot where the broken needle tip has been floating for over 80 years.

"How's that for a grip?" He's 101 and proud of his recovery after a small stroke.

"It happened as a child when my father lifted me up too quickly." She shows her indented knuckles. "It's why I could never play piano."

One picks up her harmonica, wraps her arthritic fingers around it, and plays. Another hoists the accordion strap over his shoulder and watches his fingers find their way to the right keys. Another eases down onto the piano bench, straightening her stiff back while her fingers feather out into octaves. All of them coax memory out, not always from their minds, but from their hands. Even the contemplative folded hands talk. They say, "It's all right. Everything is just fine."

When Paul starts developing his photographs, I realize that he notices the hands too. I come to envy the innocence of the camera—it opens its eyes to anything and accepts what it sees. It reminds us that open minds and innocent eyes see clearly what is there. For me, the hands are always the key. The lively old hands call us into the present and remind us of the past. They keep dancing and talking and remembering. The hands, more than anything, live the present without forgetting the past.

Gripping the steering wheel of his car tight in his hands, he says, "If I couldn't drive anymore, I'm not sure life would be worthwhile."

"Lost it in the turbines." He holds out his hand with the missing thumb, then sighs, "Glad it wasn't my hand."

With no warning, another centenarian performs a peculiar dance with his hands. Paul aims his camera, trying as hard as I am to understand what this man is doing. His mind comes in and out of focus long enough to tell us that he is demonstrating his life.

As I write, I try to capture something of what the hands keep saying: "I have lived; I am living." They always open to us with a double message, a gift from the present and the past.

On Human Utility

Again and again as Paul and I visit with centenarians, we notice the family members' proud faces. The centenarians often aren't doing anything—just being there—and yet you'd have to be quite a cynic not to see how much good they're doing the people around them.

I am reminded of the admiring faces I once saw on a group of tourists viewing a 1,000-year-old tree. For them, the tree had gained power with age, a power that had nothing to do with function in any utilitarian sense. You don't look at a 1,000-year-old tree for its board feet. With trees and humans trivial little branches fall off with time, and they are both reduced and elevated to their simple selves.

Like family members gathered around their prized old relative, the tourists stood before the tree's craggy presence, before its massive uselessness, and seemed to be awakened to the enduring miracle of life and their unity with it. They were proud to be there and seemed to acknowledge that what was before them was one of nature's gifts to them, and one that they ought to accept graciously.

Spanish Influenza

How soon we forget. The Spanish influenza of 1918–1919 that many centenarians talk about killed more people worldwide than any other disease in a similar time period in the history of humankind. It actually did not originate in Spain, but it did spread through Europe and the East. Across the world, somewhere between 20 and 40 million died—in a relatively short time. In America, nearly 4,000 died in San Francisco alone in about 17 weeks. The total American casualties between September 1918 and June 1919 were 675,000. No doubt thousands more around the country died from diseases that were made more acute by the influenza. In comparison, the total U.S. battle deaths from World War I, World War II, the Korean War, and the Vietnam War numbered 423,000.[*]

The descriptions of the flu given by the centenarians I interviewed correspond with those I've seen in medical texts—a high fever followed very quickly by severe respiratory problems. In early cases, the cause of death was often given as pneumonia. In his autobiography, the poet-physician William Carlos Williams described the phenomenon in words that are very close to those of the centenarian nurses I visited: "They'd be sick one day and gone the next, just like that, fill up and die."

In America, records show that the disease was most devastating among American Indians (James Holy Eagle was probably not exaggerating when he told me that "almost everyone was dead from the flu" on the reservation ranch to which he returned after leaving the army.) Black people I interviewed talked of the flu less often. I have since learned that black people were hit the least hard by the disease. The year of the Spanish influenza is the only year in American history in which the death rate was lower for blacks than for whites.

One of the peculiarities of the Spanish influenza is that it struck the young and robust the most severely. The healthiest, most physically fit, were often the first to go. Therefore, although centenarians in this book were at the most vulnerable age for the disease, their survival is not necessarily testimony to their fortitude. They don't know how or why they survived the flu, and probably nobody else does either.

Ellis Island

For many centenarians who immigrated to the United States, the first stop was Ellis Island in Upper New York Bay. In 1892, shortly after the federal government took over the supervision of incoming aliens, it was opened as an immigration center. In 1907, up to 15,000 immigrants might arrive in one day.

Immigrants were numbered and lettered before debarking, directed into a massive hall, then divided into dozens of lines separated by metal railings where they filed past the first doctor. Those whose health was in question were put in wire cages apart from the others, their coat lapels marked with colored chalk, the color indicating the nature of the suspected disease.

Interpreters asked all of them a question to see if the adults were mentally alert or the children hearing-impaired. A second doctor inspected for contagious diseases such as leprosy, VD, and Fauvus. A third doctor inspected the eyes.

They were then put into lines according to nationality and were interrogated to see if they had money, if someone had a job for them, whether they could read or write, and if someone were meeting them.

Immigrants often remained on Ellis Island for five days, but it could be up to two weeks if they had problems. Some of the centenarians in this book talk about the advantage of having a relative or a job waiting for

[*]See Alfred W. Crosby Jr.'s *Epidemic and Peace, 1918* (Greenwood Press, 1976)

them, though others talk about the horrible unsanitary conditions and the wire cage isolation.

Ellis Island continued as an immigration center until 1943 and was used as a detention station for aliens and deportees until 1954. In 1965 it became part of the Statue of Liberty National Monument and was reopened to sightseers in 1976.

Who's Counting Centenarians?

Shortly after I start working on this book, I call the U.S. Census Bureau for what I assume will be the definitive count of centenarians. A voice on the phone tells me that as of July 1985 there were 37,000 Americans over 100 and that by 1990 that figure would climb to 54,000.

I have since learned that the figures vary from source to source. Back in 1970, the Census Bureau found 106,441 self-reported centenarians, but 100,241 of these were disallowed. The source of greatest skepticism on the high figures was two men, Jacob Siegel and Jeffrey Passel, demographic statisticians who compared Medicare data with census material and through a series of mathematical formulations determined that there could not be nearly as many as the reported number. Most life insurance companies have followed Siegel and Passel in the skepticism of high centenarian figures.

Some people evidently have reported being older than they are for various reasons—especially to get Social Security—and, in some cases, have had to live out their lies into what looks like extreme longevity on paper. Nevertheless, I tend to take my stand with people who come up with higher figures than the crankiest skeptics. And, to tell the truth, I'd put more stock in a skeptic who interviewed a few hundred people and determined through their clumsy answers that they were lying than I would in someone who used some abstract formula and never looked a living human being in the eye. In my travels with Paul, I interview people who have lived in this country many decades but who have not bothered to become citizens. I find people who are no doubt over 100 whom state offices on aging don't even know about. And I suspect some people are not counted simply for racist reasons, like black people who grew up on plantations and don't have birth certificates. It's possible, I suppose, that a few people have lied to me about their age, but I doubt it. Try asking persons of any age to lie to you about their age, then ask them some questions about their lives, where they were when Kennedy was shot, during the Depression, during the Spanish influenza pandemic, and so on. It's not that hard to tell if people are lying about their whole life! I suspect that if in the near future some accurate method is found for counting centenarians we will find that the number is considerably higher than the skeptics believe.

Two Men in Middle Age

Two men in middle age go to visit with 100 people who are more than twice their age. This book is about 100 people over 100 but it can't help but also be about two middle-aged men discovering 100 and preparing for age as they age.

We haven't traveled long when Paul asks me, "Do these people make you want to live to be a hundred?"

"Not nearly so much as they make me want to live my life right now the way they live theirs."

"Yeah," says Paul. "That's it, isn't it?"

It is. But neither of us can explain to the other exactly *how* they are living their lives or what it is about their presence that is so powerfully moving and inviting. We might say that they're moment oriented. But that's not it exactly—at least, that's not all of it. They're rather moment oriented from afar. Sometimes I think they can be like eagles making broad casual circles in the sky while looking down with microscopic vision at what those of us closer to the ground don't even see.

Why Are You Two Doing This Book?

The first time we are asked this question, we are already halfway through the project. I say, "It's too late to ask."

"We'd better have a better answer than that," Paul says later as we're traveling.

I can remember an early inspiration. I asked a man in his 90s, "How did you get so old?" He said, "It's easy. You just take a breath like this, then let it out, take another one, keep doing this and pretty soon you'll be very old."

Beyond that tantalizing answer, it began as an impulse, really—why not visit with 100 people over 100 and see what can be learned? Visiting with centenarians who have regrets, I learn that what we are doing is exactly what they wish they had done—follow the impulse of one's heart.

Once we have started, Paul and I simply know that we're doing the right thing. The proof is in the satisfaction we feel every time we meet another centenarian.

But still our answer to the question doesn't improve much. Later someone says, "Are you like the mountain climbers who say 'Because it's there?' Is that why you're doing this book?"

"No," I say, "We're doing it because it's not there."

"We'd better have a better answer than that," says Paul, as we press on.

Nursing-Home Scene

Just before we go to visit a centenarian in a nursing home, we meet two nurses supporting an old woman walking down the hallway. A nurse is on either side, supporting the old woman under her arms as she walks.

"Stop," the old woman says.

"What's wrong?" asks one nurse.

"My panties are slipping down," she says. The nurses don't dare remove their support to arrest the descending panties, so, momentarily, the loose panties follow gravity down to the woman's ankles.

There's a decisive moment of silence. Then the old woman chuckles, steps out of the panties, and forthrightly deserts them. The three continue down the hallway, laughing together at this easy solution to an unfortunate problem.

Centenarian Profiles

Someone asked me if I could combine qualities in a person to make the ideal character for living to be 100. Well, there could be dozens of profiles, but here's one surefire hybrid:

Be a 105-pound Black churchgoing woman born in Italy, raised in Nebraska, who marries a farmer, has no children, and becomes a nurse who works until she's 85, gives her money to charity, and retires to St. Petersburg, Florida, to do volunteer work during the day and to paint, crochet, and play Scrabble in her spare time.

Name That Centenarian

Paul and I start a travel game of trying to name all the centenarians we've seen in the order in which we visited them. As we get closer to 100, the task gets more difficult. It's not that our memories are getting weaker; it's just that there's more to remember. We're just trying to remember 100 names. We imagine what it must be like for a centenarian to try remembering 100 years.

Born: Della Vandiver, February 1, 1886, Choestoe, Georgia
Married: Joseph McDonald, 1913; died, 1914
Lou Fox, 1917; divorced, 1926
Chauncy Canning, 1929; died, 1936
William Zieske, 1953; died, 1954
Children: none
Principal occupation: nurse
Current residence: Beckett Point, Washington

Della Zieske

Della Zieske lives alone in a wind-tattered little house that sits close to the beach on a large sand spit projecting into Discovery Bay on Washington's Olympic Peninsula. Waters here insist on a year-round temperature of about 45 degrees, cold enough to turn a person into flotsam in fewer than 15 minutes. Seagulls, clams, and salmon love the cold water and foggy beaches. So does Della; she landed a 17-pound salmon a few months after her 100th birthday.

"I try not to catch them any bigger than I can carry." She is 5 feet tall. Two fishing poles twice her height hang on her kitchen wall. The hooks are shiny and the lines neatly wound. The rest of the house has the abandon of an 11-year-old's room: unfinished projects are strewn everywhere.

"I'm not a good housekeeper. I have too much work to do." A *National Geographic* lies facedown on the table, the makings of cinnamon rolls clutter the counters, and a large unfinished quilt is suspended like an umbrella over most of her small living room. Her work does not include shooing a long-haired cat from the kitchen counter or cutting off a fledgling tree that has snaked up through a crack in the floor.

As the room temperature starts dropping toward that of the water outside, she relights her small wood stove, wrapping the kindling in newspaper as her "surefire" way of getting it started. With both hands she lifts a rusty gaff hook from a nail near the refrigerator. She's not using it to land a large fish this time but to drag in pieces of firewood.

"I couldn't live in a nursing home. They'd make me keep my room clean. I live here so I can do as I please. People visit me, and when they leave, it's all mine."

The last of her four husbands died more than 30 years ago. "I've had some offers since then, but I wouldn't want to live with an old man, and a young man wouldn't want to live with me. So this is just fine.

"I have some regrets. I divorced one of my husbands. He swore at his parents. I told him I wasn't going to be married to anyone who curses his parents."

And that was that. She left him and never returned. But years later, while living with her next husband, she learned that her divorce had not been a legal one. "I was terrible. I was a bigamist. But we all have something to live down.

"People always want to judge, but I'll tell you how I judge a person. Just ask him what he thinks of his neighbors. If somebody doesn't like his neighbors, you know there's something wrong with him, not the neighbors.

"But you don't want to hear an old lady babbling on. Let me give you some blackberry jam I made. Now where did I put it?"

❧ Della was a nurse for nearly 50 years, but she doesn't talk about health much. A pack of cigarettes and a half-filled ashtray have their places among the projects on her kitchen table.

"Oh, I didn't start smoking until I was 50, and most of the time I'm so busy I forget about them."

"But I don't know how I got so old. I really don't know how this happened. I guess longevity runs in the family. My mother lived to be old. And I've never liked sweets. When I was a little girl, I gave my Christmas candy to the other kids. I never drank much either. But there's another thing. Luck. My third husband and I were walking along the street one winter. It was almost Christmas, and I stopped to look at some colored lights. He was just a few feet ahead of me when a car skidded on the ice and killed him. It could have been me, but it wasn't."

Della has left a few pieces of newspaper on top of the stove. They start to smolder. She turns and brushes the glowing paper to the floor with a stick. There aren't any smoke alarms in this house, but she doesn't seem worried. The cat doesn't look worried either. They seem to be ready for whatever comes and against any odds—like that little tree easing up through the floor.

Born: April 4, 1889, 10 miles north of Pine Ridge Agency, South Dakota
Married: Elizabeth Turning Holy, 1922; died, 1969
Children (3): Gus, James Jr., Willie
Principal occupation: printer
Current residence: Rapid City, South Dakota

James Holy Eagle

"My grandfather, his name is Iron Horse. He was with the Indians when they wiped out Custer," says James Holy Eagle.

On his living room wall hangs a painting by French artist Guy Simon picturing him and Sitting Bull. From the ceiling hang streamers with the six sacred colors of the Sioux: red, blue, green, yellow, black, and white.

James Holy Eagle is the oldest Sioux Indian —"a peaceful man," says his granddaughter, "because he worked on all the treaty issues." In 1975, he met with President Gerald Ford to talk about broken Indian treaties and claims to land taken from the Indians—a meeting that drew a favorable written response from Ford, though little action. In honor of his age and place in Sioux history, South Dakota has declared a Chief Holy Eagle Day.

"It's not the same being an Indian as it used to be," says Holy Eagle. "In the old days was a whole lot better. Right now in this town if I see an Indian and if he don't know me he goes right on. Before that, when you see an Indian come, you shake hands and talk. In the olden days all Indians was the same as related."

In those good old days, he once stopped to talk with an old Indian couple at a favorite meeting place— "down by the crick"—a place called Mother Butler's. Holy Eagle had been raised by his stepmother Alice Lone Bear. But the old woman of the couple thought that his real mother's name was Good Woman, who was of the family of Sitting Bull. The man of the couple had known his father, Iron Horse, and had also fought in the battle that killed Custer.

"I asked the old man, I said, 'Grandfather, I know when the Indians fought Custer. I know you were there. Grandfather, I want to know who killed Custer.' He said, 'I was the youngest one, and at that time they were fighting over there on horseback and guns were going smoking, and I can't tell you who killed Custer.' That's what he told me. He don't know. Years ago after that, somebody told me he heard Rain-in-the-Face killed Custer."

James Holy Eagle was 12 when he started attending a Bureau of Indian Affairs boarding school at Pine Ridge and later, in 1912, started attending Carlisle Indian School in Pennsylvania. He studied to become a printer and distinguished himself as a cornet soloist and as a right guard on the football team.

"I got there and learned it was just the same as college. I worked in a printing office, and I played football. We played football against all the white kids over there—Yale, Harvard—you know. We had the best football and track team.

"That's where James Thorpe went. He went to the Olympics. That James Thorpe is an all-around man. He's just as big as I am."

Holy Eagle broke his shoulder in a game against Yale and still has a protruding bone from the injury, but he graduated at the top of his class in 1916 and was hired as a band director and boys' advisor at the Indian school in Greenville, California. When World War I broke out, he enlisted and was sent to Camp Dodge. Irving Berlin was there too. "Our band played a lot of the songs he composed."

But Holy Eagle remembers the 1918 flu as well as he remembers Berlin. "I had the flu, not too bad, and I had to drive a coach to haul the soldiers to the hospital. Many died. The flu picked out anybody."

When he left the army in 1919 to manage his aunt's ranch on the reservation near Merriman, Nebraska, he found that many people there had died of the flu too. He worked the ranch, but, as he says, "Printing was my main trade." He found a job in the print shop in Martin, South Dakota. He married in 1922 and had three sons, all of whom enlisted in the military. Besides his work on the ranch and as a printer, he has been a mechanic. In the devastating 1972 flood in Rapid City, South Dakota, he lost many of his possessions. Today he lives by himself in a modest apartment in Rapid City.

"He is a very happy man," says his granddaughter. "He likes men visitors, but he prefers the company of women."

He also likes to be playful.

"You know why Indians wear feathers on their head?" he asks. "To keep their wig wam." He laughs.

"I got white man's teeth," he says, and laughs again, showing them.

Every morning and night he prays and sings a song in Lakota. "We all should put God first," he says. "It seems like it helps you to go through the day and night."

❦ "How did I get so old? Well, I tell you—don't worry, that's one thing. Sometimes I'll get hungry, and it don't worry me. I don't worry. Worry will get you old quick."

Born: December 16, 1884, Hamlin, New York
Never married
Children: none
Principal occupation: social worker
Current residence: Portland, Oregon

Ruth Inez Austin

I was arrested for assault in New York during the garment workers' strike. But the judge released me when he learned about my crime. I hit a policeman with my muff."

That was close to 80 years ago, and Ruth Austin was living up to a family tradition of social activism. Her parents' house in upstate New York had been a station on the Underground Railroad, and her family was part of the large underground movement helping Black people escape from slavery into Canada.

Before she started swinging her muff, she already had directed her activism toward the needs of immigrants by working for the Immigrants Protection League and as a special investigator with the Consumers League. At the time of the garment workers' strike she was teaching at Lenox Hill, a settlement house for immigrants on the upper east side of New York City.

She was an activist and an early feminist. Because language textbooks for foreigners were almost exclusively formulated for men, she wrote *Lessons in English for Foreign Women*, published in 1913. Although some chapters, like "A Day's Work in a Cigar Factory," concede a woman's place in pre–World War I America, the book shows so much compassion for the immigrant woman's situation and makes such a generous use of poetry by women for women, to supplement the lessons, that it could well be regarded as a feminist classic.

Her early biography sparkles with accomplishments, even though she suffered a severe physical handicap. Her hearing was so seriously impaired that a specialist told her when she was a girl that she should plan for a quiet life on the family farm. She must not have heard him.

"A handicap is awful but you can outlive it," she says. At 102, she still watches lips as she listens and, with two hearing aids, seems to catch everything that is said—and some things that aren't.

Most of her career in social work was at Gads Hill in southwest Chicago, where she started in 1914 and continued through 1947. She still is on the Board of Directors. Gads Hill was a large educational and recreational neighborhood center in industrial Chicago and served immigrants from a wide assortment of ethnic backgrounds. This was Al Capone's territory at a time when, as she says, "he had everything," including the respect of many immigrants whose well-being he defended. In the eyes of Capone's men, Ruth Austin must have been doing the right thing, for they evidently once offered her some retroactive protection. "I was knocked down and my purse was stolen. The next day they [the assailants] were found floating in the river."

Ruth Austin is an unsung American heroine. It was Jane Addams at Hull House in Chicago who received most of the public attention and acclaim, winning the Nobel Peace Prize in 1931, but Ruth Austin's impact on Chicago immigrant life is in many ways comparable. An instigator of the theory that recreation is one of the best forms of therapy for the handicapped, she is recognized by serious students in the field today. "Play as medium," she says modestly.

Ruth Austin lives alone in a ninth-story apartment in Portland, Oregon. Even though the longtime woman friend who moved here with her has died, her apartment does not sag with the dreariness of a lonely person. "Oh, I have had a gorgeous life," she says.

Ruth Austin's only regrets are in what has been lost in the kind of community work to which she dedicated her life: "Old settlement workers have been engulfed by caseworkers. The old intimacy has been lost. If you asked a boy what he knew about Jane Addams, he would say, 'She likes pie.' There was that kind of intimacy."

❧ Ruth Austin says she owes her longevity to wide reading, curiosity, and an involvement with life. Her more than 50 years of social service dance, smile, and act their story through the ethnic artwork on her walls. The art reflects several ethnic traditions of the people she served.

Born: January 28, 1886, Wilcox County, Alabama
Married: Leila Marsh, 1924; died, 1958
Children: (1) Caswell
Principal occupation: school teacher and principal
Current residence: Monroeville, Alabama

Patrick Jonathan Carmichael

Patrick Jonathan Carmichael's name belongs with those of people like Booker T. Washington or George Washington Carver. Like Washington and Carver, he dedicated his life to the education of young Black people. The fact that his name is not remembered as clearly as those may be a quirk of history.

Carmichael was the founder, teacher, and principal of Purdue Hill Industrial High, a school created for Black children. It was located in the middle of the corn and cotton fields of Alabama.

His one son who attended the school and became an educator himself says, "When he founded Purdue Hill, there was nothing like it in Monroe County, no course of study for Blacks. But he was a man of perfection in everything he taught. At one time he was the only teacher with as many as one hundred and forty students in one room."

Patrick Jonathan Carmichael was born the son of a freeman, who earned his way out of slavery in North Carolina before moving to Alabama and the Rump plantation. Carmichael attended Snowhill Institute, which was modeled after Booker T. Washington's Tuskegee Institute. It was here that the dream for his own school began. After graduating from high school he taught five years, then founded Purdue Hill Industrial High.

"The state put up just seventy-five dollars a year for expenses," he says. "Students paid tuition of twenty-five cents a year and paid in chickens or cans of syrup if they didn't have the money.

"You couldn't get a dime out of a state to build a Negro school back then. I'd write letters to people all over the country who I thought had a little charity about them to help us. I'd be the last man to put his light out because I'd be writing letters."

"He got twenty-five dollars a month," Carmichael's son adds. "He fed us kids by farming, getting up before dawn to work the fields, raise chickens and cattle and pigs. He had a big garden. All his earnings went back into the school. At night he'd write those letters to wealthy people in Boston or New York, trying to get a little money for the school. He was persistent. A little at a time. People in the area built the school. It started out as a one-room school with one teacher and eleven students and grew to a twelve-room school with two hundred and fifty students and ten teachers."

"I had a way to handle my students," says Carmichael. "You have to guide your students and direct them, and you have to keep order."

"He'd take the stick to you," his son adds.

But the school closed in 1964. The reason? Patrick Jonathan Carmichael feels it was the civil rights movement. Carmichael's son explains. "He feels that most of the work by early pioneers in Black schools lost all of it through integration and illustrates his point with this story: 'A dog is swimming in a creek with a bone in his mouth and sees his own shadow in the water. So when he turns to try to get that bone, he loses what he has.' The early generations worked to build schools and other institutions, then felt they saw something better, but it wasn't real, and they turned loose everything they had. Now we don't have those schools."

Patrick Jonathan Carmichael is now living with his son and daughter-in-law. He is 101 but has been with them for only the past few years. After retiring from his career in education in 1958, he lived alone on his farm until he broke his hip after going out to feed his cattle. He was 97.

"We're staying home more now," says Patrick Carmichael's daughter-in-law. "We never had any children of our own and wanted some. Having him around is sometimes like having a child in the house. I wake up worrying about him. It's a joy and a frustration, but we know we may need the same thing some day. We're learning to do as we hope to receive. It has been good for us."

"I didn't get along with my father when I was younger," says his son. "He was such a hard-working, disciplined man. Now it's different. It's like we're getting another chance. I have to take care of him, do things for him like shave him. He needs me and we're developing more of a buddy relationship."

❦ Patrick Jonathan Carmichael has been a visionary who followed his vision with a hard-working, disciplined life. No smoking or drinking. He eats country food: greens, peas, fried chicken, catfish, smoked pork.

"He's always been a fussy eater. He didn't like junk food and seldom ate sweets," says his son.

In all those years teaching and farming, didn't you eat any bad food?

"There wasn't anything bad to eat."

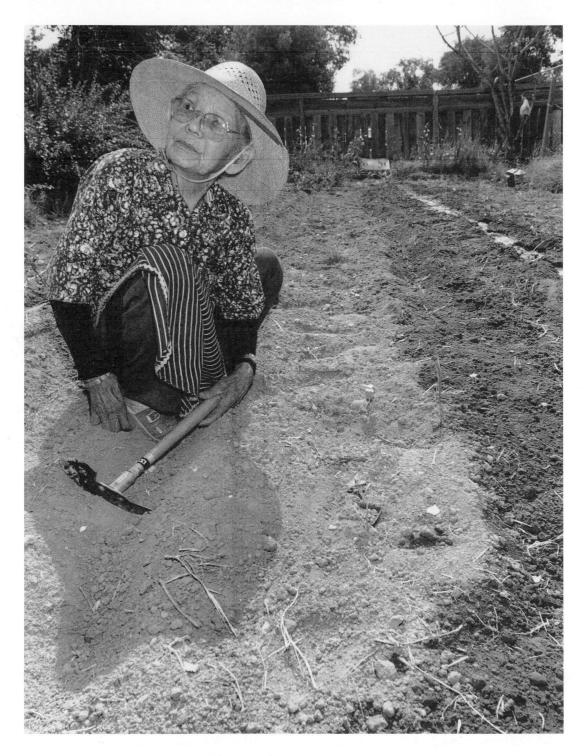

Born: Kisa Okuna, April 4, 1888, Kosa-Kumamoto, Japan
Married: Matahichi (Mat) Iseri, 1906; died, 1961
Children (12): Thomas, Mitsuo (Mike), Manabu (Mun), Masato (Mas),
Alice Yoneko, Mae Sadako, George, Daniel, Gengo, Akio (Oscar),
Carl, William
Principal occupation: gardener, homemaker
Current residence: Ontario, Oregon

Kisa Iseri

Kisa Iseri works in her garden. She works in her garden a lot. Wearing a long apron which hangs over her feet, she stoops to weed. Nothing in her body seems to creak, but some part is always moving: her eyes, her waist, her neck, the weeding and hoeing hands, and even the toes which constantly seem to be in motion in her open sandals, as if gripping the ground or maintaining the delicate balance of her small body above them. Her hands appear both younger and larger than the rest of her as she works. She is in continual motion, little bodily gestures that keep her and her lavish garden operating in harmony.

She lives in a modest house near the Buddhist Temple in Ontario, Oregon, where she moved about 15 years ago. Worshiping and gardening occupy her life.

"She moved here to be closer to the temple," says her daughter-in-law. "And she looks forward to seeing how her things are growing."

One sugar pea plant in the middle of the garden is drying on the vine for next year's seed. Under the awning at the rear of her house lie mustard seeds drying. "She's looking ahead already to next year," says her son. "She doesn't look back."

She has large bundles of rag strips that she has cut up from discarded fabric into 8- to 12-inch strips that she uses in place of string to tie up her cucumbers and other plants. She has duct-taped a bright red strip of cloth to the handle of each of her garden tools so that she can more easily find them. She grows cabbages, cucumbers, tomatoes, eggplant, beans, peas, plus raspberries, peach trees, cacti, roses, and a variety of other flowers. She gives some of the fruits and vegetables to her family and still cans and makes jelly.

"She can't forget the days when she had to be frugal," says her son. "Even today, if she goes out to a Chinese restaurant, she saves the disposable chop-sticks for use in her garden."

Kisa steps over hoses and scraps of wood so easily that she almost seems to have memorized where every obstacle lies. She moves through her garden and stoops with ease but weeds with some effort. The number one enemy among the weeds is salt grass, with roots so deep she must use a fork or hoe to get into the soil and loosen them. But she doesn't hesitate to pull hard, leaning back with all her slight weight.

What is your favorite plant?

She thinks for a second, looking around over her garden. "They're all the same to me."

Do you ever get tired?

"No, I'm strong."

Good food?

"Yes. My vegetables."

About 20 years ago she made a slight gardening error by cultivating some marijuana plants that were growing in her garden. The state police came and told the family about it. "I didn't know what it was," Kisa said. "It's just such a beautiful plant that I've been taking care of it." Her daughter-in-law says she cooked with it, not knowing what it was, and that she thought it added to the flavor of her sukiyaki.

Kisa is part of the diminishing number of Iseis, first-generation Japanese, many of whom were adults on December 7, 1941—Pearl Harbor Day. Kisa and her husband had a vegetable farm near Kent, Washington. Although one of their sons enlisted in the army the following February, by May the rest of the family was interned. While they were in camp, her son, who served with the famous Japanese–American 442nd Regiment, was killed in France.

"We were retained behind a barbed wire fence while our brother was out fighting for our country. And dying for it," says Kisa's son. But he remembers that Kisa never complained about camp: "She said, 'We are aliens, but you kids are citizens of this country—do as you're told.' She didn't say this in a harsh tone. She has never spoken in a harsh tone to anybody. She doesn't want to be thought of as someone who is always preaching. Her advice is always simple: things like 'Be thankful for what you have' or 'Always say thank you' or 'Don't bring shame to the family.' "

What makes you happy today?

"Number one, everyone is so good to me and they all treat me with affection: everybody does things for me. I have nothing more to ask—that's the beautiful part."

How did you get so old?

"I don't know. Perhaps the tea I make has something to do with it."

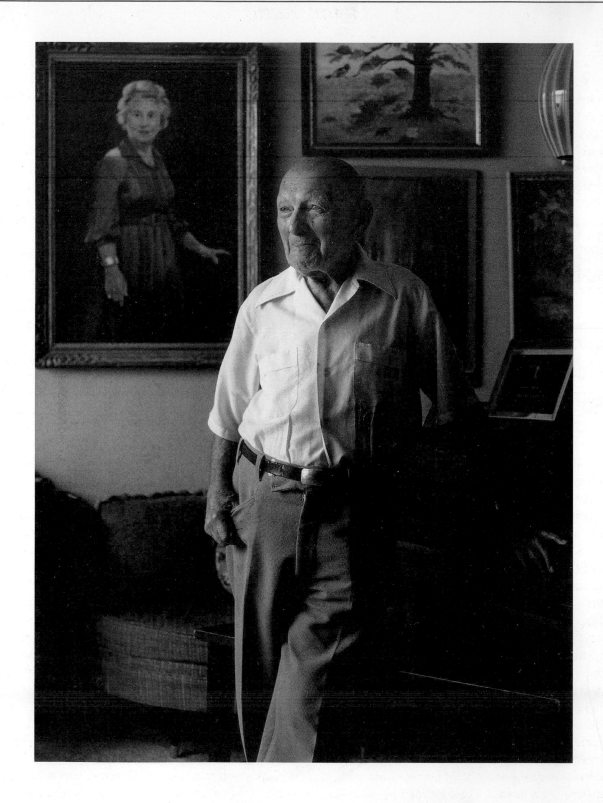

Born: June 21, 1885, Berezitch, Russia
Married: Wilhelmina Levin, 1913; died, 1979
Children: (2) Royal, Richard
Principal occupation: portrait artist
Current residence: Miami Beach, Florida

David Kane

At the height of his career in New York City, David Kane was painting portraits of moneyed people like the Rockefellers, the Vanderbilts, and J. P. Morgan. His portrait of Henry Clay Folger, chairman of Standard Oil, still hangs in the Folger Library in Washington, D.C. His studio, on Fifth Avenue, in William Randolph Hearst's old mansion, was set up in what had been Hearst's library. Kane portraits were selling for up to $5,000 in the 1920s and 1930s, though he sometimes had to defend himself against anti-Semitism:

"In those days, prejudice against Jews was so great that I sometimes signed my paintings 'D.E. Kane' so that people would think I was French. I was a foxy little fellow."

At 102, David Kane is still painting, but he paints imaginative pieces rather than realistic portraits. They're not selling for $5,000, and the proceeds are rarely for himself. He has become a fund-raiser.

"I live on love of giving. When I hand the American Heart Association a check, it's good for my life. I have no words to describe my feelings for their activities."

With David Kane in his 11th-floor Miami Beach apartment are three men whose combined ages barely equal his 102. He is the only one in the room who is not sitting down.

"There isn't anybody who doesn't know me, thanks to the newspapers and TV. When I go to people's doors, they empty their wallets for me, and this fills my heart."

He speaks with a breathless urgency, first an intense whisper, then a grand arc of sound, accompanied by equally grand gestures. He walks around at the pace of someone who is always late and has reason to be. He is the number one door-to-door fund-raiser for the Greater Miami Heart Association. Claude Pepper became his friend and admirer, seeing in David Kane an unsurpassed model of what old age might be like.

David Kane moved from New York to Miami 27 years ago for his wife's health. She had severe heart problems. Both she and one of his two sons have died from heart disease, but his remaining son was saved by a heart-valve replacement.

"When my son had his surgery, it was the first of its kind. When I hear his voice today, I could scream with joy. Nothing that I do can equal the work of the Heart Association."

Paintings are everywhere in David Kane's apartment, covering most of the walls and shelves and part of the floor. A portrait he painted of his wife for their 50th wedding anniversary, 16 years before her death, is the most prominent in the living room. His studio is their bedroom, and he paints on a large piece of cardboard placed across her empty bed.

"When I look at that painting of my darling, I don't grieve. It makes me thankful for all the years we had together." Holding up both hands toward the portrait, he says, "That was the greatest blessing of my life."

He is working at an increasingly fast rate, with several paintings in progress at once. Most of them are for charity. He has given one show to raise money for the Israeli ambulance fund but usually sells his work and gives the money to the Heart Association.

"I don't call myself a painter, I just paint. I get up at three or four in the morning and paint. Then I spend a few hours reading, and then I go out to walk. Nobody ever sees me in the morning because they're all asleep. And I am grateful when I go out in the morning. I don't say, 'I had a miserable night.' I say, 'This is the day the Lord has made.'"

❧ David Kane does not wear hearing aids or glasses. His health and vigor at 102 are astonishing. He doesn't drink or smoke, and he's a light eater, but he thinks the secret to health is in a person's attitude:

"My theory is that if you're occupied, if you're busy doing something, you live. Happily. And if you sit around and bemoan your life, what's happened and so forth, you're a sad person. You die young.

"I have a philosophy of life that's very positive. Don't say you grieve. I'm grateful I had my darling for sixty-six wonderful years. I'm not grieving because she's not here. I feel she is here." He looks out his apartment window and gestures toward Biscayne Bay where he had her ashes dropped from an airplane.

"Enjoy whatever you see of nature that we didn't create. Look at the sky! Look at the clouds! Look at the water! Look at the trees! I say, 'Be grateful.'"

Born: Ethel Blaker, February 14, 1889, Kent, Hythe, England
Married: Stewart Noel, 1920; died, 1964
Children: none
Principal occupation: restaurant supervising cashier
Current residence: Victoria, British Columbia, Canada

Ethel Noel

Oh Lord, fill my mouth with
worthwhile stuff
And nudge me when I've said enough.

So reads a plaque on Ethel Noel's bathroom wall. She is a talker and she knows it. Only yesterday she had afternoon tea with friends at Victoria's famous old hotel, The Empress. No doubt she said a great deal—though it's hard to imagine that a voice from her table or anywhere else told her that she'd said too much. She's too warm and civil, and has as much respect for her listeners as she has desire to speak. She spices her talk with conversation starters, not enders. Like these:

"Canadians are more honest than people in the States, but people in the States are more imaginative—they're always jumping from one thing to another, aren't they?"

"I think when people get to a certain age they shouldn't have to pay income tax. Do you?"

"Wouldn't you say the health system in Canada is very good for older people?"

"One of the penalties of older age is that you hardly ever have anyone to whom you can say, 'Do you remember when?'"

"I find Anglican women are quite keen on sherry."

Ethel spent her childhood in England, back in the days when Queen Victoria still rode the streets of London in the royal landau. "I was expecting to see someone quite different. She had a little black bonnet on, and she was glancing from side to side at the people—like this (nodding slowly to the left and right). She was round and tiny. Oh, she was a small, dumpy person, really."

Evidently, some voice nudges Ethel as she makes her final pronouncement about Queen Victoria. "Now don't write that down!" she amends. "I'm more tolerant than I was as a young person," she says. "I would go a mile to avoid trouble now, whereas earlier I might not have done. It takes the years to give you that vision. Some don't reach it."

Whatever vision Ethel has reached, for her, people are paramount. She lives in a lovely apartment furnished with many pieces that her antique-collecting brother found for her: furniture and paintings that seem to extend naturally as expressions of the woman, a kind of reserved opulence. But things do not substitute for human community. She has outlived all of her immediate family, and they are no longer around to answer the question "Do you remember when?"

"Life diminishes," she says. "My husband and brothers are all dead. There's a vacancy, but you learn to be thankful for the things you have."

She doesn't complain that she had no children. Instead, she offers her own wisdom for other childless people: "There's no crime in not having children. So many women seem to feel that their life is all displaced because they don't have children. But it isn't. I figure you can be happy and see that other people are happy just as much without children as you can with them—and sometimes more. You can be just as useful in your life, just as happy. There are lots of children who need a helping hand, and you can fill your life and theirs. It's a good way to live."

Ethel's father died when she was a baby, and she moved to Canada with her mother when she was 17. She settled with her mother and one brother in Vancouver, only to face poverty. Against her brother's protests, Ethel found a restaurant job, working as a cashier for the White Lunch Company. She stayed with the company for 45 years. At her retirement, she was in charge of collecting money, paying wages, and overseeing the banking for all the restaurants that had become part of the White Lunch chain.

Although Ethel is alone today, everything she says argues for contentment. "I love the city of Victoria. The quietness and peace. It's a lovely place to be. I have so much to be thankful for, so I don't dread what may come. I figure what the good Lord wants you to do He will see you do, so I take what comes and am very pleased. If I went to bed tonight and the Man Upstairs said, 'I need you up here, Ethel,' I'd be very content."

❦ "I had every childhood illness there is. I had rheumatic fever and I've had surgery for cancer with cobalt treatments afterwards. That was thirty-six years ago.

"They keep asking me how I got so old. I say, 'Well, there's no secret.' I have a very small appetite, and I have always tried to have good food, properly cooked. Also, I've been very fond of carrots, and that's it."

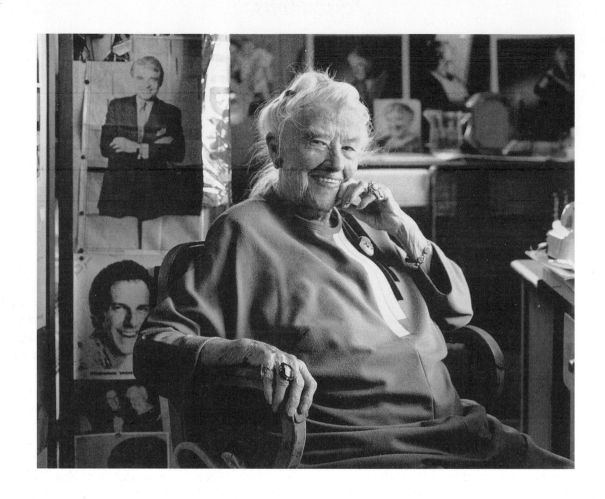

Born: Jesse Crooks, December 27, 1887, rural Missouri
Married: Robert T. Nores, December 8, 1907; divorced, February 13, 1917
Saul Haas, August 22, 1919; divorced, March 2, 1942
Children: none
Principal occupation: actress
Current residence: Seattle, Washington

Jesse Haas

"Oh, my dear," says Jesse Haas, "there is so much to do, so much to do. This planet is in such an awful mess, and it just keeps me busy trying to straighten it out. And I'm the luckiest person on earth—that, at one hundred one, blind, deaf, and crippled, I am still able to help. My hair isn't red anymore, but my spirit is fire."

Jesse Haas was a professional actress for 68 years. "I'm not acting now," she says, but, as if out of habit, her eyebrows and arms rise in synchronous gestures.

"It's her altruism that makes her life worth living today," says a friend. "She sits in her studio for hours writing letters, keeping up a constant correspondence. She has hundreds of names."

"I'm usually at my desk writing and phoning," says Jesse. "I reach out. I have a file of several hundred people. Always somebody in trouble, or in sorrow, or sick or worried. And I'm just kind of able to cheer them up and inspire them to get through it."

The people Jesse reaches out to include young actors and actresses, but more than a few news people and politicians hear from her regularly too. She says her best writing time is between midnight and 2:00 A.M.

Her studio where she both works and sleeps is at the rear of her large house. The room, filled with theater memorabilia, has several filing cabinets and an accordion room divider covered with pictures of other actors and of herself in various roles and in magazine ads. Her desk with its file boxes of names and unfinished correspondence overlooks Lake Washington. Although she is legally blind, she points out the window and calls attention to the color of the water and the sky.

"I'm grateful for every moment I live," she says. "I don't have to get down on my hands and knees to pray—every moment is a prayer. But if you want to know the prayer I live, here it is. I give it to you: Oh, God, Infinite Mind, / Ruler of countless planets and stars, / Look down upon this microscopic grain of sand, / Writhing in anguish, / With ignorant and destructive wars, / And with love and pity, / Lend a helping hand.

"You can't ask for more than that. This planet is no bigger than a pinhead in the universe, but here we are, and I'm trying to do my bit to get people to stop killing each other, torturing each other, and losing hope in themselves and their own abilities to act. What's wrong with people—wanting to fight!

"And I think of the theater. I think the theater has the power to change things. The Church is struggling to do it, but the theater I think has more power for good or evil. The theater is alive. The theater is live people. There is nothing like it, walking out on stage—you can just feel the audience out there—that wonderful relationship between a live actor and a live audience. It is my dream."

Most of her professional theater life has been in Seattle, though she had her first professional experience in 1910 with the Ferris Hartman Opera Company in Los Angeles in the back line of the chorus. "I was hungry for the stage," she says. She soon discovered that she could sing above a high C, which, she says, combined with her nice legs, started her career. She and another young woman developed a vaudeville routine that required five quick changes during a 10-minute show. They played theaters on the Pacific coast.

Shortly before World War I, she wrote a one-act play for three women. (She was in the post office in Portland to get her copyright card on the same day the United States entered the war.) A few years later Mae West rehearsed in the play, then went off to New York. "She took my character to New York, changed her to a 'come-up-and-see-me-sometime' character and got rich. That happened."

Jesse started playing stock, including 26 productions with Gene Keene's Cirque Playhouse and many more performances with Seattle theater companies. Her favorite role of her long career was Miss Hoadly in *The Silver Whistle*, a play that was a forerunner of the movie *Cocoon*, with old people sitting around a retirement home doing nothing but feeling sorry for themselves. Hers was a comic role, the old tippler who sneaks out at night for the bottle she has hidden in the flower beds. The rather blatant moral of the play may have become something of a motto for Jesse's life thereafter as the characters learn how the power of the mind can be used to begin living. However lighthearted her role may have been, she took the moral seriously and declares to this day, "What you believe you can do, you can."

❦ "How did I get so old? I don't know. I'm busy."

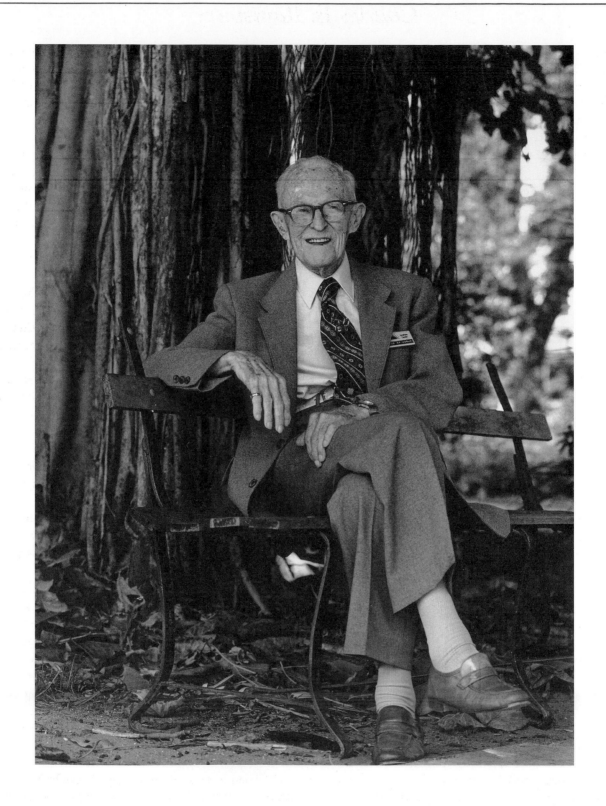

Born: February 12, 1886, Troy, New York
Married: Sylvia A. Cramer, 1917; died, 1965
Children: (1) Dorothy
Principal occupation: salesman
Current residence: St. Petersburg, Florida

Charles E. Rainsbury

If you've seen the movie *Cocoon*, you've seen Charlie Rainsbury. He was 98 when he was cast for the role of Smiley, a retirement home resident who wistfully watches his peers become rejuvenated in this movie about youth and aging. The real-life 101-year-old Rainsbury is more youthful and energetic than the character he played in *Cocoon*.

"I have no aches, no pains—never have had. I never had a headache, I never had indigestion, and I take no medicine. I never took time off from work because of sickness. The last time I know that I was sick was 1922. I eat anything and everything. If a doctor told me to go on a diet, I'd tell him to go to hell. I make my own breakfast—bacon, eggs, coffee—up to 10 cups a day. I haven't had a hard life, I've had a busy life."

He is busy today, earning the title of St. Petersburg's oldest active volunteer. He works six days a week from 9:00 A.M. to 3:00 P.M. for a large multipurpose complex for the elderly that has over 15,000 members and serves over 500 people daily. He coordinates the State Societies, clubs formed years ago when people from various states started flocking to St. Petersburg for winter vacations. When business is slow, he works crossword puzzles.

You act as if you've been rejuvenated.

"Well, not really. I fell and broke part of my hip. My leg was sleeping. That's why I'd give this advice to millions of old people: If you're going to get up, wiggle your toes. If they don't wiggle, don't get up. If old people followed that advice, there wouldn't be so many broken hips. But I don't worry, never have."

It was no accident that St. Petersburg was chosen as the spot for filming much of *Cocoon*. The city's reputation as a place for rejuvenation goes back over a century when a Dr. Van Bibber at an AMA meeting declared this area the healthiest spot on earth and urged that an international Health City be built here. Today the elderly people of St. Petersburg are visible everywhere, walking the sidewalks lined with jacaranda, magnolia, cabbage palms, and banyan trees; playing shuffleboard on the immense courts; visiting on park benches; or idling down sidewalks and streets on adult tricycles. The city is so deeply identified with the elderly that among its many labels is the sardonic "God's Waiting Room."

But Charlie Rainsbury is among the New Old, people who may not have found the Fountain of Youth but who live lives that show the Fountain of Old Age is not dry. The city's banyan tree may be their best symbol. Like so many of the elderly of St. Petersburg, it is a transplant that drops new roots from old branches and thrives in its adopted environment.

"I have only one regret," says Charlie. "I let my drama teacher talk me out of a career onstage. She warned me that an actor's life would be debilitating."

That was in Hartford, Connecticut, back in the 1910s when he acted in some comedies. Following her warning, he became a salesman. "I started selling in 1913 and have been selling ever since."

In his sales heyday, he once sold 10,000 percolators in a few days. He had the notion that anyone could make sales, so he introduced the idea of getting any and everyone to sell on commission.

"Even ditchdiggers sold them because they realized they had friends. Everybody is a salesman."

At night, to ease the stress of sales work, he read comics. "I'd get all the funny papers that I could. I'd read them until I fell asleep. I did this my whole sales career."

In retrospect, he believes that everyone should follow their dream, not the commonsense advice of cautious teachers: "I wish I had tried it," he says. "But I had to wait until I was 98."

His role in *Cocoon* was big enough to get him listed 20th on the credits and to earn him more money in 12 working days than he had ever made before in an entire year.

"It's a good story. It means something to me. I think, what is a cocoon? It's just a fluff-thing there. But it graduates—it's a beautiful butterfly. You and I were cocoons until we were born. If we make good and do things for others, then we're butterflies."

Charlie Rainsbury may have broken from the cocoon himself: he's doing things for others and he followed his dream to his day on stage. But the salesman is still in him. "I'll always be a salesman. Today I sell myself to others."

❧ "There is no secret to old age. I may be here tomorrow morning; I may not be. I have nothing to say about it. Tomorrow is another day."

Born: Sarah Nathanson, April 8, 1886, Rumania
Married: Sam Silvers, 1919; died, 1934
Children: (1) Clara
Principal occupations: drug store operator, community volunteer
Current residence: Los Angeles, California

Sarah Silvers

The laughter starts in her eyes and spreads across her face. When friends walk in, they are greeted by her laughter and, today, by fresh *hamentaschen*. Her front door is never locked.

"Anyone who wants to visit is welcome to walk right in," she says and smiles. "I am sorry I cannot walk easily to greet you."

Sarah Silvers lives in a low-income senior apartment building run by HUD and the Jewish Federation. Friends from inside the building and out are constantly stopping by to see her. A close friend says, "Her life is characterized by guts. She is a tall rock. Her courage and dignity are an inspiration to those who know about her."

Her friend's admiration lets the world know there is more to Sarah Silvers than her convivial laughter. Someone has said the fullest laughter is given only to those who have known the deepest pain, and Sarah's laughter has the fullness of suffering. But those around her seem to feel she has done more than endure suffering, she has conquered it. She was orphaned as a child in Rumania and has lost her only daughter, all five of her brothers, and all three of her sisters. Eight years ago she was hit by a truck. Three years later she fell while evading another one. Her legs are greatly swollen from the injuries.

"What we can fix, I try," she says smiling, "but nobody can do any more for me."

The darkest story of her life is the death of her husband over 50 years ago. They had met in California and together had owned and operated a successful drugstore. But his roots were in Russia, and when he heard that the Russians, under Lenin, had promised to establish Bero Bidjan, which was to be a Jewish homeland in Siberia, he and other Jewish–Americans wanted to help. He and other professional people from the United States sent supplies, then decided to travel there in person. When they arrived, they found that the Russians had taken the land back from the Jews.

"The Jew can't win with the Russians," says Sarah. "My husband was so disappointed that his heart busted. When he got home, he was practically gone."

He lived on in a debilitated state for nearly a year and died. Upon his death, Sarah ordered an autopsy. She holds up her hands with fingers spread and explains:

"The heart is leaves. It's full of fine leaves and blood goes through these lines. He couldn't catch his breath because there was no blood coming. All these leaves, all his veins, were plastered one with the others—he couldn't breathe. And that's why he died so young. His heart couldn't take it."

An Old Testament passage reads, "Any wound is better than a wound in the heart" (Eccl. 25:13). But there is also an old Jewish proverb which says, "God is closer to those with broken hearts." And it was with her own heart broken that Sarah immediately had to deal with the medical bills associated with her husband's illness. She sold their drugstore and went to work in a food market. She tried to get a job when she was in her 70s, but the clothing store where she applied wouldn't hire her because they couldn't insure her. When she was 75, she traveled around Europe by herself. Until she was 85, she was driving a car. She worked for years for the Sortel Hospital, as a volunteer for Gateway, and has done extensive volunteer work for the Organization for Rehabilitation Training. Placed inconspicuously around her living area are the many plaques and awards she has received for volunteer community service.

Today she reads and listens to tapes. A charcoal drawing of Golda Meir hangs on the far wall. Near her hang pictures of her granddaughters, a cellist and a dancer, and of her bearded Rumanian father in black hat and suit. Some of her life's dreams have not come to fruition: she wishes she could have been educated, and she wishes she could have been a singer. "But I listen to music today," she says. "I don't like the music that they hop around with it, but I do like the long-hair music.

"The time goes by," she says, "and it is nice."

❦ *How did you persist for over one hundred years?*

"There is no secret," she says. "There is no prescription for growing old. But when you work hard, you get hard. And go on living."

Perhaps her comment could best be appended with a quotation from *Midrash*, Leviticus Rabbah (.30): "If you want to endure this world, equip yourself with a heart that can endure suffering."

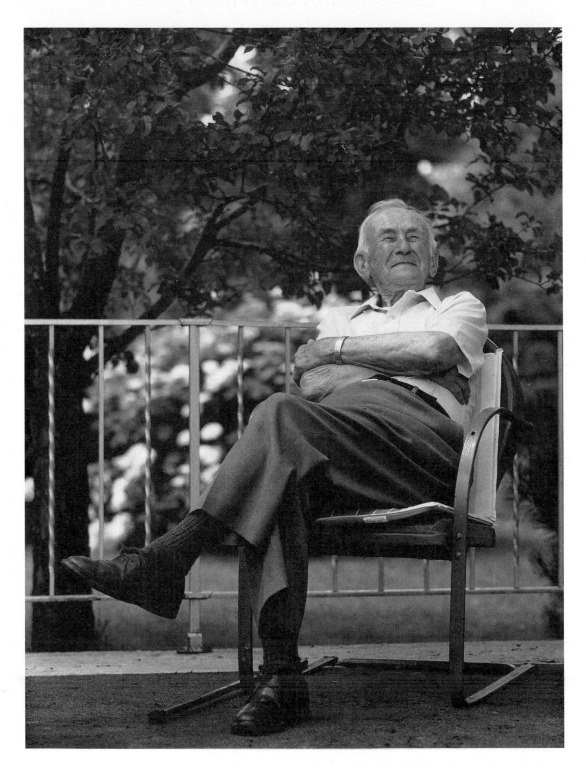

Born: October 29, 1887, East Brookfield, Vermont
Married: Mary Emma Markolf, 1913; died, 1979
Children: (2) Harriet Elizabeth, Donald Monroe
Principal occupations: farmer, civil engineer, land surveyor, machinist, foundryman, blacksmith,
cartographer, inspector of electronic aircraft gauges, homemaker
Current residence: Glover, Vermont

Ernest Monroe Wheatley

The Wheatley family is eminently a domestic race; loving their homes and firesides; shunning notoriety; not aspiring to political or other public favors; but faithful and honest, industrious and economical. Rather disposed to keep their own counsel and somewhat stubborn when opposed.
—From the *Wheatley Genealogy*, by Dr. Hannibal P. Wheatley, 1902

What does it mean to be a New Englander?

"Connection to the past. I'm proud of it. My ancestors came over on the Mayflower. [He laughs.] New England is a very wonderful spot in the world—the land, the towns, the history. We are known for little things—like inventions. This is typical of New England. I tried to invent a way of boiling down sap in a vacuum so it wouldn't change color. I've experimented with methane gas; I discovered methane gas in a creek bed and trapped it under a bucket. And I've been interested in finding gold in Vermont. I made a gold washer for one of my neighbors so he could go panning in stream beds.

"Oh, living is a long series of this and that. It's a world of wonders. Vegetable life or animal life or mineral life—or anything you take up—it's a world of wonders. I was raised on a farm, and with farm life you have everything: botany, geology—everything that exists is on a farm. A farm boy is not limited to books. I grew up in a favored circumstance, you might say. So many times I wished I knew more about this, or that I knew more about that."

Ernest Wheatley's son describes him as a jack of all trades and master of many. As a child, he learned to cook, helping his mother in the kitchen. ("I like to eat and I like to cook. They go together somehow, don't they?") In high school he eavesdropped while older classmates were taught geometry, then passed the geometry examination without taking the course. He went on to Norwich University in civil engineering, graduating in 1909, and is its oldest graduate. ("I don't think I was a good student. I had too many interests.")

"In life you can do the things you want to do and tell them all to go hang. Norwich was a military school and they used to tell you to wipe off the grin, but I'm still grinning."

After college he surveyed his father's farm, worked on building projects for a marble manufacturing company, worked in a power house, and owned and operated his own machine shop. He is a tool-and-die and jigs-and-fixtures specialist. He worked for a map-making company, and was the final inspector in an aircraft instrument plant. He is Vermont's oldest licensed surveyor.

Then there were his hobbies. An oil painting he did—*An Early Snowstorm*—hangs on the wall. ("I wasn't really an artist. I just painted for the fun of it. Kind of selfish, isn't it?") He was and still is a ham radio operator. He was a beekeeper. ("That's a joke. I asked a fellow if he'd let me put some bee hives on his property and I'd give him twenty-five pounds of honey. I ended up buying him the honey.")

Ever thought of writing a book?

"Yes. It would be called *The Cluttered House*. I get a lot of fun out of living, and that book is one of the jokes."

Ernest Wheatley is nearly blind but is smiling almost every moment. He rises from his chair outside and walks cautiously along the patio railing. In the distance is a countryside of small streams, tree-covered hills, black-eyed Susans, and Queen Anne's lace. He no longer can see the immediate or distant landscape, but he still says, "I wonder as I wander. It's a great world if you get as much fun in it at one hundred as I do."

❦ *You look so healthy. Are those your own teeth?*

"Yes, they're mine. I bought them. [He laughs.] I start laughing and then I can't talk. [He laughs.] Really, the first secret is to have a good family. They are the secret of life. Start with your ancestors, then children, grandchildren, great-grandchildren. The whole clan. My family roots can be traced back a long ways. In 1772, Captain John Wheatley gave a servant girl her freedom. She took the family name and became a famous poet [Phillis Wheatley, 1753–1784]. I might say all my family are humdingers. That's really important."

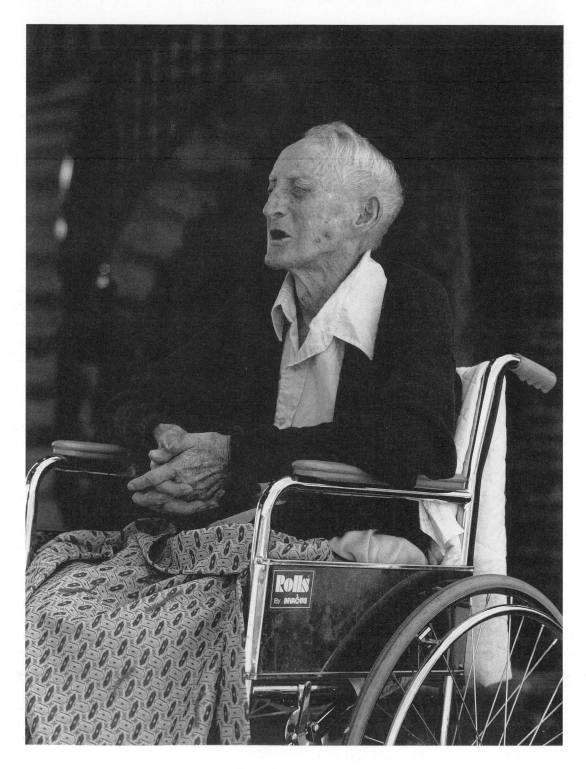

Born: September 22, 1886, Parson, Kansas
Married: Allie Snodgrass, 1937; died, 1953
Florence Maie Butler, 1957
Children: none
Principal occupation: butcher/meat cutter
Current residence: Wichita, Kansas

Philip Thomas McGough

Philip McGough lives on the edge of fantasy. Talkative, argumentative, playful, and imaginative, he is at every moment ready to diverge from the expected or predictable.

"Some people think they're millionaires," he says. "Well, I'm a millionaire. All you have to do is reach out and pull in all the air—be a millionaire. A millionaire is made out of air. Then he makes another millionaire. It goes like that."

"He's not senile," says his supervising nurse at the large veteran's administration hospital where he lives. "Fantasizing is his way to cope with being alone and separated from his wife."

Philip McGough's wife is 87, and because he has moved into the hospital, they live far apart and seldom see each other. But his biography suggests that he has always used his imagination to cope with loneliness and to give meaning to his life. He has never lived strictly along the lines of societal norms. He was a walker and a dreamer, a very curious person who preferred looking as he walked to the speed and stress of driving. When he retired from his butchering profession at 65, he declared that life begins at 65 and learned to paint and dance. But because he wanted to travel with his second wife, he also learned to drive a car—at age 70. In his old age his imagination may be his way of transforming reality. In some cases it may have been mind over matter—like his recovery from a hip fracture at 97. At 98 he was not only walking again but dancing a high-stepping two-step with nurses. His paintings in old age have drawn public attention, and he has won prizes in regional art competitions.

Why did you start to paint?

"I love the sky, I love the sunrise. I love everybody. And I love life. I love to see a smile on a child. I thought, 'Oh, I wish I could do that,' but I was old. Well, a camera can take a picture, but that ain't no good. I started to paint."

He became adept in oil and watercolor, painting mostly scenes from nature, especially roses.

Philip McGough's mother died when he was nine, and he grew up under the care of his grandparents. At 23 he started working with the railroad and then delivering groceries with a horse and cart. His proximity to food preparation for the public led him into the meat-cutting and butchering profession. But in 1917 his career was interrupted by World War I. He volunteered and served as a mess sergeant and cook in Italy. When he returned, he went back to butchering in Wichita where he has lived nearly 80 years. He did not marry until he was 50, and has twice married widows. His stepdaughter says that when he married his second wife, she was very uncomfortable with his kindness. He cleaned the house, did the cooking, and treated her with such sustained thoughtfulness that she could hardly believe he was real.

Perhaps one of his secrets is that much of the time he isn't "real." He likes to embellish his stories with grandiose extensions of the fact. In his stories of delivering groceries as a young man, he begins telling of deliveries he made to the Vanderbilts and the Edisons. "They wouldn't have anybody else deliver for them," he says. He loves to twist words and speak in little rhymed couplets. At one point he begins reciting a long doggerel, free-association poem that begins with "John Tall / was so small / we put his picture / upon the wall," but the rhyming narration goes on for several minutes to include Bobbin Robbin and an assortment of imaginary characters. He concludes the rhyming barrage with "God makes it up / not me. I'm next to God / One, two, three. "

❦ "Exercise is how to get old." He holds out his hand and demonstrates his terrific grip.

"And eat what you should eat. Eat meat, bread, cornmeal. I like lamb, I like ham. Don't eat a whole lot of slop.

"And everybody should work. Even God works. When I wake up in the morning, the first thing I say is 'Where is God?' He always says, 'I am here,' and then I eat breakfast.

"And try to please everybody. If you see somebody having trouble, try to help them. I started helping people when I was a little boy. I taught people who didn't know how to make mud pies."

But Philip McGough is tired of advising anyone. It's time for his afternoon nap. He sings,

Heigh ho,
put me-e-e to bed
Who-o-o's go-ing
 to put m-e-e-e to bed?

Born: Bertha Spivakovsky, January 30, 1886, Ekaterinoslav (now Dniepropetrovsk), Russia
Married: John F. Normano, 1910; died, 1945
Children: none
Principal occupations: teacher, secretary
Current residence: Middlebury, Vermont

Bertha O. Normano

The Bolsheviks didn't catch Bertha when she fled from Russia in 1917. Because her husband was a banker, they both were among the very elite and a particular target of the Communist revolutionaries. Everything in their apartment had been confiscated—"In one night, everything was gone," she says.

Her husband had gotten out earlier and knew better than to come back. Bertha had to leave their home to hide out with her in-laws in St. Petersburg. Her mother-in-law helped her escape by dressing her in modest clothing that would not draw attention when she caught the train from St. Petersburg to the frontier. When she got off the train a Finnish clergyman helped her continue her escape by sleigh during the night. She was carrying money and jewelry. Had she been caught with these, she might have been executed.

The only thing pursuing Bertha Normano today is old age, but she's an accomplished escapee. "Don't use that word [old age] around me," she says. She submitted only briefly to the confines of a nursing home, but it was not for her. "All those old people are so dull," she says. "They're just 'remains.' "

The strong will and mind that must have saved her in 1917 are with her today. She exercises by taking walks behind a shopping cart she calls her "Cadillac." She has had cataract surgery twice so that she can continue her avid reading. She resists distressing news by reading old newspapers instead of current ones. "Like Pushkin, I'm old-fashioned," she says.

But there is a social side to her that is not at all old-fashioned. She loves visitors, bubble baths, and going out to dinner. "I just love to go out to eat in restaurants," she admits. "I like lobster, clams, and shrimp."

"She's very flirtatious and conscious of her own beauty," a friend adds. She has a boyfriend who is 30 years younger than she is. He lives in New York and has arthritis, so he is not able to travel and see her. But he does send perfume.

"I've had a very good time always," Bertha says. "That's in my nature. I enjoyed the cinema, the theater, music."

She had been educated in Russia, but when she left in 1917 she followed her husband to Helsinki and Berlin and then New York, helping him in his career as an economist in international banking. She could type and worked as his secretary. They came to America in 1931, but when she was widowed in 1945, she started her own career, first as a secretary for the Institute of Asian Economics, then as a teacher of Russian at the Asian Institute, at the Extension Division of the City College of New York, and at Hunter College. Later she worked as Executive Secretary of the Russian School at Middlebury College, and, finally, as a teacher of Russian. She didn't start teaching until she was about 60, but by the time she retired from Middlebury College at 82 she had earned the nickname of "backbone of the Russian Department." For several years she was the acting chairman, highly respected by her students. In 1986 the college gave her an honorary doctorate.

"My greatest pleasure today is reading," she says. "My mind works very nicely. I know an enormous amount of Russian poetry. And what I cannot remember I spend half the night trying to remember. And I do remember."

She demonstrates her memory by reciting for several minutes from a Russian narrative poem.

❦ "I almost died from diphtheria when I was two years old. The physician said, 'The girl is gone.' My uncle was a military physician and said, 'Why not experiment?' He put something sharp in my throat, cutting to let the pus out. That saved me. But my whole life I have had swollen glands in my throat."

She was supposed to have had her tonsils out at the time of her escape, but she didn't because of her fear of the Bolsheviks. She still has her tonsils. "I don't know how I got so old. My brother lived to 98 in Russia. If I have a secret, I won't tell you—because then it will not be a secret anymore."

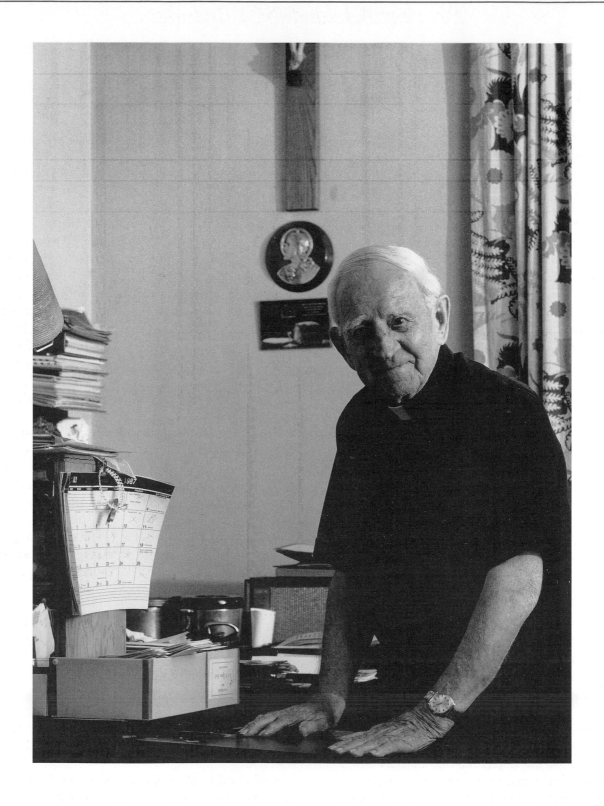

Born: February 5, 1884, Deschaillons, Quebec
Never married
Principal occupation: treasurer in schools run by Brothers of the Sacred Heart
Current residence: Harrisville, Rhode Island

Brother Adelard (SC) Beaudet

Although Brother Adelard is known as the Father of Schoolboy Hockey in the State of Rhode Island, he sometimes distinguishes himself today by swimming on his back with a lit cigarette in his mouth.

What keeps you up?

"Willpower." He laughs.

Brother Adelard is a small man with a big smile. Not a saintly smile—a mischievous smile. He looks always to be on the verge of laughter. He lives with between 20 and 28 other Brothers in the Provincial House, a retirement home for elderly members of the religious order, Brothers of the Sacred Heart.

Next to the building several Brothers swim and wade in the large donated swimming pool where Brother Adelard swims daily and occasionally performs his little trick. Inside, other Brothers chat in the large reception room. One sits in an easy chair, reading. The atmosphere is quiet and casual.

Brother Adelard is the oldest resident and the oldest member of the 3,000-member Brotherhood, now and ever. He is in his small room, working.

"I have two hundred benefactors and every month I send them a ticket, a receipt." The "benefactors" are customers for a monthly raffle. This has been his job for the past 22 years since he moved into the Provincial House. He sends the tickets in to the Franciscan Mission Guild in New York where the drawing is held. He writes all the correspondence and keeps a complicated record system. Old-fashioned record books lie open on his desk, but no calculator.

"He hardly ever makes an error," says a younger Brother.

"My share is half of what I sell," says Brother Adelard. His money goes into funds for their cemetery and their missions in Africa.

Brother Adelard was born in Quebec on the banks of the St. Lawrence River, where he learned to play hockey. He was one of 16 children. As a young man Brother Adelard became a leader in the parish, organizing a boys' hockey team, but "causing quite a commotion, raising quite a bit of hell in the parish." Like the disgruntled parent who may counsel a rambunctious son to join the army, the local priest evidently counseled Brother Adelard to join the Brotherhood. He did at 19, enlisting into a service where he is now an 83-year career veteran.

The Brotherhood of the Sacred Heart requires its members to make three vows: poverty, chastity, and obedience. Members resolve to live a religious life, a common life of sharing, to practice celibacy, and to carry out the ministry of education. Most, though not all, of its members are involved in youth education.

Brother Adelard taught school for five years in Canada before coming to Rhode Island, where he introduced Canadian hockey. He has been inducted by the state's Heritage Society into the Rhode Island Hall of Fame for his contributions. His picture hangs in the Rhode Island Civic Center in Providence.

In 1912 he started hockey in Central Falls Sacred Heart Academy, but later went on to a 30-year career at Mt. St. Charles Academy in Woonsocket. In the early days of his coaching, when he had little hockey equipment, the boys invaded the nearby woods to find saplings for sticks and used their homework pads as shin guards. But before he finished his career, his team won 10 state and two national championships. In 1935 they had a 27–0 record, and in 1939 his boys took all the All-State berths. One year he was expelled from the league for having a Canadian boy on his team. Brother Adelard responded by going independent and playing freshmen teams from such schools as Harvard, Boston College, and West Point. After leaving Mt. St. Charles in 1954, he returned in 1963 to help build the state's first high school hockey rink, which was named in his honor—the Brother Adelard Arena.

The pictures that dominate his room are not of hockey stars but of the Pope. He has a portrait signed by the Vatican and one signed personally by Pope John Paul II.

❦ "There's little stress in this life," says one Brother. "Brother Adelard always disciplined himself and tended to his own affairs, but his life was never stressful. He likes to live and let live. He's very sociable and always takes time to relax."

All the Brothers in the home appear relaxed and content, seeming to take their security not from what they have but from what they know they can do without.

Brother Adelard's smile never fades from his face, not even when he gives his own condensed prescription for longevity: "Mind your own business, have a good cigar, and take a shot of brandy."

Born: June 27, 1887, La Push, Washington Territory
Married: Eloise K. Newlands, 1918; died, 1974 (?)
Children: (3) Ruth, Philip, Edward
Principal occupation: mechanical engineer
Current residence: Escondido, California

Royal R. Pullen

Royal Pullen is something of a health nut and one of the most lucid conversationalists anyone could hope to meet. He does his own cooking, manages his own affairs, and has spent over 50 years saving his own life.

He was told in his 40s that he had only a few years to live; he had a bad heart. The diagnosis was correct—he did have a bad heart, and still does. Over the years since then doctors have refused to give him a general anesthetic, fearing that it might kill him.

When Royal was told about his impending death, he quit his mechanical engineering job and started traveling in search of a healthful place to live. He and his wife found Escondido, California. Royal wasn't planning to die, but figured that he'd have to work at staying alive.

He designed and built the house where he still lives and planted an extravagant, healthful orchard and garden which still flourishes. Behind his house stand lemon, peach, pear, persimmon, plum, avocado, fig, orange, and tangerine trees. Although the orchard is filled with debris and looks messy, everything is organic. Beneath all the trees lies a deep pungent mulch supplemented with epsom salts. The fruit on the tangerine trees is exquisitely sweet.

Across the orchard, between the fruit trees, lie the fruitless remains of a giant palm tree. Its shade was stunting the fruit trees, so Royal dug a trench around it allowing him to sit down and chisel off the roots. He spent two years chiseling at the roots before neighbors helped him pull the tree down.

Evidence of his life-saving labor is everywhere. Instead of abandoning his garden and orchard when his legs started giving him trouble, he built railings along the fences and sides of the house. Now he uses the elaborate network of railings to support himself as he works. An adult-model tricycle sits near the front door and an exercise bike faces a picture window overlooking the lushly unkempt backyard orchard. He uses his tricycle to go shopping—"before the drunks are out." And the exercise bike? The odometer reads 4,336 miles.

He lived his early childhood among the whale and seal-hunting Quileute Indians on the west coast of Washington Territory where his father operated the first trading post. He remembers vividly those years before his health worries, eating the slippery pieces of blubber which the Quileute cut in licorice-size strips and gave the children to chew on as they played. He skipped rocks and built driftwood forts with the Quileute boys, who taught him to speak Quileute and whose only English words were swear words which they taught Royal. He remembers Indian women combing lice from the children's hair and then eating the lice from the comb. He remembers the old Russian copper kettles in which the Indians boiled whale blubber for its oil or dozens of seagull eggs which they then ate in the shell. The Quileute have remained in the area where Royal was born. He is among a very few who still remember the Quileute language.

Life among the Quileute is only one short chapter in Royal's history. His parents, especially his mother, are another story. When his father's trading post was forced to close after a long legal battle with the government, his mother's response was to follow the gold rush to Alaska where she eventually became the legendary "Ma Pullen," owner and operator of the Pullen Hotel in Skagway.

The rest of the family did follow her to Alaska, but Royal's mother sent him and his brother to school in Seattle. Both became outstanding football stars and are legendary in University of Washington football history. After graduating from the university, Royal returned to Alaska and dredged gold in the Klondike. "There was so much," he says, "that the edge of the buckets would come up yellow."

During World War I he served in France with the Corps of Engineers. Afterward, he moved with his wife to Lead, South Dakota, to work in the mechanical department of Homestake Gold Mine, a job he held until he was warned about his health problem.

❧ "I stay healthy because I do so damn much work," he says. "You have to be an extrovert too—enjoy people and enjoy work."

What about all these health and diet books you have around your house?

"Adelle Davis is one of the best things I ever read," he says. "But everyone has to find what is right for them. I have found what is right for me."

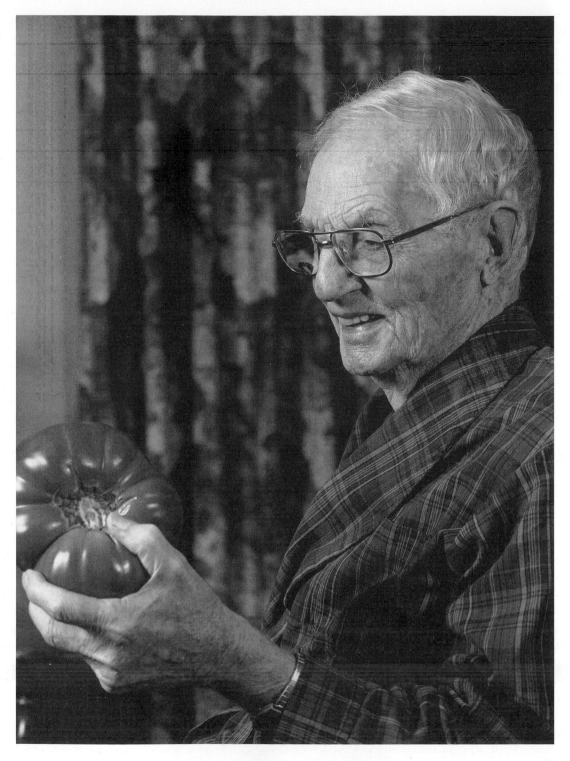

Born: May 29, 1885, Hersman, Illinois
Married: Wilma Belle Curry, 1910; died, 1916
Florence Josephine Curry (sister to Wilma), 1917; died, 1973
Children: none
Principal occupations: teacher, nutritionist
Current residence: Quincy, Illinois

Francis Craig Hersman

W hat is happening to the soil is of national importance," says Frank Hersman. He is one of the country's pioneer nutritionists. "One side of my history is in religious faith; the other side is that I majored in soil in two universities. Part of my life is trying to follow like Abraham in the way of God's directives. Part of it is my interest in soil. Soils are the basis of plants, and plants are the source of our food. My religious faith and interest in soil are the two main themes of my life. That has given me a different slant on nutrition from anyone else I've ever seen."

Francis Hersman lies in his bed in a nursing home in Quincy, Illinois, not far from the Mississippi River and the state of Missouri. He is recovering from a small stroke and holds out his hand boldly to demonstrate his firm grip. He is a religious nutritionist, but he's also a writer, an artist, a calligrapher, and a wood-carver. He is congenial, but also decisive and strong willed, someone who has firm opinions and wants to be in control of his life. Signs taped near his bed read: "Client does not like ice in tap water," and "Client likes dentures in when being shaved."

"As a child I was very sickly. So in high school a chum and I started studying food, and we went to the library looking for things. It just grew from then on. I'm pretty close to 'organic farming' as far as agriculture is concerned. I believe in building back the soil. God created the land and the plants, and they were good."

He majored in soil at the University of Illinois, then returned to his family farm to discover that between 1905 to 1909 the soil had been depleted of calcium, limestone, potash, and potassium.

He moved to California for one year to teach high school science with his wife, who had tuberculosis, then returned after her death to the Hersman farm. He married his first wife's sister and did a series of jobs over the next few years that had to do with soil and plant life. He returned to school, this time to Cornell, for graduate work. He progressed from studying soil to studying food and, finally, in his late 40s, he received a teaching position at New York State Junior College, where he taught nutrition.

Here he developed his own classroom material. "I learned how to test the body to tell whether it was in balance or not—with pH—urinalysis. If the pH is kept acid most of the time, your body will be in balance."

Although he cites no single authority, he admires the work of Dr. D. C. Jarvis, author of the books *Folk Medicine* and *Arthritis and Folk Medicine*. The diet that Frank recommends is high in seafoods, vegetables, and fruits, with a special place for honey and vinegar. He recommends vitamin supplements, largely because of what has happened to the soil.

Frank retired from his teaching position early, at age 60, because of a nervous breakdown. "I've always been a worrywart," he says, "but our boss was a dictator and drove me over the edge."

After retirement he did other jobs, including one that he regrets—selling sulphate of ammonia for fertilizer as a by-product of the steel business. "It's a long, sad story," he says. "That high nitrogen fertilizer is ruining our soil. It produces many bushels per acre vegetation growth, but at the same time destroys the soil God created."

Until his stroke a few months ago, Frank Hersman was still walking. He has been active and is determined to be again. He started painting when he was 65, kept a garden until he was 100, and has been wood carving since then. He loves to talk and tell stories. He wrote a newspaper column for years and has recorded many of his anecdotal memories in published pamphlets.

"I truly feel that having an interest in the arts in old age makes life worth living," he says.

He is also an active contributor to a family scholarship fund. Already over $50,000 has been raised and paid out. Frank is the primary fund-raiser, largely through the sale of his paintings and carvings.

A nurse interrupts and says it is time for Frank's medication. Frank says it is not, that the medication was only to be given if needed, and it wasn't needed. The nurse insists that it is doctor's orders. The argument gets tense. Finally, Frank's nephew goes with the nurse to find out what the doctor intended. Frank was right. No medication. His nephew comments: "Frank teaches us that we should listen to the elderly. Often they know better."

❧ "My mother lived to 102. I had a sister who lived to 97 and another who lived to 89. One brother who was a chain-smoker died younger. How I took care of my body has something to do with getting old. But that's not it altogether. When we die is when the Lord decides."

Born: Mary Frances Hipp, September 7, 1886, Naperville, Illinois
Married: Clinton Milroy, 1907; divorced, 1909
Bernal Adams, 1911; divorced, 1914
Orren Carney, 1924; divorced, 1930
Henry Clark, 1938; divorced, 1940
George Annand, 1940; died, 1946
Children: (1) Leo (Milroy)
Principal occupation: seamstress
Current residence: Pasadena, California

Mary Frances Annand

M ary Annand was married five times and she's still laughing. "I admit it—I'm a flirt," she says, and laughs.

When she was almost 100, someone in her family called a Pasadena paper to announce the big event. But the family's big news was no news to the editor who took the call: "It's no big deal to be one hundred, lady."

Since Mary Annand could flash neither fame nor money, reaching the big 100 did not make her a rose worth parading down the columns of the Pasadena newspaper.

Ironically, the playful and eccentric Mary Annand would probably agree that turning 100 is no big deal, just another of life's jokes along the way.

"I just like everybody. I have nothing against anybody." If she's troubled even for a second, she opens her stuffed scrapbook and her assortment of curious interests. Here are pictures of odd breeds of pigs, an article on beauty tips, pictures and stories of movie stars, an article on what people do and don't wear, cartoons, a story on how to create success with mind power, a *National Enquirer* piece on a six-year-old motorcycle daredevil rider, maps, pictures of elephants and of Dan Rather.

Why the maps?

"I always cut out maps. I like to study them."

And elephants?

"I'm very fond of elephants. They have minds of their own."

What about Dan Rather?

"Oh, he's my boyfriend."

Most of Mary Annand's life has not been as wild as her scrapbook. She started cutting stays in a corset factory at 13 and worked her way up to seamstress work in a sweatshop, sitting at a sewing machine 10 hours a day, six days a week, for five cents an hour. The place was Aurora, Illinois.

In that factory, sewing machines of several seamstresses faced each other, the finished products from both sides falling into a center trough. Workers could not talk to each other. They could not even look at each other. And the boss was always watching.

Were you happy?

"Oh yes. Never worried about anything. Just follow the routine. Let each day bring what it wants."

She holds up her small hands with their very short fingers. During her working days in Aurora,

she accidentally drove a needle into her forefinger and the tip broke deep in the flesh. She went on working, and the needle tip has floated under her flesh ever since. "Feel this," she says. "The tip of the needle is still in there. When I push on it right there, it still pricks me."

By the time she moved to Los Angeles in 1911, she was a fast and accomplished seamstress who had no problem finding and keeping work. She learned to dance on her short bathroom breaks. Out of view from the boss, she and her co-workers practiced their steps.

"I loved to dance," she says. "That was the only chance I had to learn. I went to dances until I was in my 70s. Then I stepped on men's feet. I started to feel foolish."

What about all those husbands?

"Well, I was a very passionate woman. And I like men."

But she doesn't want to talk about her husbands.

"When she's through with someone, she's *through* with them," says her granddaughter.

She does want to talk about her one son who seems to have been the most important man in her life. Even so, when he died, she did not go to his funeral.

"When she's through with someone, she's *through* with them," her granddaughter says again.

🌰 Mary Annand hints that her longevity may have something to do with the way she lived:

"I always walked several miles a day. I'd talk to the flowers. I'd say, 'You're God's little children.' I even talked to the weeds."

When she went dancing, she'd walk home afterwards, probably talking to the flowers all the way.

"I never drove a car, never had a bicycle, never had a little red wagon."

She pulls her knee to her nose to show how agile she still is. She exercises in bed every day to stay in shape.

"See you in Sunday School," she says, giggling. She's still flirting.

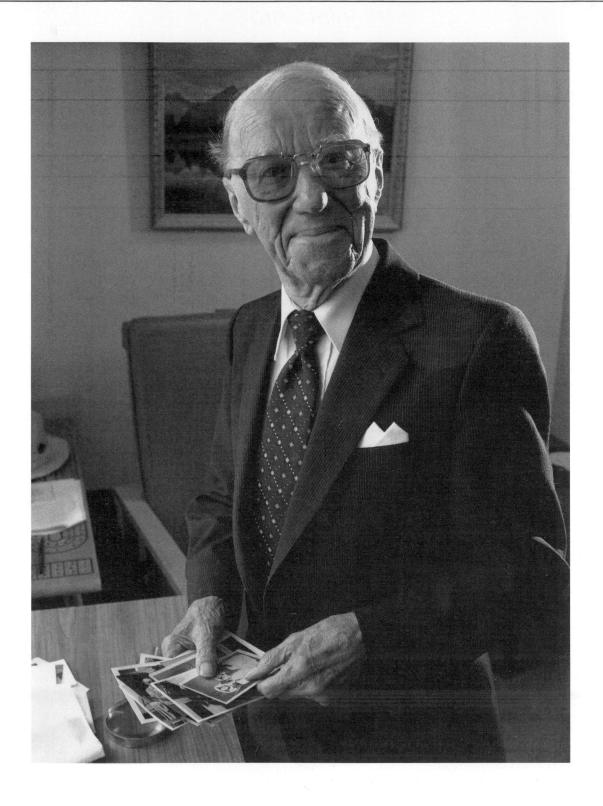

Born: Herbert John Lord, September 12, 1888, Ramsgate, Kent, England
Never married
Principal occupation: printer
Current residence: Victoria, British Columbia, Canada

John Lord

The longer I live the less I think of the hereafter." John Lord is the last of a large family. "I'm the only one left. We can't live forever—we'd be unfortunate to live on and on. But I don't talk to people about religion. I just say, 'Stay with it' —so long as it helps them face death happily."

He seems sufficiently busy with the here and now, fussing through the clutter in his room. "I'm the untidy one," he says. "I'm used to living alone."

John Lord has never wanted much more than the freedom to work and read and live his life peacefully. He says he's never really thought of getting married. He's been a Mason for over 70 years and found that this gave him all the social life he needed.

"I've never had a car. I've never driven. I was never keen on it. I walked instead." And then he turns, as if to acknowledge the fact that what he values in his life today is honest talk with people: "And I've never had an intimate friend, man nor woman."

On his desk lies a plaque that appears to have been put there recently as a gag gift. It reads, "I found the perfect woman, / and who could ask for more?/ She's deaf and dumb and oversexed, / and owns the liquor store." "It's the liquor store that appeals to me," he says.

He leads the way down the hall to a visiting room overlooking a large flower garden. He has precise posture and is dressed in a pin-striped suit, with pressed shirt and neatly knotted tie. He swings his arms far back and far forward with each stride. It's almost a Charlie Chaplin walk. He's just over 5 feet tall and weighs about 105 pounds. "Most I ever weighed was one hundred twenty-eight. Now I'm down again, so they're trying to fatten me up with milk shakes."

He seems excited by the visit, by the camera, by the attention. "Now look what you've done to me," he says. "I'm feeling ready to go! I've got to remember I'm losing my balance: I turn around too quickly and I've got to put my feet down."

He came to Victoria after retiring from a 40-year career as a printer for *The Leader*, a newspaper in Regina, Saskatchewan. Of course, that is now 40 years ago. He was born in England, left school at 14 to help in his father's grocery store, then at 16 became a printer's apprentice. Printing was to become his life's work.

In 1908, at age 20, he left for Canada to join a brother who had already settled in Saskatchewan. He tried homesteading north of Regina, where another brother had also homesteaded. Winter temperatures dropped to minus 64 degrees. "You'd actually get used to it. You wore glasses, and you had to be careful about breathing too deeply. We used to burn twelve tons of coal in one winter."

He and his brother lost their cabins and possessions to a fire that almost took his brother's life as well. The event drove John to Regina and his career in printing. He started working at *The Leader* in 1910, a 48-hour-a-week job, for a weekly wage of 10 dollars. "Now the printers get paid twenty to twenty-three dollars an hour. But the more you get the more you want."

When he arrived in Victoria, he returned to part-time work as a printer. "A few days a week," he says. "And I did this until I was eighty."

❦ "If somebody asks me, 'What should we do to live this long?' I say,

Be ye temperate in all things
And remember that spoken word can never never be recalled,
and in all circumstances, keep your cool.

"It's a good old Biblical instruction and I added the rest. They used to say I got so old because I didn't get married. Now they say it's because I walked so much. I haven't been sick much, but I sometimes think I learned to be scared of getting sick when I had my tonsils out—no anesthetic, the doctor just sawed them out with a blooming saw."

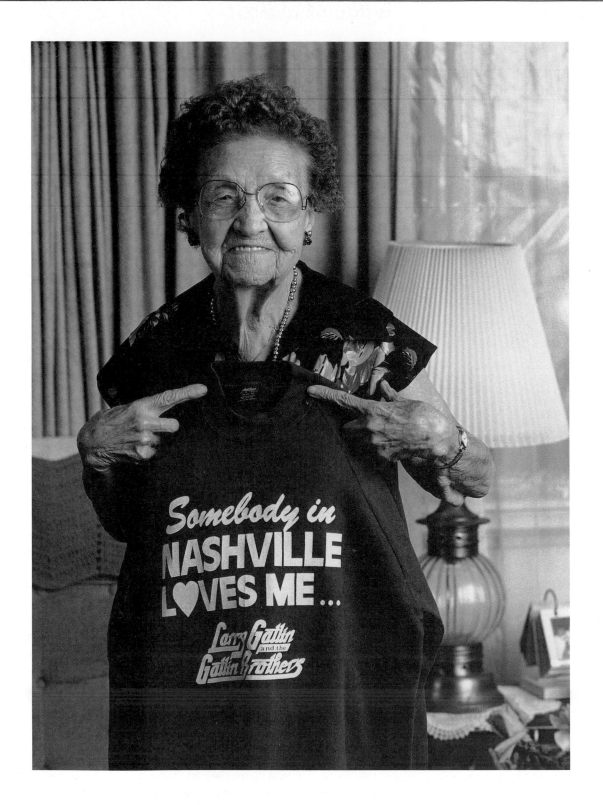

Born: Willie Mae Ward, December 3, 1886, Ellis County, Texas
Married: Julius P. Brock, 1904; died, 1966
Children: (6) Homer, Doyle, Otis, Thelma, Hubert, Eva Mae
Principal occupation: homemaker
Current residence: St. Petersburg, Florida

Willie Mae Brock

I'm in a bad humor," says Willie Mae Brock as she opens her front door. "You're early, and I don't have my hair fixed."

A parakeet scolds the air in the background. Over her shoulder, in the next room, a 3-foot Willie Nelson poster smiles a scruffy smile. She walks across her rainbow-colored carpet in her blue dress through her entertainment center of a living room: bird figurines, a large TV, a fancy stereo system, and stacks of country western and country gospel records. Overseeing the whole scene from the wall is a portrait of Jesus.

Willie Mae sits down on her sofa, still fussing with her hair. "I don't like old people. When they showed my picture on the Willard Scott show, I thought 'that old woman's not me.' There I was, big as a screen. I despise white hair. Old people look funny to me. I color my hair."

You live alone?

"Yes, I don't want to live with anybody."

You like parakeets?

"Yes. They understand me. I have only one. I had more, but the cats ate 'em."

You like Willie Nelson?

"Well, he's not my favorite, but he sent me a poster."

You like all kinds of country western and country gospel?

"Well, I don't like women singers. Wu-uh-uh," she sings, making fun of their voices. "Except Donna Fargo and Tammy Wynette and Loretta Lynn. I really like Larry Gatlin and the Gatlin Brothers, the Oak Ridge Boys, Gene Watson, Merle Haggard, George Jones, and the guy that stutters."

Mel Tillis?

"Yes, that one."

That's a pretty big TV set you have there.

"I watch it every morning for a few hours. I like to watch services. Jim Bakker was one of my favorites, and I still believe in him. I think people are just jealous of him, trying to break up this religion.

"And then I like to watch Tennessee National Network on cable TV, then later in the afternoon I watch Westerns.

"My great-grandson is a talent coordinator for Radio City Music Hall. I've been to Nashville four times. When I'm there, I don't stop. I go to all the shows—Grand Ole Opry—all of them."

You were born in Texas?

"Yes. Born and raised on a farm. My mother wasn't well. I worked hard, harnessed horses, plowed, milked cows. My father died when I was fourteen, and I thought, 'Oh, now I can date before I'm fifteen.'

"People just hired their kids out in those days. My father's death left us with debts, so all of us kids worked and gave the money to our mother. I could pick three hundred pounds of cotton a day. I grew up with my husband and he was a champion cotton-picker. He could pick five hundred pounds a day."

You married young?

"I was sixteen and he was twenty-one. My mother wouldn't sign the papers to get the marriage license, so my older brother did it."

Forged your mother's signature?

"Yes. And then we didn't want anybody to know we were getting married. We went to the preacher's house. He and his wife came out, and he married us right there in the buggy."

She followed her husband to Oklahoma, where they lived for 40 years. He worked for the railroad. Many of her relatives now live near her in Florida. She doesn't remember when her interest in country and gospel music began.

About 20 years ago Willie Mae Brock had bone cancer. She had surgery, 12 cobalt treatments, and was bedridden for weeks. "It was kinda nice just lying around. I never thought I'd die. They said if I lived I'd have to use a walker the rest of my life. I said, 'I still got two legs. I'll just walk.'"

In 1918 she had typhoid fever. In 1912, while she was pregnant, a boiler full of boiling water spilled over her legs.

"Burned my legs off to the bone," she says. She was several months in recovery and the skin on her feet still "doesn't breathe."

"It's one way to make sure you don't have sweaty feet."

Today Willie Mae Brock walks, though her feet still bother her from the burn 75 years ago. She has transplanted corneas in both eyes. What's more, longevity doesn't run in the family. But she's still here, with no secret other than being the way she is. And her hair isn't gray—perhaps not perfectly arranged, but it isn't gray.

Born: September 18, 1884, Hogsby, Smoland, Sweden
Married: Anna Christina Bergstrom, 1915; died, 1966
Children: (4) Edith, Arthur, Evelyn, Harold
Principal occupations: farmer, butcher
Current residence: Oakland, Nebraska

Walfred (Fred) Leonard Linden

*W*hat about you is still Swedish?

Fred Linden laughs.

Is laughing Swedish?

"Yes, it is."

Really, what does it mean to be Swedish?

"It means I guess we have to take everything as it comes, good or bad. Most of it has been good for me."

Visitors from Sweden described Oakland, Nebraska, as a "genuine Swedish town." The town celebrates its annual Swedish Days, of which Fred Linden has been the King, and the local newspaper prints a regular "Swedish Chuckles" column. Here's a sample:

Question: How can you tell a level-headed Swede?

Answer: If the sluice runs out both sides of his mouth.

A pair of old farmers' workshoes and a spittoon sit on the floor next to Fred Linden's bed in the nursing home. He likes his tobacco. The sluice isn't running out both sides of his mouth, but he refuses to concede the right to have his brass spittoon in his room. The nursing home workers don't like the spittoon, but they put up with it. They have lined it with a plastic sack so they can empty it without getting any on their hands.

Fred Linden is one of the genuine Swedish articles of Oakland, born and raised on a small farm nestled in the woods near Hogsby, Sweden. He has been in America since he was 19 and in the Oakland area the past 82 years. His hearing is totally impaired, but he happily answers any written question that is handed to him.

"I was born in an area of Sweden where people were said to have *rotabagge* [baggy root] noses," he says. This seems to be another Swedish chuckle, and he laughs.

Perhaps he accepts his hearing loss so congenially because he has known greater hardships in his life. His father died when he was only 10 months old, and his family was left with their home and nothing else.

"We were so poor that when my mother sent me to get a cup of flour from a neighbor, they turned me down. And that neighbor was a relative too."

When he was 10 he learned to tie grain shocks for twenty-five cents a day. At 12 he went to work delivering meat for a butcher. He worked for the butcher for six years before word of the Golden Land sparked his hopes for a better life. The Golden Land was, of course, America. Rumor had it that all Americans were rich because of the discovery of gold.

He took a ship to England, then sailed to America on seas so rough that everyone, especially he, was seasick. "The ship would go down and when the propeller came up you could hear it, R-r-r-r-r. There was dancing on the boat. Oh yes. There were people playing. Then they start to puke. Then we danced again."

A cousin helped him find work in Chicago, where he worked on the cable cars and then for a hammer shop, making railroad axles. He met his wife, Anna, in 1910, when he was working on the railroad, and moved to Oakland in 1912 to start farming. He sharecropped, 50/50, and plunged $5,000 into debt, but World War I drove the prices up and he was able to pay off the debt in two years.

In 1915 he married Anna, who had gone back to Sweden to see her sick mother. He bought his own farm in 1926, and remembers the tough years of the Depression, especially the Dust Bowl years, when the ground around Oakland was covered with yellow dirt from Oklahoma and Texas. He stayed on the farm until 1966, when his wife died, then went to live one month at a time with each of his four children—"bumming around," he says, for 10 years. Since 1982 he has been in the nursing home.

Like so many people who have spent many years in poverty, he does not talk about the hardships but only about the importance of his family. And he is a compulsive chuckler.

❦ *What is life like for you today?*

"Well, it can't be better."

"He loves to sit in the sun," says one of his relatives. "And he loves to watch sports on TV." And, when there is nothing around to chuckle about, he reads.

An old picture of Fred Linden shows him a heavy man. He was a big eater. His parents did not live to be old, but he has had a very regular life-style. He didn't smoke or drink, but he has always chewed. "He's just not a worrier," says one of his relatives.

"I don't think I have a secret," says Fred. "I just never let anything get me down."

Born: October 13, 1882, Birkenhead, England
Married: Edna Coombs, 1909; died, 1922
Lola Wikoff, 1931; died, 1955
Children: (3) Henry, George (aka Ernie), Edna
Principal occupation: sailor
Current residence: Seattle, Washington

Henry H. Neligan

To meet Henry Neligan is to step back in maritime history, not only into the days when England's was the largest merchant fleet in the world, but into a time when manners were an avenue of goodwill. There is something both intimidating and receptive in his demeanor, in his vest and tie, in his wooden cane and the way he uses it, not to lean on but to tap and flourish in a gentlemanly way. All that is missing is the derby. A gentleman from toe to crown.

And in his mannerly smile is a gentlemanly interest in women. "I like to get in the elevator with all ladies," he says. "It makes my day." One woman in particular has been giving him the eye. "But I'm not interested. I don't want to get involved," he says.

He was born on Friday the 13th. His twin brother died at childbirth. At 104, he seems as if he has gotten his own and his brother's life too. He is energetic, articulate, gracious. He has spent nearly 70 years at sea, but the sea winds haven't weathered his smooth forehead, and he still stands straight as a mast.

His granddaughter tells a little more about his background with and attitudes toward women. His first wife was a Tlingit Indian he met in Alaska. The two of them had to endure continual racial prejudices against their short marriage, which ended with her death when she was not given proper medical attention after minor surgery. His granddaughter says that he lives in continual sorrow over the loss of both her and his second wife, that his affection for them has never diminished. He believes that his deep attachment and feelings toward women are owing to a former life when, he believes, he was a woman. He is attracted to women, but respects them and their ideas. He holds liberal views on women's rights, including their right to choose an abortion.

"He is very adaptable," says his granddaughter. "Very quick to adjust his thinking to those around him. Some of that he learned from sea life, where it was necessary to survive—'one for all and all for one.'"

"Letting yourself get old is a problem that starts in your head," says Henry. He danced regularly until he was 101 and still goes out for an occasional drink with friends.

Born near Liverpool when Victoria was queen of England, he set off to sea as a stowaway at age 14, when his father, a captain in the Merchant Service, challenged him to quit his formal education and do something to become a man. For him, meeting that challenge meant spending the next seven decades at sea. He has been 1,500 miles up into the equatorial jungles of the Amazon River and into the arctic waters off Alaska. He has served on steamships and sailing vessels, on a submarine patrol boat in World War I and a Military Sea Transport Service vessel during World War II. He has tales of sailors being shanghaied from boarding houses in Port Townsend on the Strait of Juan de Fuca in the early 1900s and of feeling himself transformed by the beauty of hundreds of porpoises zigzagging in dazzling patterns ahead of his ship in Puget Sound. He tells of a 196-day voyage around the Horn from Wales to Acapulco and of dancing every night on a six-day shore leave. His ship duties were usually as cook or steward. He rose to the position of first steward on passenger ships.

He survived two shipwrecks, one in the North Atlantic and one in the Bristol Channel: "We were in a terrible storm and hit rocks in twenty feet of water. We were hung up on the rocks, and I watched the timbers bend with every wave. Then they broke, splinters flying everywhere, and the crew hung on to the rigging. We saw a sail ten miles away and we thought it was a fishing boat, the kind that would only be able to hold five of us, and we were a crew of twenty-one. So we cast lots to see who could go on board, who would be saved. But then men started dropping, letting go and falling down into the sea and drowning. Then when the boat got closer, we saw it was a shore life-boat, big enough to hold all of us. We all could have been saved, but only seventeen of us survived."

You have an amazingly good memory.

"I work at it," he says. He uses mnemonic devices. "But part of it just happens. I've been waking up lately with old songs in my mind, ones I learned as a little child. I'm remembering in my dreams. These things are in my mind all the time, and they are happening while I am sleeping. My dreams are getting deeper and deeper, and I am remembering more and more of my life in them. I think I will die in my sleep."

❦ Henry Neligan has a ready answer for anyone who ventures to ask how he got so old: "Keep your feet warm, your head cool, your bowels open, and trust in the Lord."

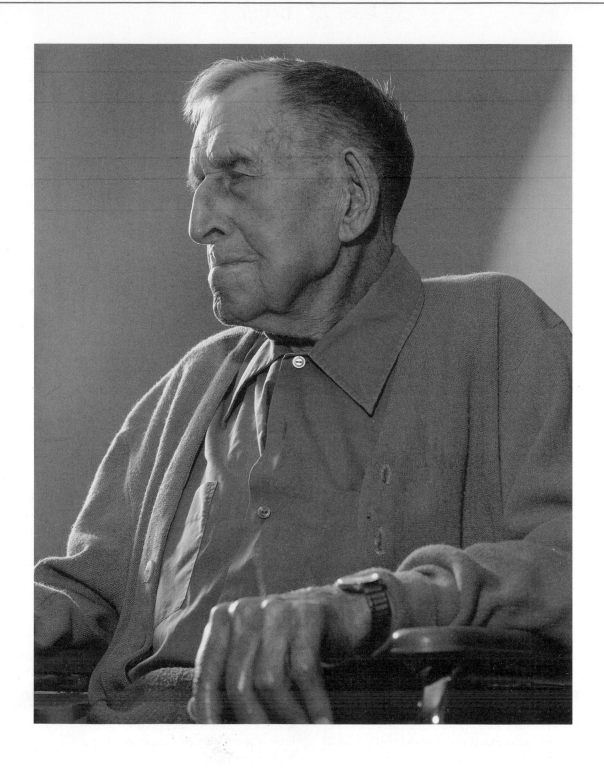

Born: January 9, 1881, Randolph, Iowa
Married: Hazel Grosvenor, 1911; died, 1980
Children: (3) Julia, Arland, Vergil
Principal occupations: farmer, laborer
Current residence: Council Bluffs, Iowa

Ciel M. Boyle

It's hard to imagine that the best days of your life might be after you're 100, but for Ciel Boyle this may be the case.

He's had poor eyesight his whole life, worked menial jobs most of his working years, and spent most of his long marriage in the shadow of a wife who did most of the talking, which was okay with him. Only recently, in the space and silence of extreme old age, has he come into his own—telling stories. He's a great storyteller, and seems to be surprising himself as much as the people around him with a talent that finally has begun to bloom.

His firsthand account of the 1888 blizzard is one of many examples. He was a child on his parents' homestead near Randolph, Iowa:

"I was about seven. It snowed all day just as hard as it could, great big flakes. The men was working all down by the barn. They just had on flannel jackets. Then about four o'clock in the afternoon, it come up—that wind turned to the northwest. And my dad said, 'What's that now? That freight train's coming up now'—the railroad was right close to the house. This fella said, 'You look out now and you won't think it's a freight train.' The snow was, oh boy, just a-boilin'. Dad had him take us boys to the house. The wind went seventy miles an hour and the thermometer was thirty below zero. A lot of people froze to death. A lot of stock went into the ravines, you know, and the wind and snow covered them up, smothered 'em. There was a schoolteacher just lived two miles from us. Soon as the wind changed she let school out so the children could get home. Two little boys she took home that didn't live very far from us. Their folks wanted her to stay all night. She said 'no,' she could make it. She went right by her home. They found her body under a haystack the next spring."

Ciel was never able to read without glasses and eventually used a magnifying glass. "I went to school for a while, but my eyes were so bad I had to quit. They've always been bad. My left eye has been blind for years. I could do things like farm all right. I could see at a distance."

Perhaps because of his limited vision, he developed his memory for details—for dates, places, exact conversations that go back nearly a century, and for poetry. He memorized the Kate Shelley Story, a ballad of a 12-year-old girl who lived close to a railroad bridge over the Des Moines River. A flood had washed the bridge out and a passenger train was due. Kate Shelley ran to stop the train and saved the lives of everyone aboard. Ciel knows the whole, long rhymed narrative and relishes his recitation, ending with: "The screech and the squeal / Of the brakes on the wheel / Bring a fast-moving train to a stop / Four hundred feet from the fatal drop."

It seems that very little of Ciel Boyle's long life has been spent in moments of this kind of happy recollection. He was off to a good start on a small farm as a young man, when a flood washed away an entire crop. He never really recovered economically, but at least he has these very vivid recollections: "Trees were over the wood barn, it rained so hard. It didn't overflow, it washed out the bank—about six hundred feet of the bank—and scattered around my twenty-five acres of oats. I had one of the nicest pastures there was in the country, and it covered that up. This was in the mid-twenties."

He went to work by the day or the month shucking corn and working as a hired hand for people who clearly took advantage of him. At 55 he was jobless and looking for work. He did work on the railroad as a section hand, keeping the rails and ties in repair, but he lost this job too, fired and replaced by a boy.

He worked around by the day and finally got a job as the sole laundry person in a mental institution, where he worked four years. Then he went to work at Jennie Edmunson Hospital, but one Saturday on his day off he and his wife were struck by a car: "Knocked me down first, then she fell on me, then he ran right over me with two wheels, broke both my legs. They called the fire unit. I heard one fella say, 'What funeral home shall we take him to?'"

Ciel Boyle wasn't dead, as the rescue attendants thought, but he was through working. In 1980, his wife died, and he had to start talking for himself, telling his colorful and detailed stories. Today in the nursing home he sits and thinks of stories and is very curious about everything that is going on. He even wanted to check out a Tupperware party.

❧ Ciel Boyle is 6 feet 2 inches tall. He didn't smoke or drink, but he never watched what he ate, and, according to his daughter, "put salt on his food like it was going out of style."

"I don't know how I lived so long," says Ciel. "I just guess I didn't have to pass away."

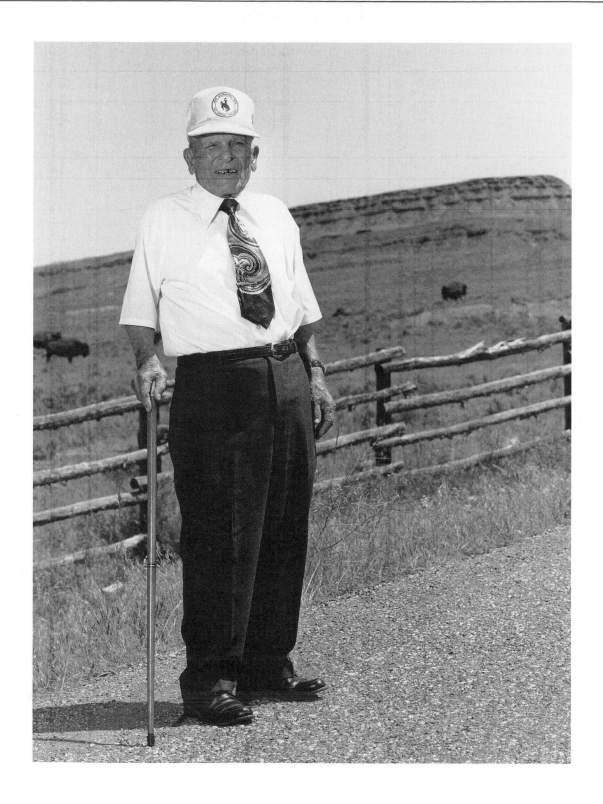

Born: February 22, 1883, Southern Italy
Married: Mary Black, 1919; died, 1980
Children: (1) Leo J.
Principal occupation: coal miner
Current residence: Thermopolis, Wyoming

Leo Roncco

Imagine early explorers counting the dreary days as they trekked across Wyoming sagebrush, then caught a whiff of sulphur, heard a serpentine gurgle, and stopped daydreaming in time to see the earth spew steam all over their wagon train. Wyoming is still like that—a place of surprises. Sooner or later it serves you what you least expect: like a geyser or a 104-year-old Leo Roncco.

He grabs his hat, opens the door to his room in the Wyoming Pioneer Home, and says, "Take me for a ride. I'll show you the country around here."

In a few minutes the old *italiano* is out of the car and standing on the road—all 4 feet, 10 inches of him—talking about his days in the coal mines. A buffalo herd grazes just over the fence, the smell of sulphur from the Thermopolis hot springs permeates the air, and in the background behind him an Indian burial site bakes a dull red in the sunlight. Tourists cruising by glance at the buffalo, then fix their eyes on Leo, as they detect the real Wyoming surprise.

"I had every damn thing you can think of—a delicatessen, a junk shop, a gas station, a liquor store, a theater, a coal mine. I been on boxcars. I been in jail. And I tell you something, mister. If you go through things like I did and you don't get killed, you're going to learn something. That beats all the damn education in the world."

Leo Roncco talks rough, but he's like one of those watchdogs that wags its tail as it barks. There aren't words in the language that can hide his tail-wagging grin. But he's the little guy and has been pushed around plenty. They called him Shorty. Still do.

"They'd tell me I was too small to drive a bus or to shovel coal, and there wasn't a damn thing I could do about it. I just had to put up with it."

He was orphaned at three and adopted by an uncle and aunt. By the time he was seven, he was lugging water to streetcar workers in Ohio—for money. He went into the coal mines by age eight and was hitting the rails by 12, "bumming around."

"Bumming around" meant traveling with a sidekick, driving spikes, getting thrown in jail because the sidekick smoked a cigarette in Arkansas, where it was illegal. It meant swinging a poker in the dark against an approaching thug and fleeing without checking the damage. It meant digging postholes in Montana for ten cents a hole, getting lead poisoning working at a smelter, selling balloons at a Buffalo Bill show in West Virginia, shucking corn in Nebraska for one-and-a-half cents a bushel, unloading carloads of groceries, working in a butcher shop, helping in the coal mines. And moving, always moving.

Marrying at 36 and having a son didn't change old habits. His feet may have stopped moving but his mind and tongue didn't. Settling in Thermopolis just meant hopping jobs instead of trains. But eventually that black gold won out. He bought his own coal company, hired 35 to 40 people, and was, for the first time, the boss.

Leo Roncco has been in Wyoming long enough to meet the residency requirements to live in the state-founded and supported Pioneer Home. It's a wonderful retirement center, located on spacious state park grounds in Thermopolis, complete with a hot mineral bath. It is another of those Wyoming surprises. In this setting Leo not only amuses the world but comforts it. He visits the sick every day. For years he grew vegetables to serve at the home. Here's the soft-hearted man, just hinted at by his uncontrollable smile. The evidence is all around town.

Everybody I talk to tells me you're a do-gooder, Mr. Roncco.

"I'll help anybody. If you can't help your fellow man, what the hell are you good for?" Then grinning, he adds, "I let people interview me because I want to help them."

❧ *All those years in and around coal mines—didn't you worry about black lung?*

"Ungh!" he says in a tone that translates, What a stupid question!

"Here's where your black lung comes in, mister man. It comes in with fellas liking drinking pretty heavy and liking smoking pretty well. It's their own damn fault if they get this black lung business."

So how did you do it?

"All that bumming around—that's where I learned all the tricks, how to get along in the world."

The school of hard knocks was survival training?

"Like I said, if it doesn't kill you, you learn something."

Born: January 1, 1886, Decatur County, Georgia
Married: Frances (?), 1954; died (?)
Children: none
Principal occupation: day laborer
Current residence: confidential

Oscar Williams

The unknown centenarian. "He has no living relatives. He was first hospitalized in 1954 and then found wandering along the road in 1975. He was hallucinating."

Education: no formal education
Work: railroad, laying and repairing tracks
Military service: not a veteran
Religious preference: Baptist
Hobbies: none
Next of kin: none

Against the wall in the corner of a large ward sits a high, metal-frame hospital bed. Down the center of the bed is an oval mound. This is Oscar Williams. He has pulled the covers over his head and looks like a small child hiding from his parents, or like a cocoon. It is 1:00 P.M.

"He covers himself and naps like this after lunch. He always wears thermal underwear, sleeps with his hat on—probably to stay warm, but maybe from years of wandering. He's a peaceful person, but prefers being alone. He'll always take the chair farthest away from other people."

A few feet away men stand around visiting. Others pass in and out of the room.

"He keeps his clothes and valuables under his mattress, probably hiding things for hard times."

One man in the center of the ward leans against a support post, rhythmically beating his fist on his forehead. The thud of knuckles on skull is the loudest sound in the ward.

The attention shifts back to Oscar Williams:

"He got married when he was an old man, but he wandered off from her. Before she died, she said it had been a happy marriage, said they got off together, but that he wasn't interested in any recreation and that he'd take any drug. Her words for him were that he was 'selfish, nervous, kind, and jealous.' "

"Mr. Williams, the gentlemen are here to see you now." He pulls the covers down just below his eyes. He is not wearing his hat. His eyes are quick and attentive, following every movement that is near him. His voice is high-pitched and soft, childlike.

He tells of chopping cane in Florida as a young man, shearing sheep, picking cotton, and then working the railroads. A life of continual work and, as he says, "walking about. Go to church. Go to town. I liked to walk about in the woods.

You can see and think. You can see the bugs just crawling about."

He pauses as if remembering the minute creatures of the woods.

Tell me more. Tell me more about your life . . . all those years.

His hands rise from the covers and together make a fluttering movement, like butterflies chasing each other. He does this again, his fingers moving like those of someone playing arpeggios on a guitar. It's hard to imagine that so much movement was waiting inside the still form under the covers a few minutes ago. He repeats the hand movements several times. Each gesture brings to mind a slightly different image: small animals running, ripples, harp music.

What was that?

He does it again and smiles. "That's me," he says. "That's me."

❦ "He had prostate cancer and cobalt treatments ten years ago. There still is some cancer in the scrotum, but it doesn't worry him and it doesn't seem to progress.

"It's hard to tell how he got so old. He worked hard, didn't eat much. Still doesn't. Whiskey now and then. Cigarettes now and then. He had some stomach problems from what he ate. He's very humble, very reclusive, but never shows any signs of unhappiness. He seems to live on contentment."

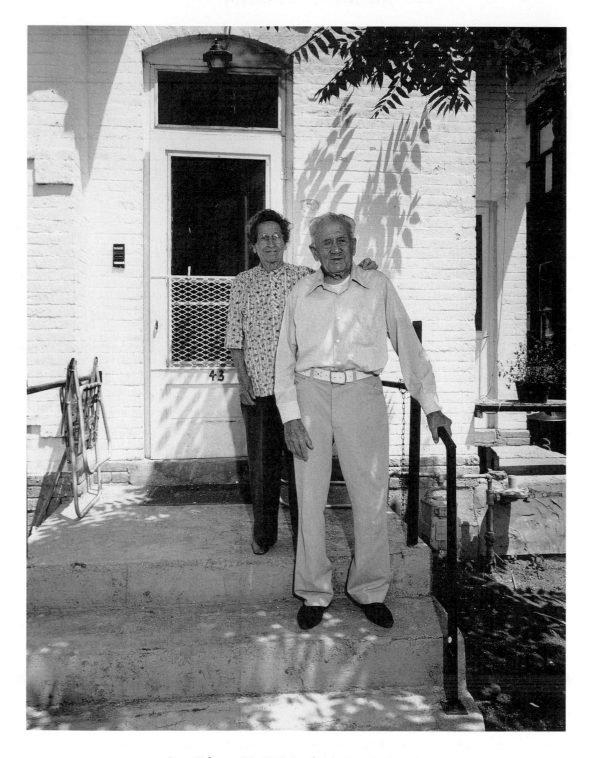

Born: February 22, 1888, Sandwich, Ontario, Canada
Married: Gladys Nyhart, 1908; died, 1950
Barbara Smith, 1951; divorced, 1951
Marie Deter, 1956
Children (7): Norman, Blanch, Agnes, Harry, Roy, Ileen, Ben
Principal occupation: carpenter, Local 55
Current residence: Denver, Colorado

James B. Garrison

My first wife died in 1957," says James Garrison.

"No!" interrupts his 91-year-old wife. "That couldn't be right! We were married in *1956*—she had to have died before that!"

The two have a kind of jousting marriage. They insult, counter, acquiesce, defer, and generally seem to be having a wonderful time at it.

"I was born in Ontario, Canada, right across from Detroit. I lost my eye when I was fifteen. Tamping powder down in a hole to blow up stumps. It spit, you know, and took my eye out. That was dumb. I left Ontario when I was young. I had five sisters. They started dressing me up for church, so I left. I got married when I was twenty. My wife was thirteen."

"She was *thirteen*!?" says his wife.

"My second wife—that was a short one—she wanted all the money she could get."

"You don't have to go telling about that."

"I got a bad one," he says. "Married six months. I was working for a contractor. She always wanted to know if I got a raise."

"I haven't the least idea about that."

"As a young man I done everything. I wrangled horses up in Rapid City in I don't know what the hell you call it—a round-up. I guess I was about seventeen and I wanted to go West. So I went West. I'd get up and get all the horses together. We'd make a rope corral. I didn't know where we were going. I didn't know what the drive was for. An awful lot of cattle. Thousands. We'd stay on the grasslands, up in there on the edge of the reservation. I think we were going to Chamberlain, South Dakota. The other guys were all older than I. They're all dead now. I rode a lot before that too. When I was just a kid I raised racehorses. I thought I might be a jockey, but I don't know what the hell I was doing."

"I'm an old cowhand myself," says his wife. "I lived on a ranch."

"I used to smoke, used to carry Bull Durham in my pocket. When I was thirteen, I used to swim the Detroit River to Detroit where Bull Durham was five cents cheaper than Windsor. I'd wrap it in oil paper."

"I never smoked," says his wife. "I was too darn poor to smoke."

"I've been broke most of the time," he says, "but I've done everything—mixed concrete, carried hog [carrying bricks on your shoulder in a 'hog'], pitched bundles on a threshing machine, worked for a movable mill, bought a team of horses and worked them hauling bundles, homesteaded."

He has a pin for being a union man 55 years—Union Local 55. Through his many travels and many jobs, his work as a union carpenter was central. "I was a president at one time—well, two times. I'm a leader, you know. I've been a foreman on some pretty good-sized jobs, but if I had to do it over, I'd take more school. But I like what I done. I'm just naturally a builder."

"He's really an architect," says his wife. "He made his own plans according to scale and everything."

The Garrisons' courtship began with a question. She says, "He asked, 'What do you do?' and I said, 'Tie flies.' My work was tying flies, you see. He had a fly in his lapel."

James says, "And I said, 'Do you make enough money to support a man?'"

It must have been a good start. They became avid dancers and went trout fishing together every week. "I never liked fishin' myself," she says. "I didn't like the mountains. It was a lot of darn hard work."

"But she always caught the fish," he says.

The two have 11 children from previous marriages. "On my own, I have twenty grandchildren," she says.

"Oh, I must have more than that," he says.

Mr. Garrison's daughter walks in. She's in her 70s and even more of a union woman than her father is a union man. They start arguing about the union, then playfully wrestle with each other.

"I'll get you for child abuse," she says, though she looks as if she can hold her own as well as his wife can.

He punches her shoulder and hugs her.

"We fight over cards. He cheats too," she says, and kisses him on the cheek.

"Now don't go getting a picture of that," says his wife.

🐾 "How did I get so old? Just work, I like to work. I like to build. I like to see things go up, say 'I built that.' And we was happy in our marriage."

"I'm mean, but I tell him he's meaner," she says.

Born: Maria Prisciliana Montano, December 21, 1889, San Luis, Colorado
Married: Jose Rubel Salazar, 1906; died, 1935
Children (12): Eloisa Ida, Marie Odila, Francisquita, Salomon, Ruben Antonio, Maria Olivama, Jose
Albert, Enriqueta Hermana, Marta Agnes, Santiago Gaspar Benjamin, Cristella Maria, Juan Bautista
Principal occupations: housewife, farm worker
Current residence: Denver, Colorado

Maria Prisciliana Salazar

Her treatment of us would be considered child abuse today," says one of Prisciliana Salazar's daughters. But there's laughter in the room where Prisciliana Salazar sits surrounded by her family.

She starts talking in a hearty voice, the strongest voice in the room: "I was born on the longest night and shortest day of the year," she says. "There are twenty-nine years between my oldest and youngest child. I have my last child when I am forty-six." Her children have been the mainstay of her life, and, evidently, she has been the mainstay of theirs.

"She's never really lived alone," says her daughter, who is an administrator in the Hispanic-owned retirement center where she lives. "She has her own room here, but she's still close to family."

"We all love her," says another. "Including the grandchildren—though they haven't experienced her kind of discipline. She's the boss and the main one. She's the queen of the family."

"We did rebel a little but didn't get very far," says one of her daughters, who tells how as a young woman of 20 she left the house without permission of the household queen. Mrs. Salazar dragged her off the bus by the hair.

"Nobody in our family ever got in any kind of trouble with the law," says a son. "We all have good jobs. And we can thank her for that. Her strictness set us in the right direction."

"There aren't many of her kind left," says a daughter. "With her you couldn't fool around—it was strictly business. But we respected her. We still respect her. It's part of the Hispanic tradition."

In 1848 Mrs. Salazar's ancestors were living in what is now New Mexico. At the end of the Mexican–American War and with the signing of the Guadalupe Hidalgo Treaty, they were granted land in New Mexico that then became U.S. territory. Her roots in the Southwest date back long before then—to the time before the Civil War and even earlier, before the landing of the Pilgrims in 1620. Some of her ancestors were among the Conquistadores and early Spanish and Mexican explorers.

"I was born in San Luis, the oldest town in Colorado. My parents did not speak English, but wanted their children to go to school and learn English."

She married at 16 and moved to Fort Bridger, Wyoming, where Prisciliana's childbearing years began, but her responsibilities went beyond child care. "We raise chickens and cows. I take care of the animals from early in the morning, take some milk and make some butter and cheese and sell to the stores while my husband worked as a caporelle for the sheep. We don't have much fun in those days."

In 1911 they moved to a 160-acre farm in Los Sauces in the San Luis Valley. This was to become the family place—what the children from then on would call "El Rancho." Her husband died while she was pregnant with her last child. One of her sons was old enough to take on much of the farm work.

"We always had enough to eat," she says. "We always had eggs and meat and vegetables. I used to make my own ham and make my own soap and boil the lard, and I know how to make a pretty good soap."

In 1946 she moved to Denver and cared for the house while the girls worked. In 1985 she moved into the 200-unit apartment where she now lives. It is the only Hispanic-owned building of its type.

"Life is pretty good today," says Prisciliana. "I try to wash my dishes, fix my bed, take my own bath by myself. I don't make my own food."

"She likes her independence, and likes to look pretty—she loves her jewelry and her make-up," says a daughter.

She rises at 4 A.M. every morning to pray. "I feel at peace," she says. "I pray all the time."

"She's praying right now," says a daughter. And she is. Hands folded, she bows her head slightly, mumbling her prayers, before rejoining the conversation. "God, fill my heart with love for you, and for everyone else too."

❧ "She's always been a brave and sturdy woman," says one of her daughters. "She has been a very well person, usually the only one who could take care of everyone else."

Prisciliana says Faith has always been her sidekick and God her doctor. Until she had eye surgery a few years ago, she had avoided the doctor for 40 years and only had midwives to help deliver her 12 children.

In 1918 the flu epidemic struck her family. "People died every day," says Prisciliana. "Every day. So many people. I cared for my children. They all had the flu, but didn't pass away. My own self, I did not have it bad.

"How did I get so old? The Lord is the one who knows. Of course, I've been working hard all the time. I just take care of the family and that's all."

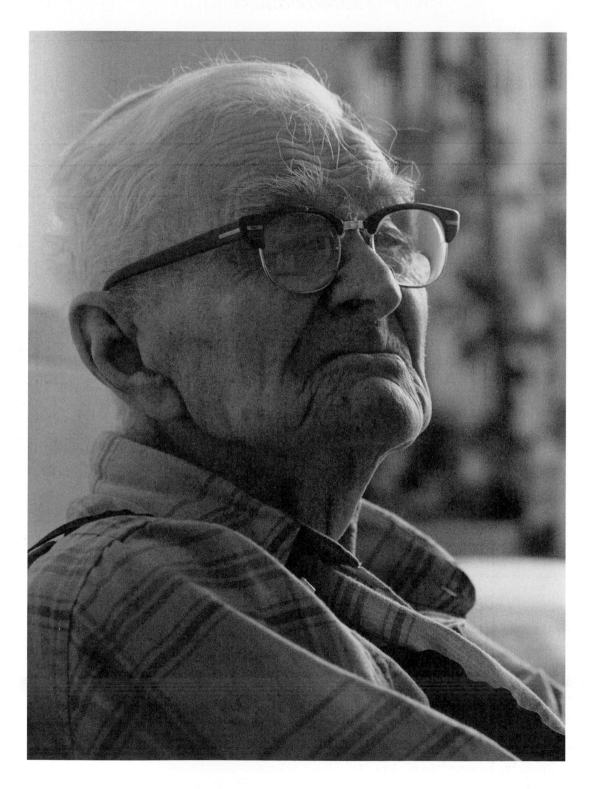

Born: April 13, 1882, Elkhart, Anderson County, Texas
Married: Lula May Payne, 1906; died, 1972
Children: (7) Leonard U., Elden M., Homer L., Gerald J., Thomas L., Robert M., Leroy D.
Principal occupation: rancher
Current residence: Mullen, Nebraska

Albert Starr

Someone in Big Red's cafe in Mullen, Nebraska, says, "I'm 106 in terms of mileage," and the mailman in his big cowboy hat says, "I must be 107 by the way I feel."

Talk is cheap over morning coffee in this small town of about 700 people, but, the truth is, Albert Starr is the first person in its 100-year history to pass the century mark.

This is sandhill country with low moundlike hills moving in near-uniform waves toward the horizon. As the product of wind erosion, their shapes have followed the wind into gentle crests and slopes. Albert Starr was attracted to this country because it didn't have the bushes he disliked so much in the Texas country where he grew up and where he farmed as a young man. He moved with his wife in 1911 to homestead about 22 miles north of Mullen. Tough years followed.

"We had to make our work happy," he says. "But it was hard. If there was a best time, I don't believe I found it. The good things was always just ahead of me. I didn't work fast enough to catch 'em."

But over the next 45 years, through persistence and hard work, he accumulated a large herd of Hereford cattle and 32,000 acres of land. He retired a wealthy man.

Albert Starr and his wife raised seven sons on their sandhill ranch.

"When I was growing up, I sometimes got to town only once a year," says his son. Albert would get to town more often for supplies of flour and sugar, or he would go in with hogs and return with coal. Mullen was a day's buggy-ride away.

He ran the ranch like a benevolent dictator. "We set up a program," he says. He assigned every boy his task: one broke horses, all milked but were assigned their own cows, one ran the hay sled, one checked the cattle, and so on.

"Our ranch functioned very well," says his son. "But we knew Dad was in charge. We didn't get many spankings, but we didn't argue with him. Dad didn't have the patience for breaking horses. He liked corn shucking because it didn't take any patience. So he did that."

What did you think about while you were out there shucking corn?

"I was thinking about the little boys growing up," he says. "What can I do for an education for the kids?"

His boys evidently were a main concern. He sent all of them in to board in Mullen while they went to high school. Before he retired, he divided his holdings among them.

"He was always working," says his son. "He could take all four teats of a cow in his hands at one time when he was milking."

When he retired to Mullen, he really didn't stop working. He was soon digging sewer ditches for the town and working as a carpenter's helper. With his financial backing and his work, several old buildings in Mullen were restored.

"He became wealthy, but then he used his wealth to help others," says his son.

❧ "He's been 'gonna die' for years," says his son. "It's really a mystery how he got to be so old."

Albert Starr was the most sickly child in a large family and has had many health problems as an adult too: he's had his gallbladder and part of his stomach removed and had blockage of the bowels that almost killed him. Although his father lived into his late 90s, all of his brothers died of heart attacks, two of his sisters died young, and one sister later died from cancer.

He is a thin man, who has never been a smoker or drinker of alcohol or coffee.

"There are lots of things that could be in the till to find out how I got so old," says Albert. "If I hadn't et cornbread and stuff like that I wouldn't be here."

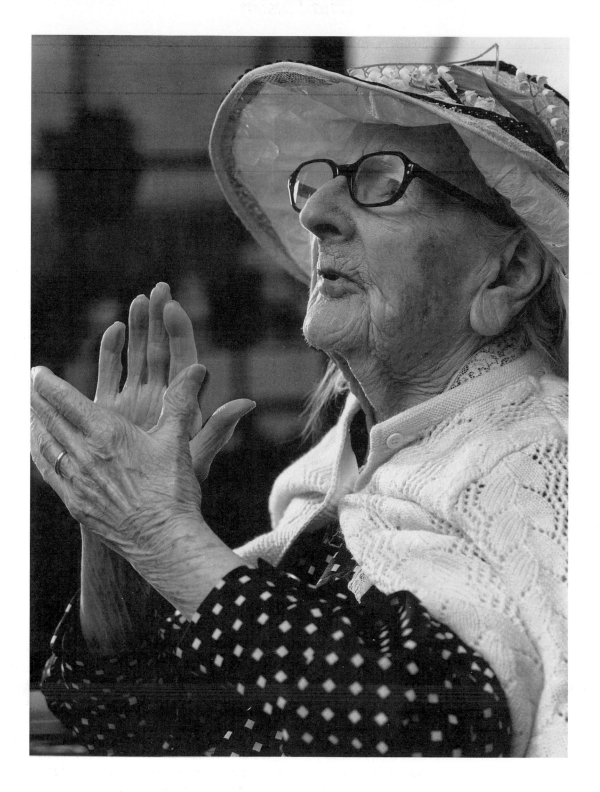

Born: Edna Gowanlock, October 15, 1888, Ontario, Canada
Married: Carl Olson, 1918; died, 1974
Children: (1) Edna
Principal occupations: munitions plant worker, homemaker
Current residence: Victoria, British Columbia, Canada

Edna Olson

Edna Olson sings, "I'm as happy as I can be—oh, what a beautiful day." Singing and praying and writing poetry have been part of her life from her toddler days through her years as a munitions worker in London during World War I, and through her happy marriage in Canada.

"I was only about two years old when God spoke to me. He told me He was God and He wanted me to believe in Him and He said, 'I will take care of you.' And he has. He said, 'Don't tell your mother yet. She'll just say you're a silly child and you don't know what you're talking about. I will send you dreams.' And God did send me dreams in the morning—before I woke up—and they would always be true dreams. They would tell me what I should do. That's how I've lived my whole life."

Edna was born in Ontario. Her natural father was mugged and murdered in Detroit when she was a child. Her mother remarried and the family moved to London. Edna went to work with sheet metal.

"I'm known as the girl who never spoiled a piece of metal," she says. "I made a teakettle with a longer snout so the kettle wouldn't boil over. The boss came in the next day and said, 'You couldn't have done that.' I said, 'I did.' He said, 'There's something about that kid that's different.' I made a kettle with a long nose. I was just in my teens. I was a smart cookie, wasn't I?"

Along with the guidance Edna believes she has gotten from her dreams, she says a minister's prayer gave her the gift of prophecy. "He said a nice prayer and asked God to give me the gift of the fairies—that was the gift of prophecy."

She feels that it was this gift that led her to her husband and her happy marriage. She was working in the munitions plant, and he was in the Canadian army, stationed in London.

"I came to Canada when I was to meet my husband and we were to get married. I met him in London—I was told that years ahead. God told me when I was a teenager He would pick my husband."

The two had met only briefly, but then saw each other again at a dinner party. "I admired him and he took to me at once. After the supper was over, he reached over and touched me on the shoulders. He said, 'Come and stand here with me. Don't you think we'd make a fine couple?' I just smiled, and so did he. I knew he was the one God had picked for me. I didn't say yes or no, but we were practically married."

Was it an especially good marriage?

"I was never out of love with him. He never got angry with me and I never got angry with him."

Never?

"I don't remember our ever having a quarrel. Not even a little one. We were so happy we didn't know we were happy."

After the war, they moved to Saskatchewan. He remained an army man. In 1932 they moved to Victoria. She says he agreed with her religious beliefs, and she promised him on his deathbed that there would never be another. There hasn't been.

Edna has painted, written poetry, and practiced faith healing. "I asked God to put healing in my hands. And He has. I don't know how many people I've helped. Thirty or forty."

Of the poems she has written, the ones she recites are on the theme of reconciliation. She composes this one as she visits:

Terrible you
and terrible me.
What a thing!
We can't all agree!"

"I wrote one that brought Catholics and Protestants together. A dream came to me:

Mary's name means a star by the sea,
Gracious name it always will be,
Mother of Christ, God's only son,
That's how our Christmas first begun.

"I was born with poetry," she says.

What are your visions today?

"I'm looking at the past and it's looking back at me."

❦ "I never thought I'd live to this age," says Edna, "But I've always been pretty careful about what I ate. I can't drink coffee. I was sick for eight days from one cup of coffee when I was just a young girl. I drink sometimes: I have a half teaspoonful of brandy sometimes. But I do what I should do and I ask God what I should do."

Born: Lula Bell Jones, January 3, 1887, Marion Junction, Alabama
Married: Mose Jones, 1905 (?) ; died, 1925 (?)
Jeff Mack, 1940 (?); died, 1962 (?)
Children: (2) Anne Page, Willy (died when a baby)
Principal occupation: farm helper
Current residence: Selma, Alabama

Lula Bell Mack

Prepare to listen. Lula Bell Mack is prepared to talk and sing. "I can't read or write. I went to school and wasn't learnin' nothin'. I was boy crazy and I didn't know it. And I was stuck on myself. Mom and Daddy wanted me to go to school. But I was boy crazy. The boys was as crazy about me as I was as crazy about them. The boys couldn't do nothin' for me and I couldn't do nothin' for them. There come the time when I see I beat it. I didn't need that no more. And I said my mama and papa sent me to school and I ain't learnt nothin' and I say, I guess I taken anything anybody thinks about the readin' and writin'. But in school, the first teacher I had, I can remember it. The first speech I had, I can remember it: 'Clap hands clap hands / Til my mama come home / My mama is the sweetest / But my papa is the best.' "

"When I was a girl about ten years old, I went out in the woods, and I had on a white bonnet, and I got down on my knees and I talked to the Lawd. And when I talked to the Lawd I was ten years old. And something come out of the tree and I said Lawd, 'What's the matter, Jesus, with me?' I said, 'My hands look new'; I said, 'The grass looks new and my feet shine'; and I said, 'Lawd, What's the matter with me?' He said, 'Little'n, I done freed your soul.' He said, 'Go tell the world what a dear kind Savior you have found.' Everybody I seen walkin' and ridin' for months I stopped and tell 'em what the good Lawd done for me. I done that.

"So I went down to the church to be baptized, white gown and white cap." She sings:

Oh let's go down to Jor-dan
Jor-dan, Jor-dan.
Oh let's go down to Jor-dan
Re-li-gi-on's sooooo sweet.

I pro-mised the Lord to be bap-tized
to be bap-tized, oh, to be bap-tized
I pro-mised the Lord to be bap-tized
Re-li-gi-on's soooooo sweet.

"I was born in the country and raised in the country. I done got on my knees and tied wire on bales of hay. I stack the bales of hay that high. I done everything on the farm but double-plow [plow with two mules] and gittin' up on the mower cutting hay. I done raked the hay, I done shocked it, I done stacked it, I done packed it. And that's all you could do to it.

"My husband had two mules, me and my husband made six bales of cotton by our lone self, didn't hire nobody to hoe it, and nobody to help pick it. I could pick two hundred and he could pick four hundred to five hundred [pounds per day]. I would pick two hundred, but mine were trashy.

"We raised our own food, had hogs and our own cows; I take me a five-gallon lard can and I'd cook them cracklins all day and all night and I'd spend all night making syrup putting the cane in the mill. I can cut up a hog as good as any man. I'd cut the jowl off, get all that fat. I'd take the hog ears and the hog nose and the hog foot and make 'sow-meat' out of it. Made chitlins too. One man said he never seen anybody clean them hog chitlins the way I done. I say, 'The longer you live you'll see a heap of things you ain't never seen.'

"I been working all of my days until I got to the place where I wasn't able to work, and then I cooked for white people. There's a white woman gets me to cook her some pineapple custard and she say she never had such good custard. And I still cook."

Lula Bell Mack lives with her nephew in a public housing project in Selma. "My nephew and the good Lawd have been takin' care of me," she says. "I can't get around fast, but I can get around slow."

Selma seems like a friendly town and the people seem to get along well. There's 20 percent unemployment but little apparent tension. There are more whites than blacks in town, about 75 percent to 25. That ratio is reversed right outside of town, but the town is integrated. Edmund Pettus Bridge, made famous by the Civil Rights marchers in the 1960s, still stands as it did then. People on the street say nobody around there talks about it any more: "It was not a pretty sight."

❦ "Man in the store ask me what I done in this life to get to be so old. I say, 'Treatin' people right, and having good thoughts of people, and trust in God.' If you do the right thing in this world and treat people right, right will follow you.

"I got plenty white friends and plenty Black friends and I try to treat them all right. And if you don't treat me nice and right, that's your business, but if you want to fight me, I'll fight ya."

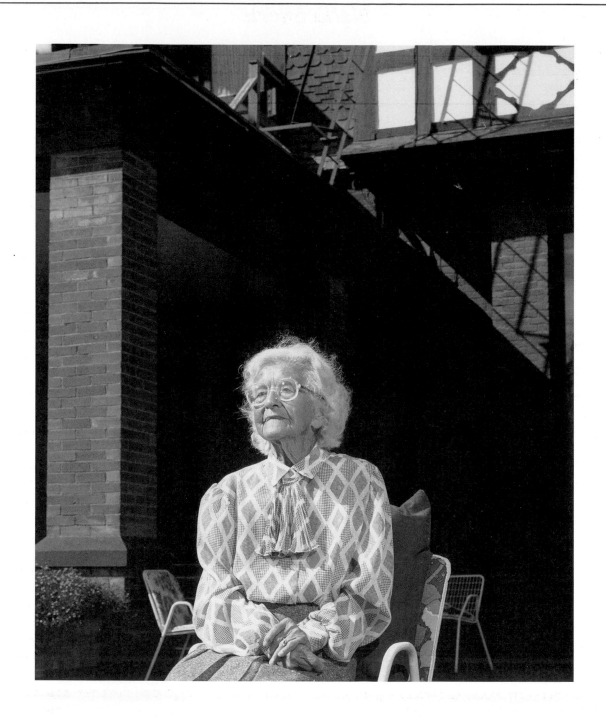

Born: Netta T. Gordon, May 17, 1885, Aberdeen, Scotland
Married: Harold Snartt, 1914(?); died, 1980 (?)
Children: (2), Mary, Jane
Principal occupation: homemaker
Current residence: Victoria, British Columbia, Canada

Netta Snartt

Netta Snartt is a tiny woman with a tiny girl-like voice. Behind the small voice is a woman of considerable substance. Early on, as a young woman in Scotland, she distinguished herself by graduating from Aberdeen University at age 21. She was a student of Latin and Greek. "I loved Sophocles," she says.

From her girlhood days something about her has brought her in contact with great people. "I remember Queen Victoria driving around," she says. "She was a little crabby-looking old lady by that time. They [the royal family] were always up and down, riding, and we weren't awfully impressed by them because we saw them so often. She wouldn't wave to the people much. She was always miserable, or pretended to be, after her husband died, you know. Of course, the people thought the world had come to an end after she died. But they soon got over that when we got [King] Edward."

At her graduation ceremony from Aberdeen, she sat next to Thomas Hardy. "I sat and talked to him. Not many people can say that. He was getting an honorary degree, and he came last. I came first, so we happened to be near. I was awfully lucky. I never will forget that. I came up first, so he turned to me and congratulated me and just asked a few things, but I was so proud that I was shaken. I could hardly speak. He was getting old, and he was quiet, but he wished me well. Nowadays many people don't know much about him. At that time, though, people did. I got a great thrill out of that—more than anything, I think. I had read some of his work before, and I've been reading him again."

At another time, she was asked to offer a bouquet to Queen Alexandra. "I was graduating that year, so they asked me to do it. I was so shaky that I didn't enjoy it at all."

Upon graduation, she received an invitation from the classics department of the University of Toronto asking her to apply, but her brother had become a professor at McGill University in Montreal, and she went to the head of the classics department there instead. But rather than pursue a career as a scholar, she was to marry an Anglican minister and raise a family.

Still, she attracted notable people. When she went with her husband to a parish in Detroit, Michigan, she was invited to have lunch with Henry Ford. "I liked him. He was very hospitable. He was very modest and very nice, and I thought his views were very good. He thought it should be possible for poor men to have a car. All the workmen came to work in a little Ford."

She and her family returned to England after seven years in Detroit. "I loved Detroit, but it was just starting to go downhill then, and I didn't like my children to go to school there."

Her real contact with Canada began during World War II, when her daughter became engaged to a Newfoundland airman. Although she and her husband spent much of their married life in England, today she is fully Canadian. "We all like Canada," she says. "I think Victoria is the most wonderful place—it's so beautiful."

She lives on a gracious former estate bequeathed to the Diocesan Anglican Church women and run by them. "My room is untidy," she says. Really, it's not. There's nothing untidy about her or her room or the beautiful place where she resides. The Tudor structure with large brick chimneys is surrounded by trees and colorful flowers. Sitting back from the street and sounds of traffic in quiet elegance, it is the home for over 28 elderly people.

At about the time of her 100th birthday, she went back to Scotland to celebrate the 200th year of Aberdeen University. They had a party for her, and she was asked to speak. She got up and told all the professors there that they were all too young, that her professors all had long gray beards. "She spoke very well for half an hour without slipping a cog," says a friend. "Everybody loved it."

Today in her retirement, she writes letters, and she says, "I give most of my attention to my family. I do worry some—I had an awful dream that I was almost out of money; I don't like money matters. I'm not used to working with it. But I am seeing everything from afar now, and everything is easier. I'm not terribly anxious to live long. I'm not miserable about dying.

"And I am very isolated. It can be very quiet here. It grows on you, you know. I don't cultivate people much now. I like people but I don't care for a chum."

"She likes men visitors," says a friend, "because they're more likely to talk politics with her."

❦ "I have no idea how I got so old. I had a happy childhood. My parents lived old—mother ninety-nine, she was lively; and father about ninety. They never seemed very old.

"I didn't smoke. I do like a drink of sherry; I always have some sherry. I don't think it's much of a crime, do you?"

Born: April 11, 1886, St. Kitts, British West Indies
Never married
Children: (1) Winnie
Principal occupation: governess
Current residence: Oakland, California

Geraldine Pringle

Geraldine Pringle knew Mae West and she knew Mae West's intimate secrets. She was best friends with Mae West's maid. They talked.

What kinds of secrets do you know?

"Well, you know, Mae West was pretty active in the sex department. But I never talked."

Maybe now is the time.

"No, it isn't."

Sophie Tucker, Fanny Brice, Al Jolson, George M. Cohan, Will Rogers, Irving Berlin—Geraldine Pringle knew them all. They wanted her advice on tunes and acts they were polishing. W. C. Fields was there too, teasing her with his sleight-of-hand tricks and practicing his juggling acts in her backyard. She liked him.

"He was always tricky. Keep you laughing all the time." Though Geraldine Pringle is not a forgotten show-business luminary, she was on the scene. She was the maid and governess in an entertainment family where the others visited, and, with Mae West's maid Beulah, she knew what was going on.

Time has swept the stage of most of those luminaries, but Geraldine is here, quiet, still behind the scenes, smiling. She sits in a wheelchair wearing blue beads and flower earrings. Her eyes are peaceful and steady, eyes anyone would trust. Her hands move as if coaxing attention toward them, then rest on her lap like a bouquet. The hands look soft, as if they have touched only lace or velvet. A little rouge brightens her cheeks, and she is quick to smile. The hands, the eyes, the smile—she is a glowing heirloom of affection.

Born and raised in the British West Indies, she worked on a farm, fell in love with a white man, and had a daughter by him. She moved to Harlem with her child, Winnie, but at age 19 Winnie died of pneumonia. Geraldine had already begun working for the Tinneys, a theatrical family who lived on Long Island. The husband, Frank, was a blackface vaudeville comedian in his early days in show business and later starred in Ziegfeld's Follies; the wife, Edna Davenport, was a singer, dancer, and comedienne who introduced such popular songs as "I Get the Blues When It Rains"; Edna's sister, Stella, was a dancer, who became famous with the stage name La Estrellita and is mentioned in a Jack London novel for her perfect figure. But in this family was also a son, a four-year-old boy named Frank, Jr. She focused her maternal love on him, caring for him while the rest of the family followed their fortunes on stage. He is living today and is appropriately and officially known as her next of kin.

Geraldine spent more time with Frank, Jr., than did either of his parents. And although she was known only as the governess and maid, she was the family pillar. In the fast-paced show-business life that eventually led to a divorce between Frank, Jr.'s parents, family conflicts erupted. Once, during an outright marital tussle, Geraldine hit the elder Mr. Tinney over the head with the carpet sweeper. He fired her on the spot. Geraldine's response: "Nobody fires me."

And nobody did. When the marriage broke up, Geraldine accompanied Frank, Jr., his mother, and La Estrellita to Hollywood, committed all the while to raising Frank, Jr. During the money drought of the Depression, Geraldine worked to help support the household. Years later, when Frank, Jr., married, she moved in with his family and committed herself to the next generation, the Tinney's two children.

Longevity has given Geraldine her moment on stage and has given the living a chance to reflect on the impact of her life. Frank Tinney, Jr., remembers that Geraldine Pringle was the reason his father stopped his blackface comedy acts. He feels that she erased racial prejudice from his family and the many entertainers who were close to them. Though she was never onstage, she may have been the behind-the-scenes force that started the dominoes falling, eventually ending that racially offensive form of stage comedy for everyone.

❦ What is her secret for old age? "Men and brandy," she says. "Men are never too old."

Frank Tinney, Jr., knows Geraldine better than anyone else does. "She taught us all what generosity really is," he wrote at the time of her 100th birthday. "It is giving yourself, your work, and your time. Geraldine Pringle could never lie, steal, or hurt anyone. . . . She has never been bothered by grudges, envy, greed, or selfishness. There are very few Geraldine Pringles in this world."*

*Frank Tinney, Jr., *A Bio on Geraldine Pringle*, mimeograph, 1986.

Born: July 20, 1885, Disco, Illinois
Never married
Principal occupations: Bible school teacher, bookkeeper, receptionist, church promotional superintendent
Current residence: Boise, Idaho

Rosa Mae Wolfe

I'm just a lone and wily wolf," says Rosa Mae Wolfe. She enjoys her pun on her name, though she is anything but a sly predator posing in lamb's clothing. In fact, she has been a kind of spiritual economist who has measured the worth of money in terms of what it can do for others.

While supporting her grandmother and mother into their old age, she was at the same time a hard-working volunteer business woman in the charity work of her church. She first helped establish a church, then helped found an orphanage, then a religious college, and finally helped in the expansion of the children's home facility to include the retirement center where she now lives.

She is a timid person ("My greatest struggle has been getting over that timidity") and someone who has avoided the public eye ("I'm used to working in the back all the time"). Though she may have been inconspicuous, the results of what she has done are not.

As a young woman, she worked at whatever job she could get to take care of her mother. She worked as a bookkeeper, but mostly she worked for doctors. She admits, "I never had time for a social life. I never thought of having a family of my own. I had a boyfriend when my mother became very ill, and I told him, 'You can get another girl, I can't get another mother.' "

She started teaching children in Bible school when she was 17. "I love children," she says. "Those kids still come to see me. But the church has been my life's story."

In 1919 she came to Idaho. The church was organized in 1924 and she worked hand in hand with the elders, serving the church while making a living working for the doctors, doing secretarial work. In 1946 the owner of three chain stores offered funding to establish an orphanage. Her church agreed to cooperate, and Mae became its first director. Besides church work and helping with the children's home, she was instrumental in helping found Boise Bible College. And she was on the board of directors when the children's home branched out to include the retirement home and became Boise Christian Homes Inc.

When her mother died, she sold her house so that she could come to live on the premises and care for the office for no monthly pay. She sold her home to the first buyer for cash and built her present house which will be given to the home upon her death. She retired from secretarial work at 92 and lives alone.

"This is the house that I had built. I furnished the money that got the ground and the money that built it. I paid all the expenses. And when I'm through with it, it goes here."

Living for causes seems to delight her, and not in an ethereal way—she enjoys remembering the construction of each building at the home, the details of hallways, rooms, and corridors and savors the extent to which she feels monetary investment has brought returns to human lives.

Perhaps respect for the tangible gift has roots in her early childhood. She moved with her family from Illinois to Nebraska when she was six months old. They first lived in a sod hut at a time when a few buffalo still roamed the plains around Red Rock and when pioneers' hopes collapsed under the whims of the weather. It was a world in which gifts were cherished. Mae tells this story: "We never had very much for Christmas. And I remember getting a little red rocking chair, and they hid it in the hay mow under the hay. And I found it. And I'd go up there and dig it out of the hay and just rock in it up there in the hay. And then I'd put it back under the hay. And I played with it a long while before Christmas. And I kept that little red rocking chair until I brought my mother out here."

Mae Wolfe has been a kind of supplier of little red rocking chairs ever since, working from behind the scenes to give others what she believes they need.

❦ "My life has been filled with miracles," she says. "I never felt that my money is mine to spend. I've had as much illness as anyone. I've had ulcers and used raw eggs to relieve that. I've had heart trouble ever since I was a child. When I was eighteen the doctor said I wouldn't live through the night. A reporter heard about this and wrote it up in the paper. The next day I read my own obituary. I still carry that heart with me. It's still here. I carry that heart that I have to watch all the time.

"But I think I've stayed healthy because I've had arthritis of the spine and have had to exercise to stay well. I've had pain all my life, but you don't have to write about that."

Born: Julia Blake, April 12, 1886, Natchitoches, Louisiana
Married: Ben Nash (?); divorced (?)
Albert Preston, 1926; died, 1964
Children: (1) Mary
Principal occupation: church janitor
Current residence: Oakland, California

Julia Preston

This is only a small Baptist church in Oakland, California, but the pastor's voice rises in the grand oratorical style of Martin Luther King when he spoke to large, open-air audiences:

"A person this age has seen some tribulation in her life. A person this age knows more about tribulation, its heights and depths, than any of us in here!"

In a pew near the front of the church sits Julia Preston. The wrinkles that ripple from her smile are like those on a child's face. She looks cherubic. This is her day. The mayor of Oakland has agreed to name an annual Julia Preston Day, and the church is holding a tribute service to establish a scholarship fund in her name.

The church has been the center of Julia's life ever since she helped her second husband in his church janitorial work in Louisiana. In Oakland her job is to usher and to lead in the choir.

"She is the most faithful usher we have," says the pastor a few hours before the tribute service. He teases her by saying he might wear a green shirt to the tribute service. He knows she has strong feelings about proper church attire, and she knows he is baiting her.

"You should look like a preacher, Rev," she scolds him. "You wear a white shirt."

When the church service begins, not only is the pastor wearing a white shirt, Julia is wearing a white dress and white gloves. She enters at the back, walks slowly down the rose-carpeted aisle, past the communion table and the shiny collection plates. The "Inspirational Choir" follows her and she holds out her arm, formally, toward the choir risers. On the rear wall behind them are two large speakers, pictures of the past and current pastors, and, in large print, the banner-sized "Church Covenant." There are drums, a piano, an organ, and a sound control board. The choir sings:

Be stead-fast, un-movable, always a-bound-ing in the Word of the Lord. Your la-bor is not in vain.

They sing with a zest that would make the Mormon Tabernacle Choir envious. They make the silver paint flecks on the white ceiling twinkle. Julia sits smiling, clapping her white-gloved hands to the music, at the same time moving her shoes on and off her swollen feet. Little sparks of pain that interrupted her smile when she walked down the aisle are not there now.

"We have seen your quiet kind of strength," says the pastor. "Mother Preston, your labor is not in vain."

Several members of the congregation rise to give their tributes to Julia. The atmosphere is jubilant and inspired. This is all for Julia. Her lips twitch nervously at the realization.

The sounds of the celebration must be carrying through the church walls and into the neighborhood where only a few hours ago police and ambulance sirens blared and the victim of a family squabble lay bleeding and unconscious on the sidewalk. "That's the neighborhood," the pastor said. "It's not uncommon here." He is a former prison guard and knows violence well. Respecting his own legacy of fear from his years of prison work, he has moved his church office desk so that it faces the door and he can see who is approaching.

Mother Preston, what does the church mean to you?

"The church means people. The church helps people," she says. "It helps me. I know I love them, and I believe they love me. They walk up and hug me and kiss me."

"She is an inspiration here," says the pastor. "Many people come to church because they feel if Mother Preston can do it, so can they."

❧ Julia Preston doesn't talk about diet or good genes. "The Lord let me live," she says. "When I was one hundred, I asked the Lord to let me live to get another one. Now I ask for one more."

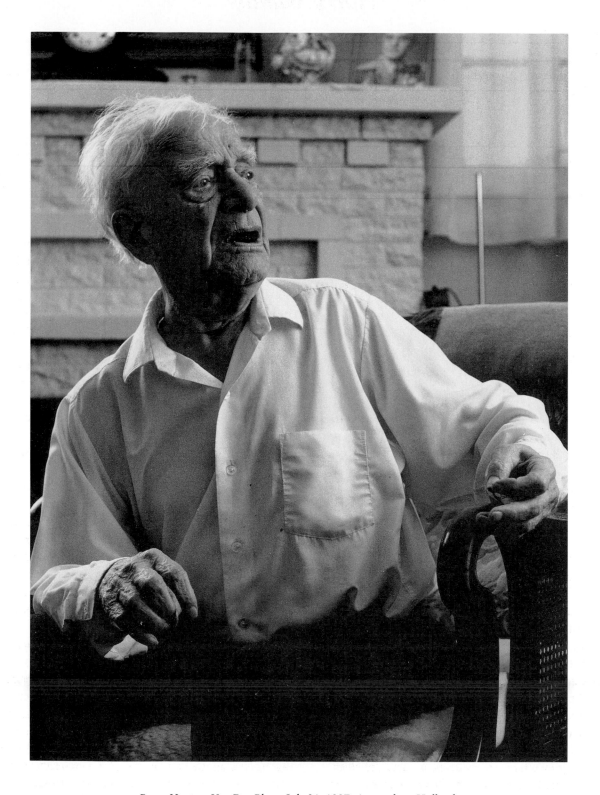

Born: Herman Van Der Ploeg, July 31, 1887, Amsterdam, Holland
Married: Frances Konoski, 1919
Children: (9) Francis, Beatrice, Lucille, Patricia, Dorothy, Richard, Harry, Barbara, Theresa
Principal occupation: tailor
Current residence: Boise, Idaho

Harry Wander

Harry Wander's granddaughter writes: "My grandfather is highly intelligent with a photographic memory and total recall. He only needed to read a book one time and could quote chapter and page from it. In another time and place he would have been a history professor; instead he was a ladies' tailor like his father before him. . . . He loves classical music and can sing most operas from memory in the language in which they were written."

This old tailor with the mind of a scholar, a student of science and history, a lover of Shakespeare and Byron and of opera and art, lives quietly with his wife of 69 years in a modest home in Boise, Idaho. He likes to play bridge because it gives him the chance to talk politics and economics and history. A hundred years of photographic memories make for a pretty complex mental filing system, and Harry's brow knits as he shuffles through the options, pausing now and then to delete the extraneous before speaking.

He was born in Holland at a time when the class system still labeled people from birth. "There was no hope," he says, remembering his boyhood. "The schools were first, second, and third class. I was the son of a poor working man, so I went to third class." Only the best students in the third-class schools could study a foreign language. Harry was one of them and learned German, which was then the international language of tailors. But he also attended his uncle's night school and learned another language, French.

When he was 17, he had finished his tailor's apprenticeship and left for Paris. His brother Frank, who was to become something of a partner to Harry most of his life, soon joined him. And here began the adventures of two precocious young men. They tailored clothing, but they also tailored their lives to include museums, cathedrals, and palaces. They became needle-and-thread nomads, working for a while and then moving on, traveling to Italy and all over Europe. They lived in Berlin and Vienna and in many resort towns in between. Within a few years, Harry was proficient in nine languages.

In 1910 he moved to London where again his brother joined him. Harry loved the arts and often attended performances at the Royal Shakespearean Theater. But as the English workers started striking, he started dreaming of America.

An avalanche of details, facts, and figures follow as his mind pours out information on what was happening in the Philippines and America at the time.

The digression concludes with a mini-lecture on manifest destiny.

When Harry and his brother did come to America, they wanted to come on the first-class ship, the *Titanic,* but it was booked so they took the *Oceanic.* He arrived in Chicago when 5,000 tailors had immigrated to America in one week. He and his brother moved to Portland, Oregon, and started their own business, which failed in a year. They moved to Boise, then to the small town of Emmet, where they lost almost everything in the Depression. At some point Harry's brother Frank sold out his share of the business, but when Frank's wife died in 1922, he and his child moved in with Harry and his family and remained for 20 years. Harry returned to Boise and continued as a tailor until he was 75, then moved his business into his own home and continued until he was 84. "Mother Nature made me quit. I couldn't see the hole in the needle anymore."

His hands may have become idle, but never his mind. When there is nothing else to do, he likes to sit around remembering lines from Shakespeare. "I often find more consolation in Shakespeare than in the Bible," he says.

If people are talking about Harry Wander right now, what do you hope they are saying?

"That I am honest. And that I have all my marbles."

❧ Longevity does run in Harry Wander's family, but so does a peculiar health practice: like his father before him, he wouldn't smoke before noon and he wouldn't drink or smoke after midnight. Their theory is that the body needs 12 hours of the day to clear itself—a kind of 12-on/12-off approach to keeping bad habits in check.

He had typhoid fever when he was seven. At 18 he had a kind of stroke, and severe influenza struck him three years in a row, once so badly that his legs were paralyzed. He was turned down by both the Dutch and U.S. armies because of a bad heart. "My heart missed eight beats a minute," he says. When he was examined in 1916 in the United States, he was told that at best he would live another six months. This news drove him to start an exercise program of boxing and wrestling.

In 1935 he had surgery for appendicitis and almost died. He had an out-of-body experience, hovering over the bed where his body lay, but, in one of his many mental gestures, he decided to return.

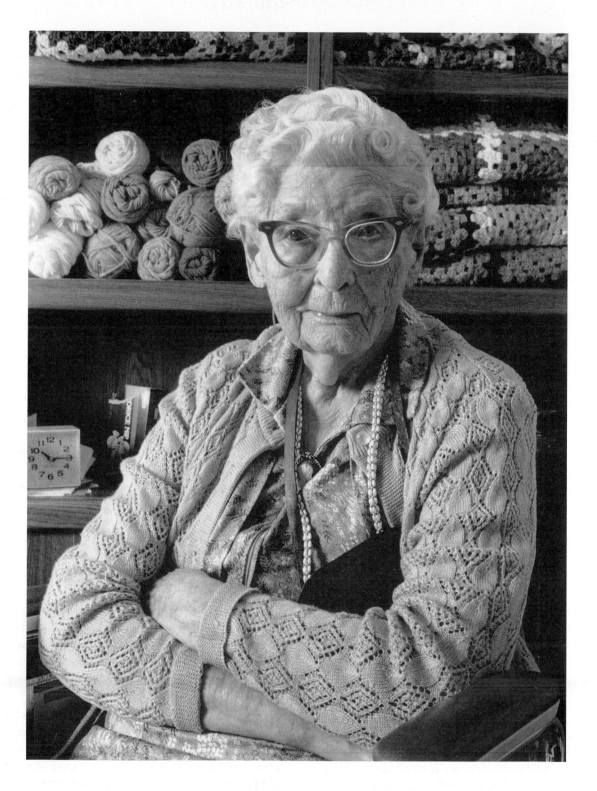

Born: Mabel Gertrude Minard, May 30, 1881, rural Lake City, Iowa
Married: Bert Taylor, 1901; died, 1962
Children: (2) George A., Blanche
Principal occupation: homemaker
Current residence: Lake City, Iowa

Mabel Gertrude Taylor

Imagine someone who can give a firsthand account of something that happened 102 years ago. Mabel Taylor was four years old: "We were moving to Nebraska in a schooner wagon. We crossed the Missouri River on a big raft. They drove the wagons right on the raft, the waves came up over the edge, and I was scared. Seeing the waves splashing over the side of the raft, I thought, 'That looks like fat meat.' The folks had butchered hogs before we left, and I remembered what that fat meat looked like. It wasn't white. The Missouri River was never white, never clear. That's why they call it Old Muddy. I'll never forget that so long as I have any memory. That water looked just like fat meat."

During those first days near Chadron, Nebraska, Mabel's family lived in a tent while they built a log house, complete with a dirt floor. Mabel watched her mother fire a shotgun at a gopher burrowing its way into the kitchen. Indians no longer roamed the plains of the area, but she remembers the raised burial platforms they left behind—"four props in the ground." She also recalls running barefoot through the grass, always alert for rattlesnakes, and imagining that the Indian children who played there before her used the same caution.

Her family was poor and she had to quit school to become a hired girl, a maid. She was never able to follow her wish to become educated: "I wanted to teach, but we didn't have money and I had to stay home. We were poor folks and couldn't buy books. Sometimes I walked the floor, I didn't know what to do with myself. I had no hilarious times, I'll tell you. If only I could have gotten books. . . ."

Because her parents couldn't make a living in Nebraska, the family moved to Lake City, Iowa, where Mabel lives today. At 20 she married a young man who worked in the local electric power plant. Eventually they bought a small acreage and expanded it into a dairy farm so that he could quit his job at the power house. She helped with the entire farm operation and lived the proverbial tough, frugal life. When she and her husband retired, they moved to Chicago to live in the same apartment house as their artist son, who had trained at the Chicago Art Institute. When her husband died, she returned to Lake City to manage her own life, to paint, and to become a bit of a local celebrity with the quality of her large embroidered wall hangings. The local library has exhibited her work.

She has lived in the nursing home for seven years. Her son's paintings and her own embroidery work highlight her room. "I try to be content," she says, "but I'm not content unless I'm doing something."

The old habits of 45 years on a dairy farm are still with her. She gets up at 6:30 in the morning. "I can't stop that. I still wake up early. I get up, wash myself, get dressed, and make my bed. I like to crochet. But lately I've been reading. I've been reading constantly in my spare time."

The constant reading is the result of modern techniques in laser eye surgery. She had almost totally lost her eyesight before having lens transplants not long ago. What a sweet quirk of history that a child from the 1880s, who grew up longing to read while attending a sod-hut schoolhouse and living in a dirt-floor cabin, should have both time and sight to read to her heart's content after she is 100!

❦ People who fear they're going to die young because they're sick so much should take a look at Mabel Taylor's health record. She has survived three separate bouts of cancer: a radical mastectomy at 25, a thyroidectomy at 35, and removal of a 7-inch section of colon at 94. She had a compound ankle fracture at 80 that would not bind until a metal screw was inserted. She once had rheumatism so bad that she couldn't comb her own hair.

Genetics has not done her any favors either: neither of her parents lived to be old. What's more, her tendency toward illnesses goes back to early childhood. She had such a serious case of quinsy as a little girl that she was taken out of school for 13 weeks and cured only after her mother wrapped a sock soaked in turpentine and lard around her neck. Her chronic sore throats continued into adulthood and once threatened to become rheumatic fever.

"I was sickly in my younger days. I wasn't strong, but I always had to work."

The tendency toward illness made her diet-conscious most of her life. She never drank liquor or smoked, and she has avoided many foods, including chocolate and some vegetables. She skips some meals today, but her relatives say that's just out of vanity—she wants to have a nice figure. What food does she like? "Bean soup."

It's not surprising that, when asked how she got so old, Mabel Taylor says, "I don't know. My prayers are mostly prayers of thanksgiving."

Born: Elizabeth Litchfield, May 15, 1886, Baltimore, Maryland
Married: Howard Taylor, January 3, 1903; died, 1952
George Hubbard, September 15, 1962; died, 1976
Children: (1) Mercie
Principal occupation: waitress
Current residence: Stanwood, Washington

Bessie Hubbard

I have the power of the Baptism," declares Bessie Hubbard. "I never get tired." From outside her small apartment you can see ceramic praying hands in the window and a picture of Jesus on the wall behind them. Entering the apartment is like walking into a religious shrine. Colorful plastic flowers loom from vases on the windowsills, three Bibles lie within a 10-foot radius of her stuffed chair, a well-worn book by Oral Roberts sprawls face-up on the floor, and paper crosses are taped or tacked generously around the room. The lamp shade has a purple cross taped to it, as does the closet door. There's one pinned to the curtain and another one to a miniature rocking chair on top of the bookshelf.

"I guess she's afraid people won't know she's a Christian," says her daughter.

In less than an hour, she bounces in and out of her chair a half dozen times, stoops and rummages through her closets looking for clippings, paces the floor telling stories, dances a jig while singing "The Star-Spangled Banner" gloriously off-key, and proclaims in action and words that her energy is limitless.

She isn't light-footed as she moves and dances about, but she is sure-footed. There is something both earthy and regal about her with her shiny silver wig riding her head like a crown.

She's a woman who seems to run on high-octane spiritual power, someone who hates TV, who has never had any hobbies, and who loves to work. She was a waitress for 40 years and still volunteers to prepare and clear tables at the senior citizen center.

"What is love?" she asks. "I'll tell you what it is. It's giving. Jesus gave me love."

Bessie has tried her own kind of giving—a large sum of money to Oral Roberts—but her family stopped her.

Her religious fervor radiates from her and her apartment. It's in her speech and in her movements. She is a dazzling testimony to belief. But others tell of the vacuum she leaves in her evangelical wake. She likes to be with people, but her constant religious talk drives people away.

"I feel that I'm alone in the world because I'm just like Jesus," she says. "They made him feel alone too."

❦ Newspaper articles describe Bessie with epithets like "peppy," "ball of fire," and "feisty." A friend has said that she is "bullheaded and too ornery to die." One reporter labeled her a health-food addict and printed her dietary regimen that omits shellfish, milk, fruit juice, and salt, and recommends ocean fish, meat, and vegetables—and nothing that is fried. Bessie disclaims the label and regimen today: "I never watched what I ate," she says. "I did start reading *Prevention* magazine years ago, but I didn't do what they said until the 1970s. I'm careful now. Not too many sweets." She turns to her guests, pats one on the stomach, and says, "Don't get fat.

"But the only advice that's worthwhile is about Jesus. I obey Jesus. He tells me what to do and where to go. Living with Jesus, I never got tired," she says. "I'm never tired now."

When the last picture is taken, Bessie's eyes get glassy. "Ding bust it, now I'm alone again."

As she stands in her doorway, there is a hint of a little girl in her slightly bowed arms and legs. "Here," she says, holding out a five-dollar bill. "Here's some money to buy lunch."

She waves goodbye, closes her front door, and within a few seconds is again singing from her refuge.

Born: Clare Retta Armstrong, April 23, 1887, Albion, Nebraska
Married: Otto Menger, 1919; divorced, 1924 (?)
Clifford Warren Axtell, 1935; died, 1957
Children: (1) Ruth Clare
Principal occupations: abstractor, realtor, insurance agent
Current residence: Thermopolis, Wyoming

Clare Retta Axtell

When a nurse heard a man's voice coming from behind the closed door of Clare Axtell's room, she knocked to see if Clare was all right. "I have a newfangled clock for people who don't see too well," says Clare. "It tells the time in a man's voice."

Clare Axtell is nearly 6 feet tall, a lean and healthy centenarian who presents herself the way most people would like to imagine themselves in old age: poised, dignified, and full of good humor.

A lot of good humor. When the nurse explained her concern over hearing the man's voice in her room, Clare said, "He's under the bed." And whatever well-being she can't give herself through her humor, the Wyoming Pioneer Home in Thermopolis probably can.

"I love it here," she says. "They treat us with respect." The Home was created by the legislature for the state's aging pioneers, and looks like the one-time estate of the very wealthy, with spacious grounds and large mineral-deposit cones rising like granite monuments not far from the front windows. There's a hot-spring jacuzzi inside the facility. It has the ambience of a place that was built and sustained for the privileged few, a place that could honor dignity—or create it.

But Clare moved to Thermopolis from Nebraska back in the days when it was still a wild western town with more saloons than manners. Shortly after she arrived, one army man made fun of her for her serious and dignified demeanor. She learned that he had said, "Have you folks seen that long, lean, lanky woman from Nebraska over in the courthouse? You know, if she smiled her face would crack."

Clare's face cracks with laughter when she recalls that story of 70 years ago. She knew she had insulted him by not laughing at his dirty jokes. There were other affronts to her sensibility when she arrived. She had been taught Victorian principles of behavior, including the rule that a young woman should cross the street rather than walk past the door of a saloon. But the streets of Thermopolis were so thick with saloons that she couldn't zigzag across the street often enough to sidestep all of their front doors. Not much could shock her today.

She had moved to Thermopolis to work as county assessor, county clerk, and clerk of court, all positions vacated by men who had been called into military service in 1916. But her doctor in Nebraska had told her that she had only six months to live from a debilitating disease that he could not fully diagnose.

"I figured I might as well die in Wyoming as Nebraska." She was 5 feet 10 inches and 111 pounds. Whatever the disease might have been, she was unable to eat any solid foods when she arrived. "I started going to the hot springs and drinking the mineral water," she says. She recovered quickly and has made drinking and bathing in the mineral water a part of her life ever since.

When the men returned from World War I, she lost her job to the veterans, and the area oil boom began. She opened an abstract office and married her first husband, who was an oil man. "But he lost his job when he went with a group of oil men who enjoyed drunken parties." What ended their marriage, however, was his treatment of their daughter, whom he struck. Clare left him. "I wouldn't tolerate child abuse. Not even once. I have been a person who makes up her mind and I don't change. I've never been a pushy woman, but . . ."

She remarried Clifford Axtell, whom she calls "a short but brilliant lawyer." With her background in law and court reporting, she was well qualified to assist him in his practice. When he lost his hearing, he fully depended on her in his court appearances. She later became a realtor and insurance agent. She hardly mentions her community work, but it's there—with enough volunteer activities to occupy some people for a lifetime.

"I don't think that any woman in town has worked as hard as I have. I get disgusted with lazy people. Most women don't know how to work. I still take care of plants and crochet. I play bridge and read *Time* and *Newsweek*. If people work while they're younger, they'll never quit. I haven't."

❧ "Truly," says Clare, "I know that water is what saved me." Clare doesn't like medicines, and she seems to bring out the worst in doctors: they keep telling her she's going to die and she doesn't. The most recent defective prognosis was less than a year ago.

"The doctor said I was so sick that eight different ministers came by to see me. The doctor came back the next week and thought I was even worse. He said, 'You can't get well this time, Clare.' I felt so sorry for him that I said, 'That's all right, doctor, I don't care.' But I got well. Maybe the Lord didn't have a mansion ready for me yet."

Born: March 20, 1882, Kreuznach, Germany
Married: Edna Reinhart, 1923
Children: (2) Alvin, Walter
Principal occupation: tie salesman
Current residence: Seattle, Washington

Max Schoenfeld

At 105, Max Schoenfeld goes to work every day in his family's tie factory. Until he was 90, he packed ties in the warehouse. Before that, he worked for 40 years as the company salesman.

He does not try to be a productive whirlwind, but he is more than a factory memento. His wastepaper basket holds his cane rather than discarded sales projections, and signed pictures of celebrities ranging from Henry Kissinger to Dinah Shore are more prominent on his desk than appointment calendars. But the workers know he is there, turning on the lights, circulating among them, checking the number of orders, and, like any distinguished executive, sitting graciously behind his desk. The 135 or so employees all call him "Mr. Max" and flash admiring smiles as he walks into the large, open working area.

"He functions now as an inspirational figure to the workers," says his son. "The office people are amazed by him, and having him around gives a sense of company continuity."

There may be more to it than that. Work in a tie factory is not inherently interesting, and the 80 workers who actually make the ties are identified by their functions: cutters, piecers, operators (margin hemmers), pointers, pocket turners, seam and pocket pressers, stitchers, tackers, tie turners, tie pressers, stuffers (for silk ties), and packers. Mr. Max just might be that conversation topic that gives them something more than a paycheck to take home. Maybe part of the pleasure of their work is being able to go to a weekend party and spice the conversation by saying, "Of course, I like being a tacker in my factory: It's the kind of place where people still go to work when they're one hundred and five."

The company's continuity goes back over 80 years when one of Max's brothers started the Seattle factory. Max had come to the United States in 1896 at the age of 14, worked for a year in a Wabash, Illinois, hat factory, then at an uncle's clothing business in Chicago for 10 years before joining his brother in Seattle. He and two brothers had primary roles in the factory's early days, one as a buyer of materials in New York, one in charge in Seattle, and Max whose work became that of salesman and, as his son says, "keeper of the peace" between the other two brothers.

It was as company salesman that Max distinguished himself. He was evidently "a natural." He had a way of remembering everyone's names and worked with indefatigable energy. And he had a trademark: cigars. The early expense records always showed "cigars" as one of the items. He smoked cigars himself until a few years ago, and as a salesman, always offered a cigar to his customers. He also had a little display trick, a way of taking a tie and deftly wrapping it over two fingers to look like a tie-knot. He demonstrates the technique, holding out the tie over his fingers as it would appear when worn.

Max had come from Chicago with no sales experience but was an immediate success, making a big sale in Spokane on his first trip out. In the early days he traveled from town to town by train with his sample case, then walked or was driven in stagecoaches. His 40-year sales record is astonishing. He sold millions of ties and was a company kingpin in building the family enterprise into a highly reputable business. To this day, the business is in the top five in the nation in volume and reputation.

Why do you think you were so successful as a salesman?

"Honesty. I gave them the facts all the way."

What advice would you give a young salesperson?

"The best thing in the world is always be honest. If customers ask a question, tell them the truth."

The company now has 22 salespeople. An office joke is that "It took twenty-two to replace the old man."

❦ Besides his regular work, Mr. Max goes to temple once a week. In recent years, until he broke his hip, he also took care of his ailing wife. Longevity does not run in his family.

What is your secret?

"Hard work," says his son. "And he has always been very moderate."

He may have been moderate, but he is also modest: "It just happened," he says. "I live just like everybody else. Really and truly, I don't know. I always told the truth. I tried to be absolutely straight and above."

Born: Karen Brendsel, May 24, 1886, Volga, Dakota Territory
Married: Joseph Brende, 1906; died, 1953
Children: (6) Godtfred, Lizabeth, Karl, Bernard, Kathryn, Herbert
Principal occupations: piano teacher, homemaker
Current residence: Sioux Falls, South Dakota

Karen J. Brende

I was born tired and never got rested up." These are strange words coming from a woman who at 101 has started playing piano for chapel services again and has a long reputation as someone who is always doing. It may be that she just expected more of herself and life than most people do. Among other things, she gave piano lessons for 35 years with up to 25 lessons a week, but of that career she says, "I don't think I was a very good teacher. None of my students stuck with it and became great players."

Karen Brende may not be adept at praising herself, but her old age is hardly the profile of a defeatist. Hanging in her room is a zither which accompanied her for years as she went around to retirement centers playing and singing for residents. She learned to swim when she was 54, graduated from the Luther Bible Institute when she was 69. In her 80s she traveled abroad, drove a car, and directed a choral group of mostly older people called "The Keen-Agers." She translated a book from Norwegian (her first language) into English when she was 97.

It was only a hip fracture at 99 that altered her active life-style and drove her into the nursing room where she now lives. The intercom blares frequently, overriding her voice as she talks, and she admits that adjustment to the nursing home has not been easy. Sometimes other residents scream in the night and she misses her independence, keeping her own house, and cooking. "I felt like a fifth wheel when I got here," she says. "I didn't know what to do with myself."

But the urge to explore new terrain has not weakened. Besides going back to the piano, she is doing some painting and regularly writes to her relatives. She reads the newspaper and discusses her concerns with others at the dinner table. Among other things, she keeps up on international terrorism and is anticipating the next U.S. moves. "I hope the United States stays out of war," she says.

She was born and raised on a farm, had an early interest in music, and was the church organist by the time she was 14. Several years after marrying, she and her husband and children moved West to homestead. In her life on the prairie is a keen reminder of how much she, like many early pioneers, craved the civilized life. She and her husband set up a school in the upstairs of the house they had built. Her husband was qualified to teach—and did. To simulate the atmosphere of a formal school, they put in school desks and he kept order just as he might in an

organized institution. He held regular school hours with scheduled recess and lunch breaks, a no-nonsense home-education program. In attendance were three of their own children along with a neighbor boy.

Their homestead ranch was only a few miles from the Cheyenne Indian Reservation. Karen tended to the sick, using massage as a curative measure. She and her husband traded with the Indians, who would bring wooden poles for firewood in exchange for cattle that had died on the range. The Indian women would come along with the men, she remembers, and would come into the house while the trading was going on outside. They would simply sit silently, never saying anything, "as was their tradition," says Karen.

"It was a strange neighborhood. We hardly had any neighbors. Two old maids lived a mile west and a couple of bachelors lived a mile south—and they never got together!"

As interesting and busy as the prairie years may have been, there must have been an unsatisfied hunger for a more lively aesthetic and intellectual life. Her husband became a county school superintendent, and they moved to Sioux Falls during the Depression. That is when Karen began her long career of teaching piano.

The proverbial doer, she is talking about going back to teaching piano in spite of her dim view of her earlier success. Maybe this time she'll be the inspiration she imagines that she wasn't then. Tired or not, she has the confidence for it: "I'm first rate and a half."

❧ "I chose healthy parents," she says, then adds, "I was a diet buff for a long time. I learned about health foods from a Dr. Snyder who came around teaching about eating whole-wheat breads and unprocessed foods. This was in the thirties and forties. He also taught combinations of foods—like, eat bread as a whole meal, combined with raisins and a few specific vegetables."

She remembers that while she and her husband lived on the prairie she ate a lot of green grasses and weeds, among them broadleaf weeds, dandelion leaves, creeping Jennies, and pig weed, often blending them together with water, straining them, and drinking the juice. "I've been very food and health conscious for a long time," she says.

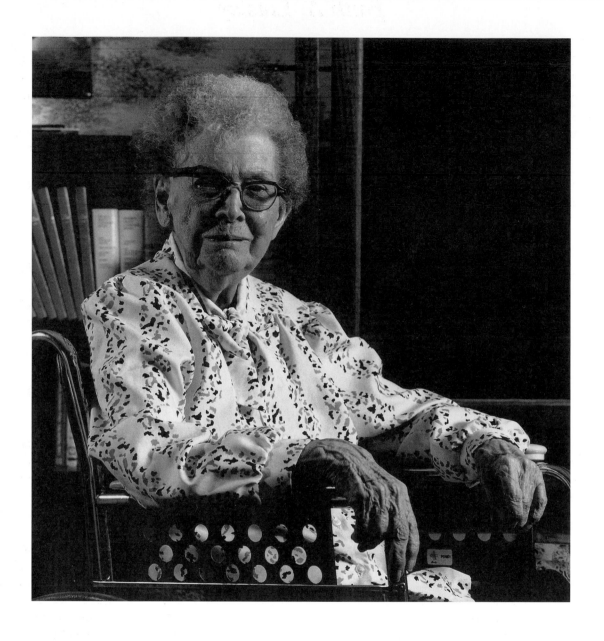

Born: January 18, 1887, Manchester, Vermont
Never married
Principal occupation: high school English teacher
Current residence: Barre, Vermont

Faith A. Linsley

The real you is in your head. Everything below the neck is just plumbing." That's one of Faith Linsley's favorite quotations—from Maurice Chevalier.

Faith Linsley was the quintessential stern English teacher—the benevolent dictator of her classroom. She made students spell correctly and memorize poetry. She graded essays as much for form as for content. She insisted on accuracy and propriety in her students' writing and took a stand against realistic fiction that, in her estimation, lacked decency. She says authors of realistic fiction are "obsexed."

"Permissiveness is a flaw in schools. There is so much talk about basics today, but some qualities of education are more basic than the basics. A teacher friend of mine used to say, 'If you can't hold 'em, you can't larn 'em.' "

So speaks Faith Linsley, as sure of herself today as she must have been at the height of her teaching career. She epitomizes old standards of order and discipline, of decency and respect. "I wanted respect and I got it," she says. "And the respect went both ways. I respected even the slow learner. A classroom is a place for mutual respect."

Children should come to school to learn, she feels, and learning should be the concern of education. "Education is a process of leading the child from where he is to where he should be."

It's hard to imagine that a person like Faith Linsley could live within the confines of a room in a nursing home and still appear to be in control, but she is. This may not be a classroom, but coming into her presence makes you feel the way her students must have felt. You want to behave yourself. You want to show respect. Even the nurses sense this power in her.

"I think I always looked like a schoolteacher. Even today almost everyone calls me Miss Linsley out of respect. I think the urge to instruct was born in me."

Also born into Faith Linsley is a sense of tradition that may have had something to do with the kind of teacher she became. "Being a New Englander means I have roots—especially Vermont roots—and I think that roots are important. I'm a Vermonter by birth and choice."

She was born in Manchester, Vermont, the daughter of parents she describes as "self-educated, interesting working people." She always won the spelling contests in high school and was asked to present an essay at high school graduation. She first taught school in 1908, then attended and graduated from Middlebury College in 1913. The following year she did graduate work at Wellesley College before starting her high school teaching career, nearly 40 years of it, 35 of them at Spaulding High School in Barre.

"One of my students said I combined knowledge and humor. That may have been the secret of my teaching."

This woman a comic? Her attraction to that 14th-century humorist, Geoffrey Chaucer, gives some indication of her wit. "I liked Chaucer—the old reprobate—he was a sly one." And she is quick to pick up the kind of humor in her own environment that Chaucer would have noticed with his keen eye for human foibles. Her favorite misprint was in a newspaper account of a speaker who kept referring to the whole population as "the masses." The newspaper printed "them asses."

"That's my favorite typo." Coming from proper Miss Linsley, the observation is doubly funny.

Today she remains an avid reader. "An old friend said, 'If a new book comes out, read an old one.' I think that's good advice."

She's been reading Irving Stone's *Love Is Eternal*, the seven-volume Williamsburg novels by Elswyth Thane, works by A. J. Cronin, along with several romances and detective novels.

What can a person do to make sure old age will be worthwhile?

"Find a job and do a good job at it. I've helped a lot of students and those rewards are coming back. They thank me for what I've done—including making them memorize poems. I am reaping what I sowed and what I didn't realize I sowed. I'm cashing in from all those people who respected me. It's wonderful to realize before I die what I've done for youngsters. And I hadn't realized that until the last few years."

❦ "I never went to a hospital as a patient until I was eighty-four years old. I didn't take medicines—they upset my stomach—and I think that's one reason why I'm so old. But attitude is the main thing—be positive. And I think my sense of humor has protected me from stress. My favorite motto on aging is this: 'Age is a question of mind over matter. If you don't mind, it won't matter. ' "

Born: Lona C. Holder, March 3, 1885, Bedford, Indiana
Married: Hamp W. Donica, 1901; died, 1962
Children: (2) Violet Marie, Harley Ancel
Principal occupation: homemaker
Current residence: Tampa, Florida

Lona C. Donica

Lona Donica's longevity has changed her great-granddaughter's company policy. The result is a model for how the extremely old can be given security.

"Having a centenarian in the family has enlightened our company policy in looking to the future," says Lona Donica's great-granddaughter, who inherited a large pest-control business that has more than 80,000 customers. When her great-grandmother lived into extreme old age, she realized that what was happening in her family might be happening in many others.

She felt it was time for her own company to look at the situation of aging relatives and has been exploring one option by putting Lona on her company payroll. Lona puts address labels on 2,000 cards that are sent out every month.

"We're looking at how employee benefits might include aging members of the family as well as the usual dependents of spouse and children. She does two to three hundred a day and keeps meticulous count. We're involving her in the company. We pay her in gifts, though she feels she is earning. This makes her proud. We put her picture in the company newsletter."

Lona's granddaughter has also responded to Lona's age and needs. She and her husband invited Lona to move in with them in their spacious Tampa home when Lona was 99. They try to involve her in family life while at the same time respecting her privacy.

"Old people need a place for themselves," says her granddaughter. "She has her own room, her own TV, and her own bath. She's home alone during the day from nine in the morning until six at night. This gives her the freedom to do what she wants: writing her letters, making afghans. But she also helps out in the house, tidying things up and doing lots of cooking for the family. She makes the best fried chicken."

Lona was born and raised on an Indiana farm and had lived most of her married life with her husband on a farm until retirement when they moved to Indianapolis. But her husband died in 1962, and she lived alone until three years ago. Not only her husband, but her children and most of her friends are dead. When she saw her nephews and nieces getting sick, her feelings of loneliness intensified. People seemed to be dying out from under her, and she lived with the fear that no one would be left to care for her or that she would become a burden on those who did.

"Why do the young die and leave me?" she asks.

She had been extremely security conscious in Indianapolis, keeping her doors bolted and not answering the door unless she knew who it was. She still has stomach ulcers and a nervous laugh but says she no longer has any worries. The base of family support has begun to counter her fears of detachment and loneliness. She is starting to see that they make up for what she has lost. Her old habits of busyness are coming back to her, habits that sometimes lead her to write letters all day long, to plant grapefruit in planters around the house, to make scores of afghans, bedspreads, and crib blankets, to keep things neat and tidy, and to cook for her relatives. She is rarely idle, except for the quiet time she spends in her room, and that time she uses for reading her Bible and praying.

And she has her address labeling work. Her family says it is a job perfectly suited to her. "She's a super nonprocrastinator," says her granddaughter. "She can't stand to leave something unfinished. And she's so neat. She's a lint-picker."

"I love to be busy," says Lona. "I love to do things for people."

The family members feel they are getting more than their fair share in return. She is their cornerstone, their link to the past, and, as they demonstrate, their way of looking toward the future.

❧ Lona Donica had cataract surgery in 1981, her gallbladder removed more recently, and she takes medication for her ulcers. "But I have been healthy," she says. "I think Indiana was a healthy place to live—the climate. And I think hard work is good for you. I don't have a secret for getting old. I just try to be happy."

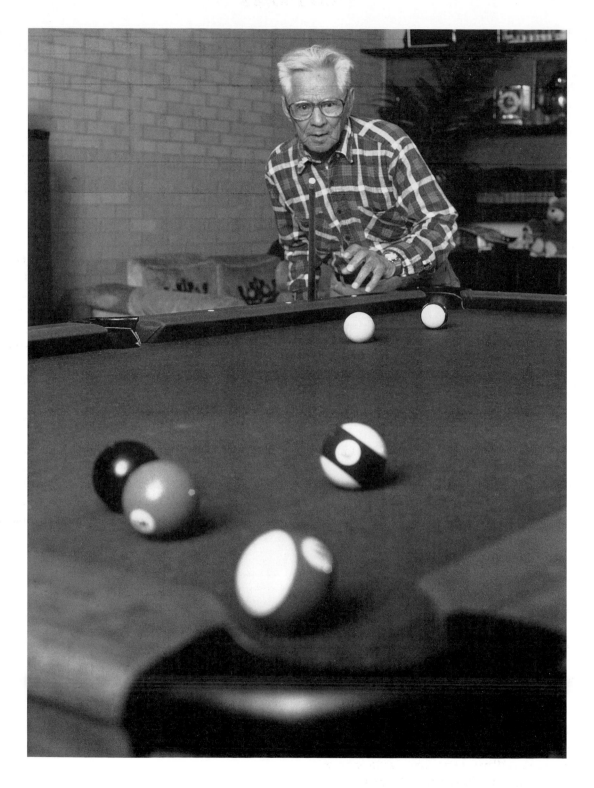

Born: January 15, 1889, Eagle Lake, Texas
Married: Ignasia Suarez, 1925; died, 1973
Children: (9) Manuel, Delores, Raymond, Lupe John, Dorothy, Rebecca, Victoria, Gilbert, Raymond
Principal occupation: railroad coach cleaner
Current residence: Denver, Colorado

Paul Flores

There's a large pool table in the family room at the home where Paul Flores lives. He looks like a man of 50 who has had a tough life, or a man of 100 who has had a good one, and he chalks up like one who is both tough and good at the game.

Once the balls are scattered around the table, he says, "If I could see a little better, I could shoot those two in one shot."

The apologies done, he proceeds to make the shot he has called. He gets into the game, moving around the table with an ease and grace that increases as he plays. He's like a fish that's been out of water too long and takes a little time to get used to the old familiar world. He's more balanced around the pool table than he was walking across the room. His movements grow quick and easy. On several shots his elbow swings up as if to coax the ball in.

"Down in corner," he says a little later. "Though I can't see it." Again, he shoots across the table and makes his shot.

"I used to play for money, sometimes sixty, seventy, eighty dollars. Sometimes I used to make more money at pool than I did at work."

He starts making bank shots as he talks, often apologizing for what he no longer can do at pool. But the old habits and style seem to return. He has good follow-through and applies lots of body English. When he misses, he sighs; when he doesn't, he sighs and smiles.

He lives in a household of five with his daughter and her family. His grandsons are proud of him; they boast to their friends about him and bring them over to prove that they really do have a 100-year-old grandfather. He holds their respect.

"He always seems to know when something is wrong with us," says his grandson.

When he's not near the pool table, he seems like a timid man, a possibility supported by the fact that he never drove a car. He had one close call in a car in the early 1930s, and ever since, he has preferred to walk.

Besides pool, his favorite pastime has long been dancing. "I danced all the dances," he says. "Charleston, waltz, all of them."

But mostly he has always worked—cleaning railroad coaches. "Cleaning the coach cars was hard work," he says. "I had to vacuum them up the backs of the seats too."

For years and years he did the same coach-cleaning work for the Burlington Railroad. "They wanted to promote him," says his daughter, "but he couldn't read or write, so they couldn't."

"My working days are gone. I don't punch no more clocks."

His mother and father were Mexican, but his mother wanted to move to America so that their children would be Americans. He grew up in a Tex-Mex setting, with lots of work and partying. His father was a laborer, and Paul started working the fields when he was about 12. His mother died when he was 13, and he was raised by an older sister. The family came to Denver about 1920, and he met his wife, who was 20 years his junior, in a Mexican restaurant in Denver. She made the tortillas, and that was reason enough for him to start talking to her.

❧ Paul Flores is one of several male centenarians in this book whose twin died shortly after childbirth. The "healthy, chunky one" died. Paul has always been skinny. And a hard worker.

"He hardly ever got sick," says his daughter.

"I love to eat but don't have no teeth to eat with," he says. His favorite foods are Mexican dishes.

For years he drank his morning coffee with a shot of whiskey in it. "Just one," he says. He used to claim that the daily shot of whiskey is what made him live so long, but he has a slight heart problem now and has given up the whiskey.

Born: Marietta Dominici, April 2, 1887, Orsano, Italy
Married: Sandino Brama, 1909; died, 1944
Children: (12) Giocondo (Jack), Glorinda, Alberto, Columbia, Tony, John, Ilfrasia (Frances), Dominic,
Palma, Anna, Santina (plus one girl who died shortly after birth)
Principal occupation: "mother"
Current residence: New Brighton, Minnesota

Marietta Brama

Are you proud to be Italian?

"Yes. Very."

What does it mean to be Italian?

"It means everybody happy. And they love music. Saturday night, all night long."

Did you dance?

"Oh, crazy!"

Marietta Brama's memories flash back to her childhood. Her father owned a mountaintop, where they lived—"one half hour straight up." It was a climate of snow in April and scorching summer heat, but always a breeze and frequent fogs. They raised wheat and livestock, and she helped with the chores. But, "I would start dancing on Saturday night and we danced all night until it was time for church on Sunday morning. We'd take time out to go to church, and then we would dance all day Sunday. Waltzes. Polkas. Saltarella. Everybody liked to dance with me. I was light on my feet. Like a gazelle. Daddy played the violin [she does an imitation of the sound]—just like a bird singing."

In 1909 she married her husband and they moved to a shack down the mountain. She continued to work for three days while she was in labor with her first child. She remembers the labor pains in the middle of watering the cattle.

Her husband preceded her to America, and she and their first two children joined him in 1913, landed on Ellis Island, but had to stay only a short time. Her husband had a house prepared in Minneapolis—with six boarders to take care of. Marietta describes the setting simply: "The house was a real dog." She cooked, laundered, and sewed for the boarders while her husband earned his $18 a week working for Pillsbury Mills, filling flour sacks. Along with the work, she had children: one about every two years. She nursed the babies until they were about two and then she would have another one.

Sounds like the dancing stopped and the work started.

"Oh," she says, "I worked day and night." She scrubbed clothes on a scrub board, with cold water, wrung them out by hand and hung them outside where, in the winter, they would freeze stiff. She made her own soap and rubbed dried bread crumbs on the stubborn stains around the collars.

"Always the work," she says. "I crocheted for all my daughters, granddaughters, and nieces (for their wedding) a white shawl. I make a lot of crochet. Always busy. Never this way [sits with hands folded].

I surprise myself. All of a sudden I'm a hundred years old."

Marietta Brama sits in her wheelchair in the retirement home reception room. She lived with one of her daughters and a son until only about a year ago. Small pocket containers, like a little saddlebag, hang over the armrest of the wheelchair. Inside the pockets are a small prayer book, a coin purse with a rosary, another coin purse with money, another rosary, a small folder with photographs, and a deck of cards. She is small, slightly hunched. Her hands are folded, showing her pink fingernail polish. There is a slight smile on her face—on her lips, but in her eyes too. She has a mischievous face and often leans forward with her hand over her mouth when she laughs, like a schoolgirl concealing her giggling in the classroom. Her whole manner is playful.

So what have you been up to lately?

She starts to say "Nothing," then corrects herself: "Bingo." When she notices that her daughters are laughing, she quickly adds. "And read. My prayer book. And rosary. Once a day to St. Anthony; on Saturday I say the one for the Blessed Virgin—that is the Third Order Rosary for the Blessed Virgin—and the regular rosary every day."

In a picture of Marietta over a bingo board, she looks gleeful. She is at the Knights of Columbus Hall, 97 years old. There's a cake in the shape of a bingo card with a big X where the cook and cook's helpers put a $100 bill.

"My hands are kind of crippled with arthritis, but not so crippled I can't play bingo."

When she talks, she gestures with her hands and her face. She laughs as she remembers the hard work. Her daughters laugh too. "She dotes on attention," one of them says, "because she's always got it."

❦ Marietta Brama was 4 feet 6 inches and weighed 155 pounds in her 70s and 80s. "I was never really fat," she declares.

She has had minor strokes, an enlarged heart, and heart congestion. She takes medication for her heart and wears a nitroglycerin patch.

"My father lived to 99 and a half. He was still going up the mountain to feed his chickens until the day he died."

How did you get so old?

"By working so hard."

Born: Daisy Carrington, February 28, 1885, Cambridge, Massachusetts
Married: John Holmes (?); divorced (?)
? Poindexter (?); died (?)
Remarried: John Holmes (?); died (?)
Children: (1) Constance
Principal occupations: seamstress, forewoman in jewelry company
Current residence: Newport, Rhode Island

Daisy Holmes

I started this ball rolling," says Daisy Holmes, "and it's still rolling." The rolling ball she is talking about is her family, and representatives of five generations of them are unraveling around her in the room as she speaks. "I don't feel guilty either. Look what I've got," and she gestures toward several, including one of her great-great-grandchildren asleep in a cradle near her chair.

Daisy Holmes lives in her granddaughter's home. Most of her large family, which includes 20 great-great-grandchildren, live near her in Newport. "I have a wonderful family and we are very close-knit. They are important to me. Would you believe I have a daughter who is 83 years old?"

"She is the nucleus of this family," says her granddaughter. "What she does is pass down love."

Daisy Holmes was born in Cambridge, Massachusetts, in a prominent Black business family. Her grandfather owned the first Black lumber business in the area. He owned a wood lot of mostly deciduous trees and would have men come in to cut and cord the wood. Unlike many Black people at the time, he owned his own home in Woburn.

"Things were good for my people in those days," says Daisy. She attended high school in Cambridge and studied both Latin and French, but, before completing school, at 17 she went to work in a jewelry factory making chain-mesh purses and decorative combs. The women hooked the chains, the men pinched them together.

She had planned to return to high school and finish the next year, but she did so well at the factory that she was put in charge of several other workers, working as an inspector, and didn't return to school. By the time she married, she had left the jewelry factory and become a seamstress in a dress factory, working 10-hour days for ten cents an hour. But she continued at the seamstress work, living in Cambridge and working in Boston, and did not retire until she was 71.

She divorced her first husband, but after her second husband's death, she heard that her first husband was ill and went to take care of him. Love was better the second time around, and they remarried.

"So here I am," she says, "one hundred and two and still able to take care of myself."

She climbs the stairs to her upstairs room unassisted. On a typical day she rises at two or three in the morning to assure herself of privacy and bathes. She makes her own bed, fixes her own toast and coffee, and watches TV serials and "Wheel of Fortune."

"She won't even visit a nursing home," says her granddaughter. "She's real afraid of them, so she's always trying to demonstrate how able she is—like washing or drying the supper dishes. That is our time to talk over old times and family."

Daisy's maternal grandmother was a slave in Virginia. Her granddaughter says, "Nana's family didn't talk much about racial issues. And if you refer to her as a 'Black' person, she'll correct you because in those days to be called 'Black' was an insult. The references used were 'Negro' or 'Colored.' She grew up in a Black community but didn't feel they were segregated. But, of course, they were."

Because of the slave/master situation, several of her descendants are light-skinned. "That doesn't make a difference with Nana," says her granddaughter.

What gives you your greatest pleasure today, Mrs. Holmes?

"I like to hold the babies," she says smiling.

❦ "This little lady weighed one hundred eighty pounds—she was a little fat lady. She's five feet tall," says her granddaughter. But for the past 10 years she has weighed a mere 110 pounds and watches that she does not "take on weight." The good health that Daisy exudes today belies a history of some very serious health problems. She had rheumatic fever as a teenager and the doctor said she wouldn't live. But she says she was healed by the laying on of hands by a traveling storefront faith healer. About 40 years ago she had a mastectomy for breast cancer that had spread into her lymph nodes, and she had pneumonia only a few years ago. Her parents did not live to be old, but longevity runs in her father's family.

"There isn't anything she can't eat today," says her granddaughter. "She loves sweets."

"I have no secret," says Daisy. "Just living from day to day."

Do you think your close-knit family has anything to do with it?

"It has a lot to do with it. We're all together and we're all for each other. Yes, my wonderful family has a lot to do with it."

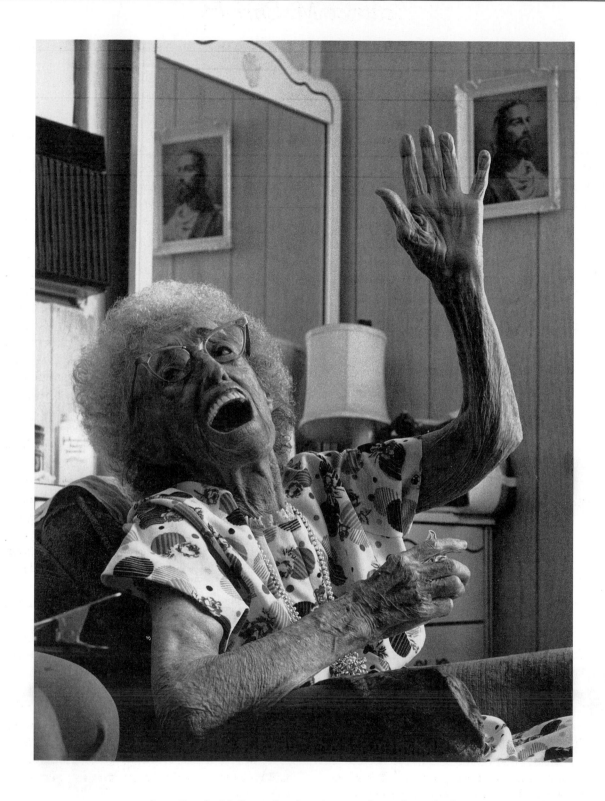

Born: Beatrice M. Carter, October 12, 1883, Plymouth, England
Married: John Enright, 1912; died, 1973
Children: none
Principal occupations: housewife, maid
Current residence: St. Petersburg, Florida

Beatrice M. Enright

Although Beatrice Enright has lived an impoverished life, at 104 she does not have a discouraging word about anyone or anything. What little spare money she has had, she has always given away. She lived alone in a mobile home until she was 100, then gave it to an area religious college and moved into the inexpensive nursing home where she now lives. At every moment, she is on the edge of ecstasy.

"I love my Heavenly Father, and I am waiting for Him to take me home. Many don't believe the way I do. I believe in God, and I know my Heavenly Father is so good. That's why I'm happy."

She mends clothes for people in the retirement home, visits with her longtime friend and guardian who comes to see her, and prays. Even when she works with her hands, mending, her spiritual focus does not alter. "I ask my Heavenly Father to give me light to see my work. And He does. I've been here four years, and I've been able to work. Praise the Lord. He helps me. He's so wonderful."

There are plenty of painful memories behind Beatrice Enright's current state of grace. In vivid details, she recalls her mother's tuberculosis:

"She had an awful cough, and she was bleeding. I can see it now. The doctor came, but he couldn't do nothing, she was too sick."

That was England 95 years ago. Her mother was dying from the disease. "My dear mother died when I was seven years old. That dear one was so sick before she died, but she was making us black dresses—all of us girls—to wear at her funeral. And my dear mother belonged to the Salvation Army. At the funeral, they took her in the street, and they had a band come to see her. In England, they kept the women out of the funeral. Just the men went to see her. They had the casket out on the street and they put it in the ditch."

While the men attended the funeral and played their tambourines, Beatrice and her sisters watched from the upstairs window of their house, wearing the black dresses their mother had sewn for them.

Her family in England was poor. Her father was a saddlemaker, and as a young girl she cleaned houses to supplement the income. When she met the man she was to marry, she waited four years so that they would have enough money to start a home. After they married when she was 28, they left for America and a better life, but used all of their money for ship fare. Her brother who had come to America a year earlier had warned them not to land on Ellis Island, but they couldn't afford not to. They were detained there for six weeks.

"My dear husband had worked four years to save money for the ship. We was in second class. I saw people in first class eating watermelon. I never seen that before. I thought 'twas red cake with currants in it. When we came to Ellis Island, my dear husband had an infection in his eyes and they wouldn't let us leave. I can remember, I'm sorry to say, I am. We was led as prisoners and we was put in a place where they had to take everybody. And they didn't give you much to eat. I was sorry I ever went to that place because 'twas my own fault. My dear brother had said, 'Don't ever go to Ellis Island.' We was sorry we ever went there. We slept in a place where there was no mattresses. And so many people in one room. I remember there was toilets, but they used to let the men come in, and I didn't like that. I wanted to go home. We was so sorry we ever came. 'Twas not England, nothing like it."

Her brother finally heard that they were at Ellis Island and went to rescue them. With her brother's help, her husband was given a job as a caretaker at Forest Park in Chicago. In 1945, they moved to Florida where he worked for a dairy. They lived a modest life through a 60-year, childless marriage.

❧ Beatrice Enright's sister lived in the same room where Beatrice now lives. She died at age 98. She had a brother who lived to 90.

"She lived a good, clean life," says her friend and guardian.

Part of her clean life today includes gelatin on her cereal every morning, a teaspoon of olive oil a day to guard against arthritis, very little meat, and avoidance of ice or frozen foods. She is under medication for high blood pressure. She thinks the medication is keeping her alive, and sometimes feels it is an obstacle to the totally spiritual existence which she anticipates. "I'm happy all the time, because I know where I'm going. It's wonderful, it's wonderful."

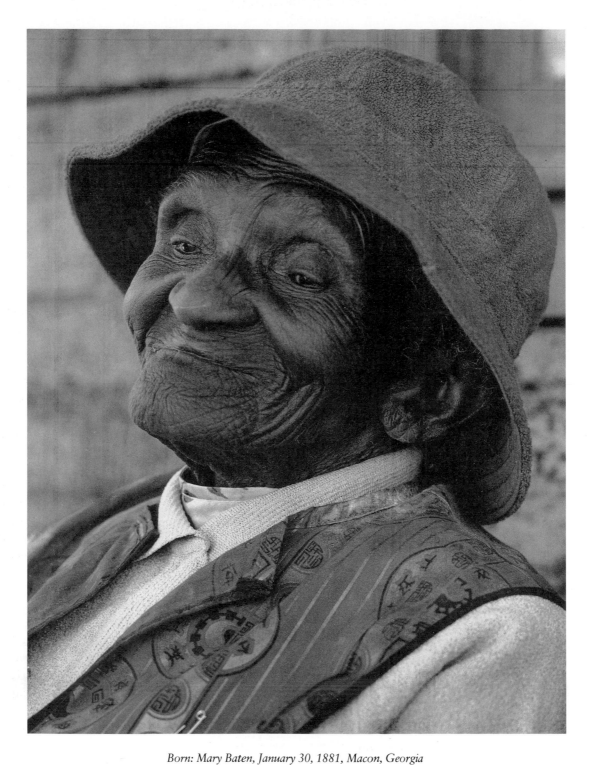

Born: Mary Baten, January 30, 1881, Macon, Georgia
Married: John Burks, 1901; died, 1920 (?)
Robert Dixion, 1921 (?); died, 1927 (?)
John Wallace, 1930 (?) ; died, 1934
Children: (9) Willie, Napolean, Etha Mae, Eunice, Foley, Jimmy, Mable, Benidee, Margaret
Principal occupations: farm worker, cook, caring for children and the sick
Current residence: Vero Beach, Florida

Mary Wallace

I was washing and cooking when I was six years old," says Mary Wallace. "I'd cook the meat. Potatoes. Bread. Greens. Squashes. And I took in ironing. Used a hot steaming iron. I was small, but they had me ironing them clothes. I iron good. I don't like OK work. It looks nice when you do it right."

The Civil War was over, but Mary Wallace's parents continued to live with the people to whom they had been slaves. They were Virginia people, and Mary Wallace still takes pride in the aristocratic association.

"My papa, he was a *Virginia* man!" she says, with heavy emphasis on the "Virginia."

"He was with his old white man when the war was going on. When the war done, the white man say, 'Come on, Ezra, we won't have to come back to the war in the mornin'—it's done gone. So my papa come on with Mr. Rudolph [to Georgia] and he stayed there with him for thirty years."

Mary says her father was treated better because he was a Virginia man, but the aristocratic association evidently did not carry down into Mary Wallace's everyday life. The adult work came early. In a loud, emphatic voice, she continues to enumerate some of her jobs when she was six: "Chop cotton! Hoe cotton! And I had to cook! Because my mother was sick."

Somehow through the working childhood, she learned to read by playing school with the white children. She knew they had been learning to read, and she'd trick them by pointing to words to see if they knew what the words were. When they did, Mary learned them too.

Over the years, she worked in the fields, cooked, and cared for children and the sick. She was a nanny for several children who were to go on into professions such as teaching. Because she was so reliable, she feels she had more advantages than most of the black women she knew.

"Worked in the fields a long time, but they had more confidence in me than they had in any other woman there. I was the neatest woman there, but didn't have no education. Master gave me more responsibility. They had confidence in me. I don't tell stories, and I worked hard. All the time! The white folks had me take care of the kids. They'd go on vacation, and I'd be there to cook for the babies. And when they come back, everything be just like they left it. They didn't have to say, 'Where's my so-and-so?' They'd come on in and everything be just like they left it."

While she worked, Mary raised her own large family. Her favorite memories are of the years when she was helping her third husband on a farm. She had her own "pretty things" then and a nice house.

But he died over 50 years ago, and she has been alone many of the years since then, growing a large garden and tending to her own needs. She lives in a small frame house with tarpaper siding in a neighborhood of drab-colored, inexpensive homes. A few years ago a local newspaper featured her in an article which pointed out the winter hazards in her poorly insulated and poorly heated house.

But today no one is worrying about the weather. Lavender wildflowers cover the sand of her front yard, quarters clink in the bright red Pepsi machine that sits in front of a house down the street, children laugh and play in the sand yards, and Mary Wallace sits on her cement-slab front porch smiling beneath a red hat. The bright colors and sounds stand out against the sand and faded houses. One way or another, everything, including Mary, seems to be blooming.

🍂 Longevity does not run in Mary's family. All of her brothers and sisters died when she was young, and her mother died when she was only a little girl.

"I have nothing to do with this getting old," she says. [She points up.] "He's the One. He decided I was put here for something, and He will take me when the time comes."

While she is talking, children from the neighborhood gather around. She calls the boys "cordwood cutters" and the girls "parlor pets." They bring their friends from school to show off their neighborhood treasure. They stare up at her now, listening and watching. A small crowd has gathered, with no purpose but to admire.

"Wow!" says a new kid. "She's one hundred and six years old!"

Cape Canaveral only 50 miles up the coast couldn't attract more attention at a blast-off than Mary Wallace is getting sitting on her front porch.

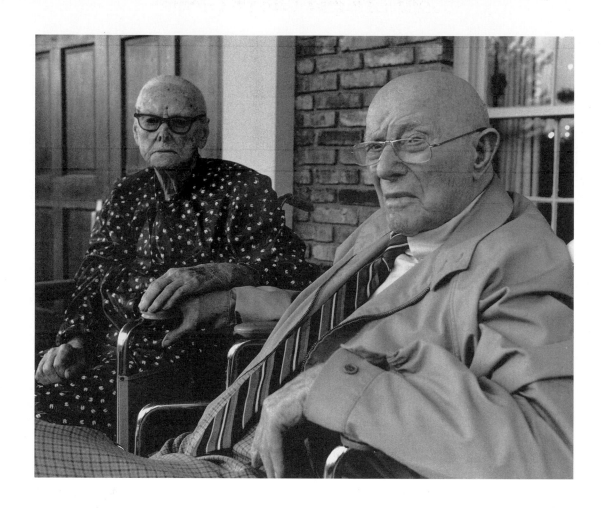

Cora, born: Cora Lee Clark, February 14, 1887, Coosa County, Alabama
Oliver, born: April 24, 1886, Coosa County, Alabama
Married: 1904
Children: (3) William, Mary, Ruth
Principal occupations: Cora, housewife; Oliver, farmer, mercantile trader
Current residence: Elmore, Alabama

Cora Lee and Oliver Glenn

To have and to hold, from this day forward, for better or for worse, for richer or for poorer, in sickness or in health. . . . Oliver and Cora Lee Glenn are the longest-married couple in the country—nearly 84 years.

They live together in a care center in rural Alabama. It is no ordinary nursing-home scene. A narrow road leads past deciduous trees covered with lacy moss, through the entry gate into the wide relief of an immense lawn and a cul-de-sac circling a large pecan tree that shades a carpet of blooming flowers. The low cream-colored building has blue shutters and colonial-style windows. The reception room has leather chairs. And then there is the Great Hall: large upholstered sofas and highback chairs, a grand piano, chandeliers, flowered wallpaper, oriental carpets, tall plants and vases, an open fireplace, ceiling-to-floor draperies, tasteful rural-setting artwork, and properly set tables where residents are served meals. And there is space— the feeling and the reality of space.

Nurses wheel Mr. and Mrs. Glenn from their shared room into the Great Hall. They do not look exhausted from holding the undisputed American title to this marathon dance we call marriage, but in the tidbits of conversation which follow lie little hints of the subtle drama of their life together.

He: "I think I've been the right kind of husband and she's been the right kind of wife."

She: "I always did what I thought he thought was right."

Nurse: "She's still jealous of him. If she sees him talking to another woman, she wheels herself right over there to see what is going on."

He: "She's always treated me nice."

Son-in-law: "There ain't any man ever lived as good as he is."

Daughter: "She's a good woman, but she has a sharp tongue. She's not near as easy to get along with as he is. There's nothing in the world she wouldn't do for others, but she speaks her mind. But I don't think he's ever been mad at anybody."

She: "I've known him since the first grade. I always liked him. His judgment is better than mine, so we got along all right. I respected his views."

Daughter: "They are very religious people. She played Bingo once, and he made her take the money back because he said it was gambling."

She: "We never had no disturbance, no fusses and arguments. He worked and I worked, and I worked and he worked."

Daughter: "They farmed about twenty or twenty-five years until after the Depression when he became a farm agent, then a postmaster, and finally a bookkeeper. They had a general store with groceries and clothes while they were farming. They'd take turns in the store. She could work circles around him in the fields, picking cotton. He likes to take it kind of easy, do the easy jobs."

He: "The nicest thing she ever done for me is marry me. We eloped. Slipped off. Her daddy wasn't satisfied with me."

Daughter: "They were strict parents—order in the proper way. But he never whipped anyone. She did the punishing. That peach tree was naked."

Nurse: "There is a constant caring. They don't reach out much, but she will pat him on his thigh and he'll look over and smile."

Daughter: "Her father had money from the California Gold Rush and wanted her to go to school. He was eighteen and she was seventeen. He slipped away from his home on horse and buggy to fetch her. She sneaked out the window and went to meet him at the wagon shed. But he had been treed by the dog and had crawled up on the shed. She rescued him and they went off to be married by a probate judge. They lived such a quiet life. Out in the country. There really were no temptations like there are today. No parties or anything like that."

She: "We're just common people. We didn't try to be something we wasn't. We tried to be a lady and a gentleman."

Daughter: "She came to the nursing home first. He kept getting worse and worse alone. The doctor said, 'You'd better get him over there too. He's just going to keep getting worse and worse until they're together.'"

Nurse: "They're so cute, always looking out for each other. He has a sweet tooth. She sneaks cookies to him under her apron."

Their children wheel them out onto the veranda with its wrought-iron tables, wicker rocking chairs, and yellow parasols. She reaches over to him and says, "Hey, boy, watcha doin'?" She smiles at their audience and says, "He's still such a handsome man."

The groundskeepers move about in the warm air watering the flowers and grass. The mockingbirds sing from the pecan trees. This would be a good place to grow old. Or to get married.

Bess Foster Smith, born: Bess Foster, June 26, 1887, Sterling, Nebraska
Married: Oliver Smith, 1918; died, 1952
Children: (2) George, Robert
Principal occupations: teacher, artist, poet, housewife
Current residence: Weiser, Idaho

Eva Breshears, born: Eva Hill, August 3, 1887, Fayette, Utah
Married: Arthur Breshears, 1907; died, 1985
Children: none
Principal occupation: foster mother
Current residence: Weiser, Idaho

Bess Foster Smith and Eva Breshears

Eva Breshears and Bess Foster Smith have been friends for over 70 years. Bess is the poet and woman-of-letters, Eva the listener, but both are lovers of words and seem to love each other through them. Eva is the first to speak: "It isn't often that a friendship can end like this, is it?" She reaches out from her wheelchair to take the hand of her longtime friend.

They met here in the small town of Weiser, Idaho, on the Snake River and have been friends ever since. They are still near each other, but now in the nursing home neighborhood of corridors and small rooms. "We have been through thick and thin. Only death can separate us, that's for sure," says Eva.

Eva is the best able to speak, though Bess was the public person: teacher, artist, writer, and a poet who was still publishing in national magazines into her 90s. She attended the University of Nebraska and studied with Louise Pound, sister of renowned poet Ezra Pound. After receiving her B.A. in 1914 and her M.A. in 1917, she moved to Weiser to teach school. When she married, she was forced by the rules of the time to quit teaching. That's when she turned most diligently to her art, painting, and writing everything from "nimble-witted" light verse to five-minute scripts for Canadian radio. She became an editor and generous mentor to many young writers, qualities that gradually brought her into the public eye and into regional esteem.

In contrast to Bess, Eva was the person behind the scene, soft-spoken and private, but always there when others needed her: substitute teacher, on-call pianist at the local school, foster mother to 16 children for varying lengths of time. But her biography is not without public achievements: at age 14 she taught 48 pupils in four grades in the small town of Riverside, Idaho. She was the youngest teacher in Idaho at the time and probably the United States. At 15 she was sworn in as postmaster of Middleton.

Though her friend Bess is the one noted for her use of language, speech comes much more easily to Eva today. The more feeble Bess repeats a word softly while others talk—"help help help" or "yes yes yes"—rhythmically in the background like a dripping fountain. Her friends and relatives say she has not spoken fluently for months. But when talk turns to her poetry, her eyes brighten. And when she hears her own poems read—perhaps for the first time in years—her mind opens, and she breaks from her repetition of single words to recite along with the reading of her poems. In a few moments she is reciting them by herself and reminiscing fluently about her life. It is as if a web in her mind has been broken and she is again free to return to her memory and her life.

About her uncontrollable repeating of words she says, "That happens to poets—the sounds keep coming. Just my mouth repeats words. But my mind thinks. That's the dangerous part."

She turns to her friend Eva, who has been smiling at Bess's breakthrough back into speech. She says, "I admire Eva because she is a great talker. She really is. And I talk the same language. Or try to."

With Bess talking freely again, Eva listens modestly. She may be exactly the kind of person to whom literary people would gravitate. Without trying to compete with professionals, when she does speak she is a natural and inspiring wordsmith herself. Listen to the simple poetry of her speech as she talks about her late husband:

> I vowed I'd never live on a farm, but then
> I met my husband. He was a country boy and
> smelled of alfalfa, really clean and good. I liked
> it, not wickedly but joyously. He was a cattle-
> man and a dreamer. He'd go to water the
> garden and when he came back he had time
> to put a flower in my hair. We had a beautiful
> life together. I think he liked my pies.

Words seem to have been the main avenue for both women's long attraction to each other. Years ago Bess wrote her poetic tribute to Eva and their friendship. She recites:

PROOF

> When you first smiled at me
> I thought it meant
> That you cared for me, just
> a little more;
> But when I saw you greet
> that beggar child,
> And that old crippled man
> who lives next door,
> A neighbor woman whom I thought
> uncouth,
> With just as sweet a smile,
> I needed proof.
> Your smiles, it seemed to me,

Linda, born: Linda Nelson, April 22, 1886, Duncombe, Iowa
Married: Ralph Messersmith, 1907; died, 1957
Children: (6) Reuben, James, Bernice, Virgil, Verne, Harold
Principal occupation: housewife
Current residence: New Hampton, Iowa

Anna, born: Anna Nelson, December 1, 1883, Homer, Iowa
Married: Martin Mickelson, 1904; died, 1915 (?)
Children: (5) Adrian, Morris, Elias, Omer, Mavis
Principal occupation: housewife
Current residence: Mt. Vernon, Illinois

Does that make you feel good?

"Not always."

Do you have any regrets?

In contrast to Linda's optimistic response, Anna says, "Yes, I do. Lots of them." She doesn't explain in detail other than noting that she disliked the bucket the five sisters had in their room instead of a toilet or chamber pot, but then says, "I pretend to forget when I don't want to answer a question."

What does make you happy after 100?

"Not much of anything," says Anna. "Sit and wait for death, you might say."

Linda says, "I'm just so glad of living."

❦ When they tell why they think they lived to be so old, the two sisters once again give similar answers: "I never overeat," says Anna. "I'm careful with starchy foods because when I overeat I'm miserable," says Linda.

Are doctors curious about longevity in your family?

Here the two part company again, giving responses which show the differences in their personalities: "Oh, yes," says Linda, "they find it interesting." Anna says, "No, they let the nurses do all their work."

Frank and Palmina Canovi

After 79 years of marriage, there isn't much romance between these two, but there's something else. Call it trust, understanding, a playful sense of give-and-take, and an ability to let the other person be.

There is also savvy, the good sense to know when to yield center stage and when to step forward. Palmina is the shy one, or so it would seem upon first encounter. She has a happy face, he a determined one. And he is the more declarative, taking center stage first, but this almost seems like a long-practiced act.

"I am a hard-head," he announces. Palmina smiles and lets him carry on. "I never have no school but you tell me it's not really the education, it's the think and the nature of the person. Some person they smart and they good people but in some way they don't have the thinkin' to it."

The thinkin' that Frank has done shows itself in the numerous products of a willful man: sculpted boxwood shrubbery all around the house, fruit trees, and a well-kept garden.

"He pries the weeds out with a stick and beats them to death," says his daughter.

He's constructed a wire-mesh figure in the form of a human, over which a humanoid ivy grows. He points around his backyard to all his recent accomplishments. "I made all this myself—this gate out of pipes—cost you fifty dollars; I made it for five dollars."

Inside the house is more of his work: two strange floor lamps he has constructed—the bottoms out of piano legs, a formica tray, an aluminum pole painted gold and silver, with parts of other lamps and little glass chandeliers on top—hybrid conglomerates that are grotesquely charming.

As Frank starts to tire, Palmina slowly takes the stage. She holds out a tray of pasta.

"The old lady made this," she says and smiles. The smile is frequent and versatile. It can be demure, curious, friendly, quizzical, infectious, and mischievous.

She opens the refrigerator door. "Too bad we don't have no whiskey." This time it's the mischievous smile. What she does have in the refrigerator are jars and jars of spaghetti sauce she has made and frozen, as well as pies, meatballs, applesauce, meat patties, and lasagne.

Frank grants her the stage as she smiles. "She likes to keep everything covered up," he says. "If she don't have anything, she makes the cover herself."

"Because they dry up," she says.

"She says they dry up," he says.

Is that a secret spaghetti sauce?

"It's my family recipe, from scratch: hamburger and onions sauteed as a base, celery, allspice, oregano, sweet basil, cumin, tomatoes—I take the seeds out and chop them up—but the real secret is garlic." She leans over, smiling. "And slo-o-o-o-o-w cooking."

The two have known each other since they were young and worked on the same cooperative farm in Italy. She was a milkmaid and he a farm laborer. They were married in 1910 and he came to America first, hoping to get them out of tenant farming in Italy. He worked on the railroad for 15 cents an hour, then borrowed money to bring her over. Starting in 1924, he built several houses in Seattle, including the one where they now live. It's worth 40 times what it cost him to build it. Over the years he also built or owned three taverns. Palmina never worked in the taverns, but she managed the grocery store.

"He had the business head," says their daughter, "but she had the personality with the customers. Many came back because of her."

Do you think your marriage has been different from others?

"No," says Palmina, "it's just nature. I've got more patience than he's got. If he gets mad for nothing, I say, 'Why you want to get mad like that for?' But we fight once in a while. About nothing. Sometimes he thinks that the house is not clean. But I never believe in divorce—not for myself, but for the kids. If I got a divorce—but there's no sense talking about that now."

"She still loves me just as good as when we got married," he says. "Still like in each other the same thing and put up with the foolish things that we do. There is no secret. Lots of people think something that is not there, this crazy living now. We worked together all the time."

"He's nice to me now," she says. "If I don't feel good, he helps me. Two or three times a night if I don't feel good, then he gets up and gets me a glass of water. He still does that. That's right. I do the same thing for him."

The two have their little idiosyncrasies. She gets up first, between 7:00 and 8:00 A.M. for an hour of housework. He rises later, about 9:00 or 10:00 A.M. and begins the day by washing his head with soap and water. Whether by coincidence or response, he has begun to grow hair back on his once-bald head.

"I never use any of that shampoo stuff," he says.

Frank, born: October 1, 1887, Casino, Reggio Emilia, Italy
Palmina, born: Palmina Bonacini, November 24, 1889, Rahnga Reggio, Emilia, Italy
Married: October 10, 1910
Children: (3) Ida, Audrey, Alma
Principal occupations: Frank, grocery and tavern owner/manager
Palmina, homemaker, grocery store manager/clerk
Current residence: Seattle, Washington

"Me neither," says Palmina. "No perfumes. None of that. Just soap is all we ever use."

Frank goes for daily walks in the alley behind the house—with a stray cat that has befriended him over time. Palmina cooks him a big breakfast, which includes 14 eggs a week.

If Frank has been the hard-head in the marriage, today he has softened into a clear admirer of his wife. He points to a picture of her on the wall. "Look at this nice old lady," he says.

The two of them kiss for the camera. "That doesn't happen very often," says Palmina and laughs.

What does often bring them together is Pinochle. Palmina lights up at the very mention of the word.

"Oh, we play!" she says. "He against me and me against him. And we fight like cats and dogs. He bids too much. Sometimes he don't have nothing and he just bids. That makes me mad sometimes."

"She don't trust me," he jokes. "She never lies except when she plays Pinochle."

"Oh, I never lie at Pinochle."

"They both cheat like the dickens," says their daughter.

Any regrets?

They both have the same regret: they wish they had more education. "I blame the United States," he says, "for not making sure the common people got education." He had only a second-grade education in Italy.

"I wish I could have gone to school more," she says. "I would talk better. And know better." She had only six months education.

❦ "We never went through old age," says Frank. "We forgot." Frank has had a pacemaker since age 97. He unbuttons his shirt and moves it around under the skin of his chest. "Can't tell it's there," he says. "They check it every three months." Before his heart problems, he had not seen a doctor in over 30 years.

There is no remarkable evidence of longevity in either of their families.

"We're so old because we haven't died yet," says Palmina.

It may be longevity through good humor: a saying on their wall reads, "Old Italians never die, they just pasta away."

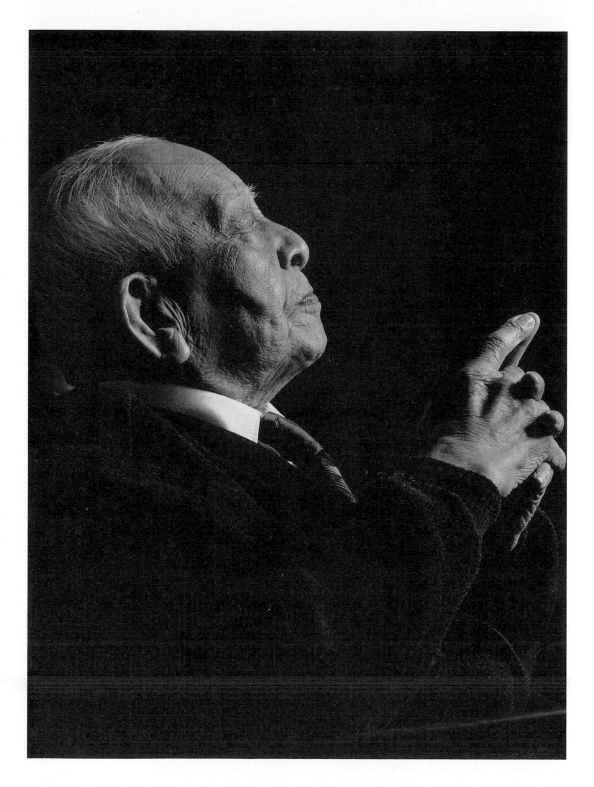

Born: December 24, 1886, Hiroshima, Japan
Married: Ichiko Fujiwara, 1910; died, 1958
Children: (5) Arthur, George, Hatsue, Mary, Hannah
Principal occupation: produce broker
Current residence: Chicago, Illinois

Frank Kenichi Morimitsu

For people over 50, it's one of those dates that makes them always remember where they were and what they were doing: December 7, 1941. For Japanese–Americans, Pearl Harbor meant more than war, it meant internment.

Frank Morimitsu does not talk about Pearl Harbor or the internment that followed, but his children do: the curfews, the recruitment to bring in Japanese things that might be used to assist the enemy—radios, cameras, swords—then the rumors, and finally the billboard announcements to gather in specified places. This was the prelude to internment.

But weren't you able to set up your own communities in the camps?

"If you call being in an area one mile square, 10,000 people living in army camp barracks with walls, cracks two inches wide, so that whenever there was a dust storm you couldn't even see one side of the room to the other. . . . There were really no rooms, just a long barrack and blankets to designate one family from the other, beds were cloth mattresses stuffed with straw, and our heat in sub-zero weather was a small coal-burning stove. We had no family life. We all ate in the mess hall. And there weren't any stalls in the toilets, just latrines, with sentries and guns facing us all the time, pointing inward, not pointing outward to protect us as some people claimed—all this bull about protecting us from other people. . . . If you want to call that a community . . ."

Frank Morimitsu does not join his children in talking about the internment years. He'd rather talk about baseball. "I was a good batter, and I was a good pitcher—curves, drops, and all of that." His memories go back to the late 1800s, when his father was recruited from Japan to work the cane fields of Hawaii. He was 11 and was placed in a boarding school, which essentially meant being orphaned. He studied English and learned how to play baseball. But he also sold gum, candy, and newspapers on trains in Honolulu, so that at age 17 he could pay his own way to San Francisco.

He lived through the San Francisco earthquake, left to pick strawberries, then returned to go back to school, working as a houseboy for an Irish family at the same time. This gave him money, but it also gave him one day a week off and the chance to indulge in his favorite pastime. "Every Saturday we would go to Golden Gate Park and play baseball."

After his arranged marriage to a "picture bride" from Japan, he worked on a Sacramento farm, taking the produce to market. He became a produce broker, started his own company with "Mori's Special" printed on the cartons, and eventually opened the "Star" restaurant in Sacramento, a place that served mostly railroad workers. His sons laugh when they remember the restaurant: "It was the kind of place I wouldn't go into today."

He was on his way to becoming the classic self-made man when the internment camp took him. He still does not talk about the experience, but, again, his children do.

"He's always been a mild, gentle man, never a worrier, and I think he enjoyed the camp. He was a VIP. He was in charge of the mess halls and was one of the very few who had a car. You saw his cigar before you saw him. He really wasn't bothered until Art [his son] volunteered for Army Pacific Intelligence. Then friends stopped talking to him. They couldn't understand anybody helping a government that was doing this to us. His younger son George had already been a pre-war draftee."

Frank Morimitsu never was able to return to the restaurant and vegetable business. He left the internment camp for Chicago, where a church had set up a hostel for placing interned Japanese in jobs. He was hired as a salad chef, then as a shipping clerk for a publishing firm, a job he held until retirement.

He has been blind for over seven years, but is still a mild, gentle man and the star of the family show. His white poodle loves him, follows him to bed, and sleeps with him. Though no longer a baseball player, he's still an avid fan. His poodle sits on his lap while he listens to baseball games with earphones. The two of them are Cubs fans.

❦ Frank Morimitsu has been careful about what he eats—he's been a big tofu eater most of his life—but he thinks his religious faith also contributed to his longevity. He converted to Christianity in 1946, and after his wife's death he became a "tape evangelist," taping the Japanese sermons of ministers in Chicago and traveling around—especially to Japan and Hawaii—holding home services with the tapes. "That was the best job I done," he says. "That's why I lived so long. "

Born: Alice Maud Owen, April 18, 1886, Steventon, England
Married: Charles Valour Thomas, 1916; died, 1968
Children: (3) Owen, Muriel, Maudie
Principal occupations: maid, housewife
Current residence: Plant City, Florida

Alice Maud Thomas

I used to sew so much, and read. But I can't read now. So I sit and think. Some things are coming back that I thought I had forgotten. I go back to my childhood, naturally."

And it is almost in a child's voice that she recalls her childhood. The place of those memories is England, the world of the large estates in which wealthy owners not only had their own servants, but their own horsemen, gardeners, postmen, and carpenters. "They owned everything," she says. "They even owned the churches."

Alice's family was not among the rich. She was the child of a dairyman who worked on one of those estates. They lived near Oxford and passively witnessed the lives of the rich. Among them were students at Oxford who, she says, "were no better than us. After they had their monthly allowance, they just went wild. The police went around with horse and cart, and when these boys were drunk, two policemen would pick these boys up by the shoulders and heels and dump them in the cart, putting one on top of the other. And that was a well-kept secret because these people had rich families. I suppose the next day there was a hand-out. But they were a wild, tough lot sometimes, no better than an average working man."

When Alice was 13, she left home to work at Haddington, a large estate. "I was the cook's assistant. I got up early in the morning and was down in the kitchen, washing dishes. I had no life at all. I used to go to bed and cry my eyes out, I was so miserable."

She is remembering the late 1890s.

In the following years, she advanced to the role of housemaid in other estates. "I never knew what people call fun. You went to church. Maybe take a walk in the afternoon. On Sundays we always had to wear all black to church. Black gloves. Black bonnet. The owners of the estates and their children were fashion plates. I remember the countess used to wear this big ostrich feather in her hat that came halfway down her back. It was ridiculous, but we didn't laugh. They had their own pew, and we had to sit in our section of the church.

"At the estate we always had to get up early. Get them up, make the bed, clean the room. And you minded your own business. Never try to associate with someone you shouldn't. If you did what you were supposed to and minded your own business,

you got along. But, really, you felt like you were in a prison."

Then she sighs. The habits of propriety and graciousness which those years must have cultivated come through as she quietly says, "But it was so beautiful. Something out of this world to live there, it was so beautiful."

Part of the beauty was the gardens. From the window of her floor, she could look out and see the gardeners working. One of those men was to become her husband.

"The only time we could be near each other was in church. And then we couldn't really talk. But there are ways," she giggles. "Slipping notes. Letters."

He went to America first. "I waited six years for him," she says. He paid her boat fare over, and they were married a few days later. She was 31. They lived on Long Island, near where her husband had his horticultural job on the east island estate of J. P. Morgan. "It was a hard, good life," she says. "Once we lived on a can of Campbell's beans for a whole week."

In spite of the frugal life, her husband dreamed of creating a blue rose. "He would put them in the cellar. But not even the Japanese with all their flowers have been able to produce a blue rose. So strange, there are so many different flowers with so many different colors, but no blue rose. Every rose has its own perfume, but none of them is blue."

Alice moved in with her son's family in Amsterdam, New York, in 1967, and moved to Florida in 1974. The nursing home where she now lives is in a quiet setting, one evidently conducive to her present life of reminiscing about life in England. Of course, most of those large English estates that she is remembering today have long since been broken up and turned into mere tourist attractions. Perhaps nowhere do they continue to exist in their old, ambiguous glory as clearly as they do in the precise memory of Alice Thomas, a 19th-century housemaid. "I kept things neat and tidy," she says.

❧ "I don't know how I got this old."

"It's her curiosity," says her daughter-in-law. "She's always been interested in everything. If she saw a flower along the road, she would have to stop and look at it."

Born: July 8, 1887, Perry County, Missouri
Never married
Principal occupation: nurse
Current residence: South Dennis, Massachusetts

Martha A. Boxdorfer

An early illness led Martha Boxdorfer into nursing. She was 18 and had gone with her sister to St. Louis to work in a clothing factory. She came down with appendicitis and spent two weeks in a hospital.

"That's when I decided to become a nurse. I just felt sorry for sick people."

"Boxy," as her friends called her, was born on a large farm south of St. Louis, Missouri, one of 10 children. "Growing up, we didn't have much reading material," she recalls, "but any little catalogue I could find I'd sit up all night with a coal-oil lamp and read it. I ruined my eyes."

She graduated from Christian Hospital in St. Louis in 1914, after working for three dollars a week while she was going to school. She then did private duty around St. Louis for nearly 20 years. She had to join a registry and be "on call" for whoever needed her. To get work in a hospital in those days required that the nurse live in the hospital and that is what she finally did.

"I had no home," she says, "so it made no difference to me. Being a nurse really separated me from my family."

Were you a loner?

"Yes, I think so."

But she stuck with her career—working as a nurse until she was 80, then doing relief work for a few more years as a head nurse. In 1942 she went to Pasadena and worked at Lavina Hospital, where she became a supervisor before retiring. In all, her nursing career covered 60 years. For the past two years, she has been living in a retirement community on Cape Cod with a longtime friend who was also a nurse.

Was nursing a nerve-racking job back then?

"No, we took care of patients. There's no comparison with nursing nowadays. They kept the patients in the hospital until they got well back then. Nurses today have too much book work. Back then, I felt like I was really doing things for patients. And relationships with doctors were good, much better than they are today."

"She was a fantastic nurse," says her friend. "One of these impossibly neat people. She never had a wrinkle in her uniform."

A deck of cards lies on a table in the living area of their home. After lunch they play "spite-and-malice," usually with four decks. Boxy still goes out and cares for their flowers. Much of her time she spends playing word-scramble games or reading large-print books.

What makes it all worthwhile today?

"You don't feel much different than you did all your life, only you can't do what you want to. I have trouble walking. I forget a lot. I have to think a few minutes before it comes back to me. Some people took advantage of me and there are some things I don't want to remember. But I enjoyed life. I liked this world. I thought it was a pretty good old world. But you'd be surprised how young people treat you, what they say when they pass you by. They're sassy. They don't care about sassing you at all. One person was so rude to me when I wouldn't move over from the aisle seat on the plane—a seat I paid for! People do not respect old people. In my late years I've gotten kind of bitter."

❦ Martha Boxdorfer is the only survivor of 10 siblings, though one of her older sisters lived to 100. She doesn't like soft drinks, but has an occasional cigarette and a glass of wine. She has not been sick often but had a bleeding ulcer in recent years.

"I led a good clean life," she says. "A busy and active life is what I think kept me here."

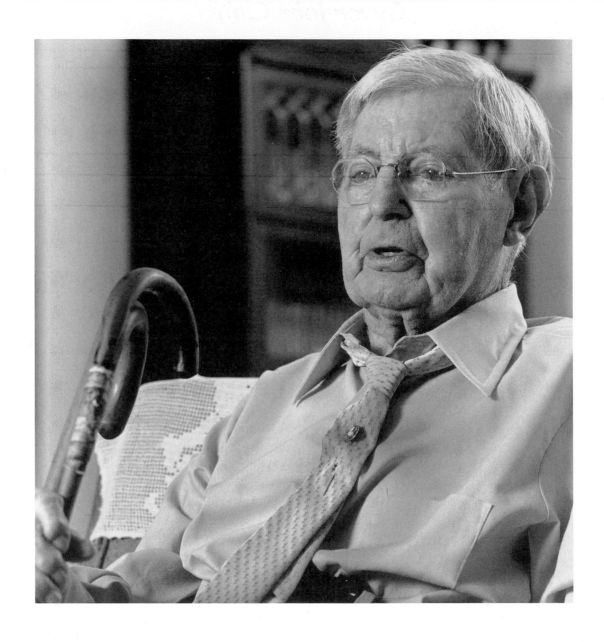

Born: December 11, 1885, Howard, New York
Married: Laura E. Waterman, 1917; died, 1934
Mary E. Jahnig, 1937; died, 1969
Children: none
Current address: St. Petersburg, Florida

Guyon John Carter

Forty-six of Guyon John Carter's 54 years in education were as a district superintendent in rural New York. He was an extraordinarily popular educational leader during one of the most difficult transitional periods in American education: centralization.

"Centralization in rural schools had to be handled very carefully—dealing with growing controls of the State Department of Education," he says.

Being a strategic, egalitarian, and cautious leader is often not a reliable way to gain praise from a public constituency or, for that matter, to assure oneself a prominent place in history. Though his work may have been unglamorous, decades of newspaper accounts show that he was not unnoticed or unappreciated: a 1926 news heading reads, "Popular Superintendent of Schools Reappointed." A few phrases spring from the page: "reappointed on a wave of wide public expression"; "careful judgement and untiring efforts"; "capable administration and pleasing personality has won him almost 100 percent cooperation on the part of his trustees and teachers."

A little deeper in the stack of clippings is another news item, this one dated 1936, 10 years later. The laudations are strikingly similar: "unanimous approval reappointed G. J. Carter"; "tireless worker"; "sound judgment and spirit of cooperation." He was credited for "a high standard of excellence, probably not to be excelled by any similar district in the state."

"I was quite broad-minded in my supervision," he says. "I never attempted things I thought would be poorly received. I felt I was there to serve the people, and always let them know they had something to contribute. I never discharged a teacher. I had a pleasant time with principals and teachers. I paid attention to the people I served. And I never asked for anything but what I got it. I just tried to be regular in everything I did and back it up with good judgment."

It's interesting that the approach in many leadership training programs today has moved from the aggressive and manipulative tactics once associated with big business to the more cooperative notion that the best leader follows the needs of those whom he leads. Guyon John Carter's approach could be seen as a model for contemporary leadership.

"Schools is all I know," he says, with little exaggeration. Shortly after graduating from high school in 1901 at age 16, he earned his teaching certificate and, for the next four years, taught in rural schools. In 1906 he enrolled at Alfred University, graduating with honors in 1910. Today, he is its oldest graduate. He taught chemistry at Keuka College and went on to Columbia University where he received his M.A. in 1924. He did post-graduate work at New York University in the 1930s and traveled widely in Europe and Quebec as part of the work. He retired as superintendent at age 70.

He is proud of his French heritage—his name was originally Chartier—and some of his ancestors came to America with Lafayette. He is from a family of teachers and, if there is a family motto, it is "Service to Others."

"Just do your job that you're supposed to do conscientiously and the best you can," he says. "I have no regrets about anything."

❦ Today he employs an older woman to live with him—his companion, housekeeper, and admirer. Tall and robust, she cares for the smaller and less physically able Mr. Carter with her own kind of dedicated service.

"I've had a lovely home with Mr. Carter and made it nice for him for eight years. I promised him I'd never leave him," she says. She supplements his foods with raw juices and vitamin A for his eyesight. She says his honesty and devotion to his work are the reasons for his longevity.

"She is half the district supervision," he jokes. "He has made heaven wait," she says. Directing his attention to the camera, she says, "Smile, Mr. Carter, smile."

"I'd sure miss it if I left here," he says. "I'd miss all the personnel."

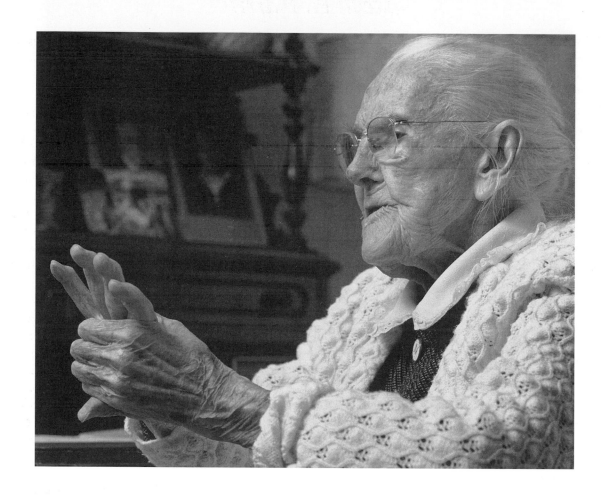

Born: December 13, 1883, near Fairbury, Nebraska
Never married
Principal occupation: college chemistry teacher
Current residence: Manhattan, Kansas

Stella H. Harriss

Quite by accident, Stella Harriss became a chemistry professor. As a young woman, she was studying home economics at Kansas State University (then the School of Agriculture) and planning to teach in high school, but World War I broke out, and many of the men in the chemistry department left to work in munitions plants. The head of the chemistry department asked Stella if she would help out and teach a few chemistry classes. Like the swimmer who doesn't know how many strokes she is capable of until she is thrown into strange waters, Stella plunged in—and stayed afloat for 36 years teaching chemistry.

When the war was over, many of the men did not return to the university to teach. By this time, Stella knew that she was suited to a career in chemistry, so she went to the University of Chicago to build her credentials. But again, as circumstances would have it, her plans were altered, this time by a fire at Kansas State that destroyed the laboratory that contained her work on her Ph.D. dissertation.

"I was separating isomers and was getting results when the building burned down. I began on it again, but my teaching work was so great that I could not do both."

As a result she never did finish her doctorate and was never able to rise to the position of a full professor in the department. But rank did not affect her reputation as a teacher.

What she lacked in credentials, she made up for in dedication and thoroughness. She established and sustained a reputation for being an extraordinarily committed teacher who was always willing to give her time to students who had difficulty. She would have them come over to her own home to work if they needed that kind of attention.

Her life in education actually began when she was five. She started early so that there would be the required six students to open a school. She began teaching at 15 while she was attending high school, and she received her high school diploma while she was teaching. She went on to college to become a full-time elementary school teacher in Nebraska before going back to college to study home economics.

"Teaching is all I ever could do," she says. "I've never been rated for beauty, but that hasn't seemed to make a difference."

Today she lives in a nursing home in which some of the patients wear electronic warning devices to keep them from wandering off. If they pass through an outside door, they sound an alarm like the ones used in some libraries and stores to guard against shoplifting. Stella Harriss is not one these "high-security" risks. Even though she is confined to a wheelchair, her scientific, exact mind is still with her. She speaks very deliberately, letting each word rest separately in the air before she goes on. She resists talking about subjective attitudes or feelings but is pleased to recall specific details, such as the homesteading requirements which her parents faced when they moved from Nebraska to Kansas when Stella was a small child—"If they could pay down five hundred dollars, they would get a deed at the end of five years. But if they couldn't raise five hundred dollars, they had to live there seven years."

One of the pictures on her wall today is of her mother taking a loaf of bread out of the oven of an old cookstove. "In all her life, my mother never bought more than a half dozen loaves of bread. I always liked to cook," she says, "so I had decided that I would teach food." But Stella never did teach home economics except for one summer while she was visiting her sister in Texas.

❦ "I was never a child who craved sweets. It would take very little sweets to satisfy me, but I suppose I was an average eater. I have lost all my teeth and it's hard to swallow, and eating is a hard job. So food is not important to me now.

"How did I get so old? I don't think I know. I picked my ancestors carefully."

Born: May 30, 1886, Evanston, Illinois
Married: Eva Lyle, September 19, 1917; died, April 21, 1978
Children: (2) Clarence, Evelyn
Principal occupation: painting contractor
Current residence: Gresham, Oregon

Albert W. Holmgren

A cigar, a highball, and women," says Al Holmgren. "That's my secret." Actually, he gave up cigars a year ago, but he still has an occasional highball. And women? He has had "a girlfriend" for the past seven years. Twice within an hour his telephone rings just once. It is his girlfriend's secret signal that she'd like him to call when he is free. They see each other occasionally, but he's a little bit embarrassed by the relationship because she is only about 70.

"We're just flirting," he says.

His relationship with the woman who is in the room with him is more than a flirtation. She is his granddaughter, and several years ago she saved his life. She says, "I woke up from a deep sleep feeling a deep anxiety and knowing that something was wrong—and a magnetic feeling to go and help my grandfather, like a voice, saying, 'Honey, I need you. Come and help me.'"

She drove to the house where he lived alone. He was feeling weak, so she rushed him to the hospital emergency room where doctors found that his heart was failing. In 20 minutes, he would have been dead. Later, they realized that they both had awakened at the same time the morning of his illness.

"She saved my life," he says, and shows the round protrusion, in the shape of a tobacco can, on his chest where the pacemaker now rests.

Today the two seem to be on the same wavelength. Often they start talking at the same time about the same subject. "There has always been strong ESP between us," she says. He agrees, though he says he has never been aware of when it is happening.

"I needed him," says his granddaughter. "I kept squeezing his hand when I felt him leaving me on the way to the hospital. He has changed my life."

She feels he has given her the strength and determination to start a new life as her children have grown. She is now a schoolteacher. To him the exchange is mutual: she saved his life; he gives her the guidance she looks for.

Al Holmgren was a painting contractor throughout his entire working life, with some time out to try homesteading. After his mother died when he was a young man, he followed his father in his painting profession from Illinois to Seattle and British Columbia and, in 1909, to Portland, Oregon. He has worked hard, traveled widely, and enjoyed a family cabin in the mountains. His life looks balanced and full.

Today he has his own room in a large retirement complex. "I like it here," he says. "I like visiting with the other residents. And I like to play cards, especially poker." He spends much of the day reading and socializing and still works several hours a week in the complex's gift store. In the remaining time, he is writing his autobiography, even though he has had only a seventh-grade education.

He doesn't talk much about the powerful relationship he has with his granddaughter, that mysterious affection and understanding that has arced across a generation. Even as they smile to each other when his girlfriend's telephone call interrupts their conversation, little needs to be said.

❦ Al Holmgren is a large man. "I used to be six feet, two and a half inches; I'm only six feet now. And I weighed two hundred and forty-five pounds most of my life."

Did your feet shrink too?

"No, they're still size thirteen."

Longevity does not run in the family and he has not been particular about his eating, but he has never been a worrier.

"He is always relaxed," says his granddaughter.

"And I think that has to do with the journal I keep," he says. "Every day I write down what has happened."

He has been doing this for 64 years, and he sees it as his way of keeping things in perspective—simply to record the events and his observations of the day has kept him relaxed.

His granddaughter continues to smile as he talks, finding no reason to suggest how much she continues to be a part of his longevity story.

Born: Mary Amelia Smith, September 24, 1887, Warrenton, Virginia
Married: Clarence David White, 1908; died, 1914
Children: (2) Richard, Nancy
Principal occupation: civil service
Current residence: Gulfport, Mississippi

Mary Amelia White

Mary White has strong opinions about almost everything and likes to express them in crisp aphorisms, many of her own making. Here is a sample:

- "Happiness is having something to do and something to love."
- "If your parents are strict, you'll be dependable later."
- "We learn by seeing and hearing, so look and listen."
- "The future is important. You should always prepare."
- "Faith in the Creator and eternity will bring the greatest happiness into any life."
- "Pray for wisdom, humility, and understanding. If we don't have these, we don't have anything."
- "I'm like Will Rogers who said, 'I don't belong to any political party, I'm a Democrat.'"
- "All people have to be prosperous, not just a few."
- "I'd rather play than study."
- "If nuts get the head of government, it's not so good."
- "When the smoke clears, there's nothing like sound judgment."
- "If there's any place that will teach you to work, it's a farm."
- "I don't know why anyone would ever want to wear whiskers."
- "When you know the truth religiously, you can lay your hand on everything that's wrong."
- "'The letter killeth, the spirit setteth free'—and that's what's wrong today: everybody has the letter and not the spirit."

She lives in the U.S. Naval Home in Gulfport, Mississippi, an elaborate naval retirement facility. The main building is an 11-story structure complete with a 500-person capacity, spacious waiting rooms, a bowling alley, library, theater, and cocktail lounge. It is located across the road from the sandy beaches of the Gulf of Mexico and is equipped with security gates, an Olympic-size swimming pool, and 20 acres of perfectly kept landscaped grounds. The average age here is 76 and fewer than 5 percent of the residents are women.

Mary White sits on one of the long benches in the large reception area reading newspapers with her magnifying glass. Behind her is one of several model sailing ships constructed by residents in the home. Next to her is her wheelchair, its seat covered with her personal belongings; it is her purse-on-wheels. She uses it like a walker or stroller. She is wearing a blue-and-red dress and has a pink ribbon in her hair, but in this spacious setting, she is no more conspicuous than a bouquet of flowers on a windowsill.

"Like Joseph, I'm dressed in a garment of many colors," says Mary White.

Mary White did not earn her place into this facility with a long military career. She grew up on a farm in Virginia, and when her husband died young, she had to go to work. She happened to be holding a civil service position in Washington, D.C., when World War I broke out.

"President Wilson asked us to resign our government jobs and join some branch of the service. I chose the Navy yard because it was where I lived. I joined the Navy on August 15, 1918." In less than one year she was discharged at the rank of yeoman, second class. But in that year she cared for the sick and contracted the devastating influenza that killed so many people at the time.

"I can hardly tell you how I felt. For days I couldn't tell where I was. They treated me with baking soda, but I couldn't even keep that down. Now it seems so long ago, it seems like a dream."

After her short navy career, she worked for the General Accounting Office in Washington, D.C., for 25 years. Before moving to Gulfport, she lived in Arizona for several years and, before that, in St. Petersburg, Florida. Today she reads large-print books from the library and writes letters. People in the facility respect her: they know she has strong opinions and that she has a way with words.

❦ "The truth of the matter is I haven't been well for years. I'm not strong. I've had arthritis bad all over me and I've been running away from snowbanks my whole life. I don't have endurance. But I worked hard all those years and I took care of my health. I had to. I ate right and I didn't drink or smoke.

"But, really, I don't know why people always talk about age. I don't care about age. I don't think it's important. People should think about experience and memory."

Born: Juliet Zuzak, November 21, 1886, Vidalia, Louisiana
Married: Sidney Marx Rothschild, 1906; died, 1958
Children: (3) Vivian, Martin, Juliet
Principal occupation: Christian Science practitioner
Current residence: Laguna Beach, California

Juliet Rothschild

Juliet Rothschild has been a Christian Science practitioner for over 50 years and, at 101, still supplements her Social Security check with her practice.

"I had boils all over my body. They came in clusters. The doctors would lance them and they'd come back. My sister had sent me literature on Christian Science, so I started reading Mary Baker Eddy. When I gave up my personal will and let God take care of it, I was healed."

Today she lives in a modest apartment in Laguna Beach. In a world of sunbathers, gourmet delicatessens, and car-grooming salons lives one woman who puts much more stock in the spiritual than the physical.

"I'm always ready to be a practitioner," she says. "I don't feel myself at all, because I always feel it's God's power. The practitioners who rely on God's power have the best results."

There is no doubt that Juliet lives her faith. Yesterday she fell and knocked over a plant that was sitting on a small table. When she tried to get up, she couldn't. "Then I said, 'Father, help me!' and I got up." Dirt from the spilled plant is still sprinkled on the floor, but Juliet clearly isn't.

"She doesn't recognize pain," says her granddaughter. "She denies it exists. At times of physical or emotional stress, she enters a trancelike state and endures. When her husband died, she showed the same control. She drew herself into a deep spiritual state and did not grieve."

Today she spends much of her time listening to Christian Science records and praying for people. She tries to take a daily walk and to watch her diet by having three vegetable-rich meals a day. Christian Science books and magazines lie around the room. She watches some television and, for years, was a regular viewer of "MacNeil–Lehrer News Hour" but watches it less often now "because they've been having so much medical on it."

Born in Louisiana and reared in Mississippi, Juliet was a precocious child who was offered scholarships to both Sophie Newcomb Women's College and the University of Mississippi. But her father believed women should get married, not go to college, and he didn't allow her to go to either school. This did not keep her from reading, and at one time she was the only member of a literary group who did not have a college education. It was through studying and reading that she decided to become a Christian Scientist.

After marrying and having three children, she moved to Los Angeles, where her husband lost money in a bad investment. Juliet went to work for Warner Brothers as a seamstress, the first job she had ever had. She worked at different studios sewing for movies and eventually became a "draper." The costume designer would bring pictures and she would copy them to fit models. In 1929, while still working at the studios, she took classes to become a practitioner. She later opened her own office in downtown Los Angeles and had a busy practice. In 1958, her husband died and she moved to Laguna Beach. She has traveled widely but lives now in her own apartment. Another older woman, whom she refers to as her "girl," comes by late every afternoon and prepares dinner, crochets afghans with her, stays overnight, and leaves after breakfast the next morning.

Juliet's grandson refers to her as "Lady Astor." There is an aristocratic charm in her southern accent and authoritative manner. When she recalls her life in the South, she says, "I had wonderful servants in my home—they milked the cows, fed the chickens, did the garden, and all kinds of things. We respected each other, but we felt we were the mistresses and they were the servants. We loved them, but we didn't feel they were equal."

How do you feel about that today?

"I still have that feeling."

How do you feel about that feeling?

"Well, I feel I should overcome that," she says. "Because everybody's equal. God knows everybody. Christian Scientists—they love everyone. Yes, that's one thing I should overcome."

❦ Juliet Rothschild's first rule is "no medicines." But she did have cataract surgery a few years ago. Before that, doctors had not applied their science to her in over 70 years.

"The best thing about her is that she uplifts everyone who comes near her," says Juliet Rothschild's granddaughter, who is not a Christian Scientist. "Something about her makes people feel everything is going to be all right. She always sees room for hope."

Juliet talks about a Christian Science lecture she plans to attend tonight, and she is slightly disturbed that her fingernails have not been polished. Others in the room smile an understanding smile. Perhaps even the most spiritual of people need a little red polish in Laguna Beach.

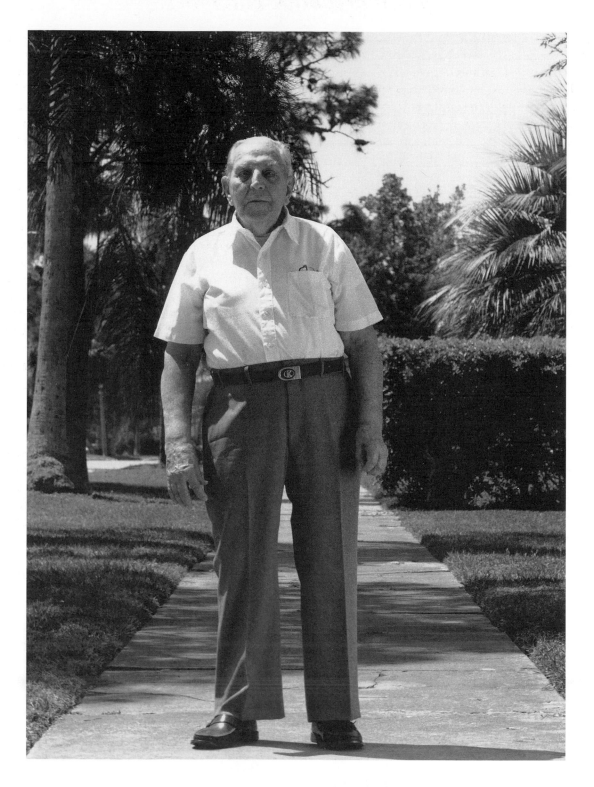

Born: November 1, 1885, Brooklyn, New York
Married: Freida Bernius, 1910; died, 1962
Children: (3) Dorothy, Evelyn, Donald
Principal occupation: tool and die maker
Current residence: Belleair, Florida

Jacob Frederick Kirchmer

My very first job was working for a pharmacist in Brooklyn. I was a 'boy' in the drugstore and I ran errands and kept the place clean. I was about fourteen or fifteen. On Saturday nights, I got to squirt perfume on the girls. They had to pay five cents a squirt, but it depended where they wanted it. Those were my best days."

After that, what were your good days?

"Work."

"He never did anything but work," his daughter says.

Even as a boy?

"Well, I would take walks by myself on Long Island. We lived on the outskirts of Brooklyn, on the edge of the woods on Long Island. And there were mostly vegetable farms there. When the farmers planted, some of the seed went flying through the air and landed along the roads and grew there. I wouldn't take a thing with me except a pocketknife because I could eat vegetables out of the ditches. I was the only one who would go out like that. I'd even eat raw potatoes, but mostly beets and carrots. In the woods there was always water bubbling out of the ground, so I'd wash them off and peel them with my pocketknife. I ate more raw vegetables. . . .

"Then I read a notice in the paper—young boys wanted to learn a trade—so I went there and they hired me. Bommer Brothers. They made special hinges for doors and all kinds of hardware for doors. When I got some experience, I was a tool and die maker. Lots of accidents on this job, little pieces of fingers cut off. You had to keep your mind on the job."

Didn't you visit while you worked?

"No. Just during lunch."

Why did you work so hard?

"I enjoyed it. I had nothing to worry about. I knew what I was doing and what I expected and I generally got it. I worked at different places in my life, but I always enjoyed it. If something needed to be done, I would do it."

What did you talk about during lunch?

"Girls."

Girls again, eh? What about at home after you were married and had a family? Did you work hard there too?

"I worked in the garden. And we had three or four acres of oak for firewood. Sometimes I'd be up at three in the morning cutting wood, then off to work. We canned vegetables and stored potatoes in the basement. We canned beans. We kept carrots in a cool place all winter. Cabbage too. Every few weeks, I'd have to take the outer leaf off. One leaf a week. We grew everything. We didn't buy anything in the store. We had chickens too. I'd take a few dozen eggs to work for the boys. I tell you it was hard work."

But what did you do for pleasure?

"I made my own tractor out of an old car. I took the whole thing apart. Then I bought two big iron wheels. I made axles and took the frame of the car and cut a piece out and shortened it. I put pieces of heavy iron on each side of the frame and riveted them together. I put big pieces of angle iron on the wheels to give them traction. I had to cut the three-eighths-inch-thick angle iron up with a hand saw. I took the whole body off. I plowed the fields with it. The neighbors all came by to see this thing. It worked, that's all I can say. I gave it away to a boy when I was through with it. It's probably still running."

What did you do after retirement?

"I couldn't stop working, I know that."

Today Jacob Kirchmer lives with his single son. Until he was nearly 100, he baked all his own bread and made his own soup. He is in good health and goes to the local "Neighborly Center" every day. He doesn't work much these days, but his image of himself is not as a man of leisure.

"Nobody worked the way I did."

"But I think he's still interested in a neighbor lady," his daughter says.

❦ *How did you get so old?*

"Don't get sick."

But how did you manage not to get sick?

"Work."

Born: May 4, 1885, Gundestrup, Denmark
Never married
Principal occupation: nurse
Current residence: Council Bluffs, Iowa

Johanna Pedersen

People ask me, 'Were you married?' I say, 'Yes, I was married to my work.'"

Why did you go into nursing?

"To help other people to get well, that's why we go into nursing. I guess I am old-fashioned. I feel that if you are married the first obligation comes to your home, and then I wouldn't have been able to do justice to both home and nursing. I just felt nursing was my profession and that's where I should put all of my energy."

Johanna Pedersen was a private duty nurse in Council Bluffs for over 50 years, retiring at age 84. "It's a long time when you look forward, but when you look back it's not so long."

She was born and raised in Denmark, receiving her nursing degree from the Deaconess Hospital in Copenhagen in 1909. She had a sister who was a nurse and a brother who was a doctor. "It runs in the family," she says, and speaks forcefully in her Danish accent about her commitment to the profession of nursing. *Duty* is a key word to her.

She came to America in 1914 and spent her first year in college in Des Moines. By 1918 she was with the Edmunson Hospital in Council Bluffs. With other nurses she volunteered to help at Camp Dodge to care for military boys who were stricken by the devastating influenza. Hers is a story familiar to centenarian nurses: "We had a ward of fifty people and every twenty-four hours, eight of them died. They got pneumonia and their lungs filled up. They couldn't breathe. All the doctors knew was to give them whiskey, because with pneumonia, on the seventh and eleventh days, the temperature will drop from one hundred eight to ninety-six, and if they didn't have a stimulant the patient would die. But it wouldn't work for that flu. It was a different bug, and I don't think they ever found out what it was."

After the war she returned to Council Bluffs for her long career as a private nurse. "One time I had tickets to the Mardi Gras, and then a call came that I had a case. OK. Duty comes first. I went to the patient. A doctor said, 'I think of you as the captain of a ship. You stay until it sinks.' He meant I would stay with a patient until the last.

"My parents were wonderful. I'm a Lutheran. But, you see, in Denmark we had a bishop who started a school two hundred years ago for young people, called The Folk School. This bishop had such influence over young people that they became better citizens. My parents went to his school and they wanted to

help people, and I wanted to help people. And I still have that in my blood. Although sometimes it's hard for me to keep my mouth shut here in the nursing home. I don't want them to say, 'Oh, that old cranky woman.'"

The tradition of the Danish Folk School lives in Johanna Pedersen. Although she resists her loss of independence in the nursing home, she is still trying to help people.

"I go down and sit with this lady. For two years she hasn't been able to talk or answer anything. She's been in here ten years. I think that's the hardening of the arteries in the brain. I just sit there and talk to her about her family and things like that. It's just a one-way talk. I know she hears me. She knows my voice. The nurses say that it helps when I go in and talk to her. I feel maybe I'm a little bit useful yet."

Has adjustment to the nursing home been hard?

"Oh, the first day I came here, the nurse said, 'It's time to go to bed so I can get the railing up.' I said, 'I'm not going to bed yet.' She said, 'You think you're pretty independent.' I said, 'Yes, and I'm going to keep it that way.' But I'm not independent anymore. They tell you when to get up in the morning. They tell you you have to go to this and you'd better go. We have some young nurses here who tell me to mind my own business. I just let it go in one ear and out the other."

A close friend of Johanna Pedersen says: "I've known her since I was a little girl, and adjustment has been really hard for her. It really hurts."

❦ "The first one hundred years are the easiest, then after that it's not so easy. None of us in my family has been as old as I am. My sister died in July. She would have been one hundred in August. My brothers died younger. I never smoked, but I had to be careful about what I ate because I had an ulcer. I got lots of exercise in Denmark, where we all went to what we called gymnastics. In Denmark young people get together and go to those exercises once or twice a week."

Do you think the nursing profession is a good profession for achieving old age?

"Absolutely. Work never kills anyone. Some of the girls say, 'How do you do it?' And I say, 'Hard work. And like your work.'"

Is that your secret?

"You bet it is."

Born: Laura Louise Phillips, February 5, 1887, Marble, Madison County, Arkansas
Married: Elmer Bowman, 1904; divorced, 1925
Roy House, 1929; died, 1966
Children: (7) Alice, Alta, Mervin (twin died at birth), June, Bill (twin Claude died shortly after birth)
Principal occupation: owner/ manager of rooming house
Current residence: Boise, Idaho

Louise House

Louise House shows us that you don't have to have a sweet attitude toward everything to stay alive. You don't even have to have sweet memories.

She arrived in a small town in Idaho in the early 1890s to the sounds of coyotes. For Louise, it was a bad start. "We thought they was wild Indians," she says, "and we was scared."

She married young, at 17, into what turned out to be a bad marriage. Her husband was a rancher and cowhand, and with him she homesteaded on top of a mountain. She was hard-working, a crack shot with a rifle, who could pick grouse out of pine trees and take off the head of a rattler. In 1921, they moved to Cascade where she ran a rooming house for sawmill workers and lumberjacks. First she rented it, then she bought it. Her memories of the place are not pleasant:

"It was like a pigpen when I got it—walls dirty, old bones under the table. They didn't have no toilet. They went in the slop cans. They was full. Oh, it was a mess. I started out with two sheets and an army blanket. All I could furnish was one bed. I rented that for seventy-five cents. Then I could buy another pair of sheets. We had roaches. We didn't have bedbugs until later when we got a mattress from a neighbor. It had bedbugs and we got that. They was hard to get rid of. Spray them. Turn the mattress over and clean the seams out. You know, bedbugs would eat you up. It was a hard life, but that's how I got started. But I'd rather do that than sit here."

Her husband was a jealous man who accused her of sleeping with the lumberjacks who boarded there. "There wasn't nothin' on earth he didn't accuse me of," she says.

The marriage ended in a bitter divorce, but she continued running the rooming house until 1946 when she moved to Boise with her second husband. After his death, she lived alone until she was 95. Today she lives in an adult foster home with several other elderly people.

So what do you do today?

"Nothin'. Just sit here. Nothing to do. At night I think about those little cabins up in the Cascades. I'd like to have one of them and be able to make my own toast and my own coffee. [Almost crying]: I fell one time—I fell several times, but this one time I couldn't get up. And they called Bill [her son]. When he saw me lying there, I guess he thought I was dead,

and I knew that was the end of me living alone. But I didn't know I was heading for a nursing home. I thought a nursing home was the last thing on earth. But I did. And I think about that song, 'Over the hills to the poor house.' I'll be glad when my time is done here. So that's the way it was. I don't wish anybody to live in a nursing home."

Why not?

"I'm the only one that's got her marbles. And sometimes I wonder if I got mine. But all the rest of 'em—some of 'em are just as crazy as nuts. They're pitiful, but then I am too. I stay in my room a whole lot. There's a fellow in there broke his hip. I noticed the other day he was talking to himself, and I don't know who he thinks he's waving to. And I got a roommate who's up and down sometimes all night walking around. And they have to change her two or three times a night. [In tears]: I'd like to have a room of my own."

Hey, you know any good jokes?

Her mood changes immediately. "I know several," she says. "They're pretty bad. But here's one. You know, there was a really old lady, and she went to the priest and confessed that she'd committed adultery. And he said, 'You don't mean at your age!' She said, 'Well, no, it was a long time ago, but I still like to think about it.'"

All those years homesteading and running the rooming house, what did you do for fun?

"I don't know. I had four kids. It was fun feeding them. If I had any time, I'd clap. I didn't think about anything."

Do you have any regrets?

"I wouldn't have had so many husbands. I wouldn't have had any of them. All I got from them is my family. It's a hell of a life, isn't it?"

❦ Thirty-five years ago Louise had cancer in a gland under her ear. Surgery and radiation treatments followed. Doctors expected the cancer to return, but it didn't.

Some years later a doctor told her, "You'll live to be one hundred."

She said, "Who'd want to?"

She has one nightgown that she is saving "for my big day"—to be buried in. Her attitude is not optimistic. Her memories are not sweet, but, as her daughter-in-law says, "She's got a lot of fire in her. She's really tough."

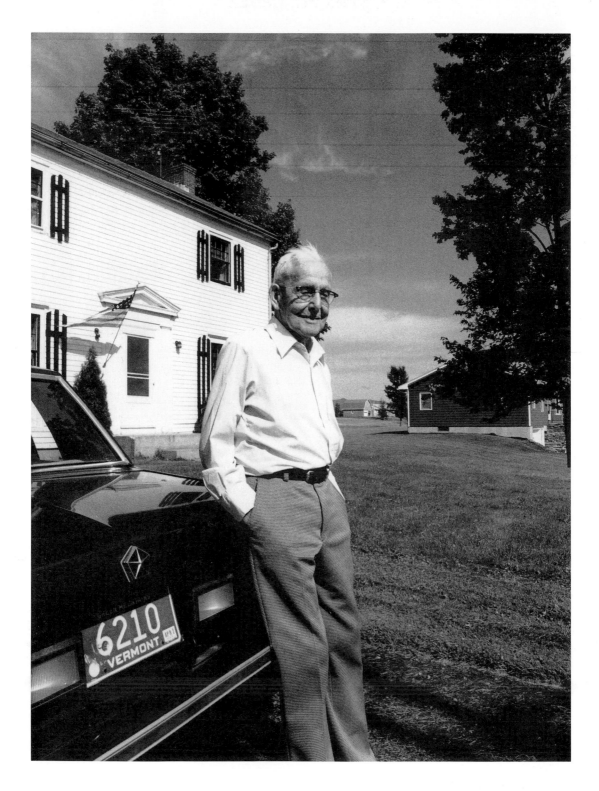

Born: June 15, 1886, Essex, Vermont
Married: Maude R. Clark, 1913; died, 1977
Children: (3) Robert R., Reba L., Donald C.
Principal occupations: farmer, custodian
Current residence: Fairfax, Vermont

Cyrus A. Leach

Cyrus Leach is a shy and gentle man. He does not look or act like someone who is harboring an obsession, but he is.

What's the most important thing in your life today, Mr. Leach?

"Driving my car."

You haven't ridden in a car until you've ridden with a driver who is 101. Everyone buckles up except Mr. Leach.

"I never wear my seat belt. Hope I never have to."

He eases his 1983 Dodge out of his driveway and down the hill into the downtown traffic of Fairfax. No one stares or makes special allowances the way they might if a student driver were approaching. Everything seems normal.

"I like to get out and drive. Always have. Started driving when I was fourteen. I've driven a good many thousand miles."

He waits for a break in the heavy stream of oncoming cars and trucks and goes for the first opening he sees, off the main road and onto a narrow and winding blacktop, past cornfields and picturesque country homes. He's a day-cruiser, and most of the rural drivers who come up behind him at higher speeds seem to recognize him as the cruising type and fall back from their tailgating positions to wait for a safe stretch to pass him.

It's a warm New England day. The clover and Queen Anne's lace bloom in picture-postcard opulence. The cattle laze against the rolling hills, as if posing to confirm viewers' assumptions of a New England pastoral paradise. Mr. Leach says the corn looks nice and that it surely is a lovely day for a drive. Only once does he draw a honk from another motorist—and that for slicing a corner a little thin and crossing a few inches into the lane of an oncoming car.

Ever had any close calls?

"No." He chuckles. "I can drive my car just as well as I ever did. I feel safe on the road. I'm a good driver, I know that. Never had any accidents."

In over eighty years of driving?

"That's right."

Except for a few years of city life in Boston, he has lived his whole life in Vermont, farming near Fairfax for many years, then moving to town where he worked as a part-time carpenter and then, for 15 years, as a school janitor. His father owned one of the first cars in the area—an EMF-30—and for years

Cyrus was the only family member who drove it.

"I've always liked cars," he says. "I'm kind of a natural mechanic. I take good care of my car."

Today he lives in a large, white house that he built with the help of his son-in-law about 40 years ago. He lives alone. The house is tidy and surrounded by a well-kept lawn and garden.

What do you do when you're not driving your car?

"Well, I'm not a talker, I'm a listener. I work in my garden a little. I sprinkle powder on bugs if I find any. I watch TV news. I can't do much but sit around. I sit and watch the cars go by."

How would you feel if you couldn't drive your car anymore?

"I don't know. I don't think I'd want to stay around anymore."

❦ "Both he and his wife were quiet, mild people," says his daughter. "They were married sixty-four years and never fought."

How could anyone possibly have a stormy relationship in the middle of these soft hills?

"Yes, I think that's part of it," says his daughter. "Never in my whole life have I seen him lose his temper."

"I just tell people to live right," says Cyrus. "That's all I've been doing. Just live good, do things right. And be careful."

Postscript:

Several months after visiting with Cyrus Leach, we learn that he died from an apparent heart attack while driving his car. No other vehicles were involved. Paul and I are saddened, of course, but then I am reminded of an old Oriental proverb that goes something like this: "May the tailor die with the thread between his teeth." Yes. May we all be doing what we most love to do until our last breath.

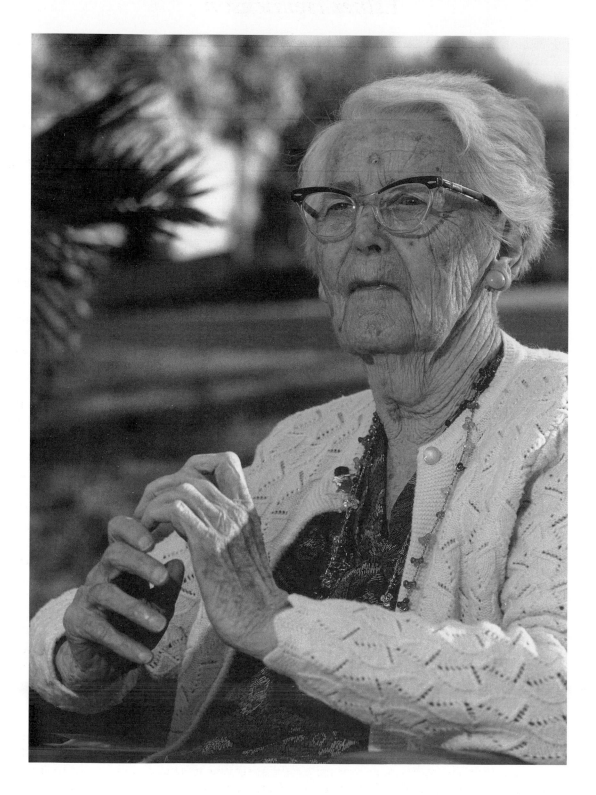

Born: June 16, 1886; Cresco, Iowa
Never married
Children: none
Principal occupation: home nurse
Current residence: Chula Vista, California

Esther Henrickson

If Esther Henrickson had carried a business card, it might have read, "Have Altruism, Will Travel."

"I was what they called a Chautauqua nurse," she says. "I'd go to a home and stay there. Somebody would say, 'We're expecting a baby next week,' and I'd go there, stay a day, stay a week, stay ten days—whatever they needed. I never married. I was always taking care of other people's kids and other people's families, so I didn't have time to raise one of my own."

Her modest career of serving others started in the Midwest. "I grew up in the farm country of Iowa and couldn't go to a hospital for training. So I took a correspondence course and studied for a year before I went out to help families who needed help."

She traveled from household to household, often in response to the birth of a baby, working for room and board. Later when she moved west, she continued this work, but also traveled to Mexico one day a week to help Mexican women learn how to sew. When her parents died, they left their house to her.

"But I'm not a business woman," says Esther, "so I gave the house to the church." The church, in turn, has provided her with a small income from the interest.

Today Esther lives in a church convalescent center in Chula Vista, California. It's a balmy spring day a few miles north of the Mexican border as her grandniece wheels her down from her room to a large pond. Fronds of young palm trees brush the air near the lawn table at the side of the pond. A mallard duck swims through the lily pads which bloom in colors of yellow, rose, and pink. A tiny green turtle basks on a log in the pond, and a little waterfall trickles into the pond. In the distance stand rows of queenly old palm trees. Esther has dressed in a pink sweater and looks as serene as the setting. She tells about her life of soft pastels, calmly, with calm gestures. What she has to tell is a life of decades of simple services for thousands of people.

She has brought with her a box that contains samples of the stocking dolls she has made over the years, gifts for children through Project Concern of the Methodist Church. "I kept a few," she says, holding up a black doll which she obviously admires. "I can't give away all my children." They are a folk-art design, made, she says, "through trial and error." She uses six stockings. The body is a double braid, six strands, and the legs are a single braid, three strands. She sews on bits of cloth for the facial features and makes the clothing from old scraps of fabric. None of the materials cost her any money. During her 30 years at the convalescent center, she has also made colorful bibs, which she has given to the hospital.

Has any of this kindness to others been coming back to you?

"I think so," she says. "I guess people have appreciated what I did."

"She has always been," her grandniece suggests, "a rock to all who have been near her."

"I don't feel anyone has used me," says Esther.

In what did she find happiness? She answers the question several ways, always pointing to her work. "I never made any money, but I had a good time doing it and I helped a lot of people."

Her grandniece suggests that those years of caring for others have had a way of being their own rewards. Some of those rewards are direct: she's never had the worries of paying for rent or board, of paying long-term debts, or of losing her money, since she's never had or needed much.

If Esther seemed unhappy or unfulfilled, it would be easy to say that she traded the good life for a life of deprivation. But her smile and wit are not deprived and there's something in her attitude that has been contagious in her family: her grandniece says that many of her younger relatives are following her example and living lives of service.

One of Esther's sisters lived to 94 and, at the time of the visit, her brother was alive at 102. Longevity clearly runs in the family.

"I weigh one hundred forty pounds. I'm just a fat old lady. My brother [at 102] is skinny. He weighs only one hundred ten."

Do you and he talk about your age?

"My brother said, 'You've got to live to be a hundred, Sis. I'll stick it out until after you've had your hundredth birthday, but you've got to do that.' "

An agreement between siblings may be as close as Esther Henrickson will come to making any claims for her secret for longevity. "Well, I had a good start—lived on a farm, had pretty good food. And I lived a clean life. No smoking or drinking and never ate between meals. And," she adds, "I've always kept busy caring for others."

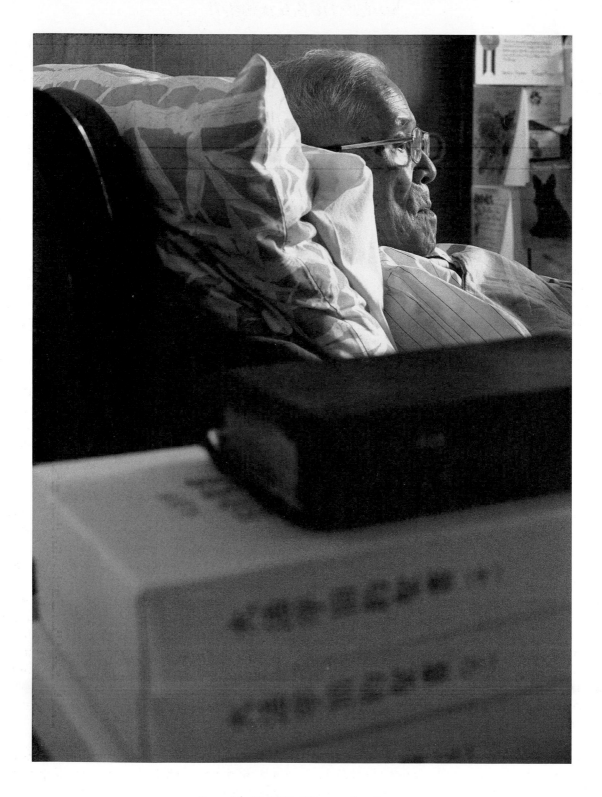

Born: July 23, 1886, Okayama Ken, Japan
Married: Kiyoka Yamada, 1909; died, 1938
Children: (11) Chiaki, Mika, Ikue, Kenji, Yasushi, Dan, Ken, Emiko, Renko, Noboru, Yukie
Principal occupation: minister
Current residence: Long Grove, Illinois

Sadaichi Kuzuhara

Each time the camera flashes, the Reverend Kuzuhara turns toward the photographer and says, "Thank you."

"That's a Japanese characteristic," says his son. "Always thankful. You don't want to be a bother. There's that Japanese saying, 'Don't stick out like the head of a nail.' Pound the nail down so you don't stick out."

The Reverend Kuzuhara lives with his daughter in a coach house attached to his son and his family's spacious home in the country outside Chicago. They are among the 17,000 Japanese–Americans living in the greater Chicago area today.

"I haven't been speaking in English," he says. "It's hard for me to speak in English now. I am so sorry for you that I am so forgetful about my life's history."

"In his late, fragile years he's always apologizing," says his son, who is a psychology professor. "Always afraid he is not giving as much as he receives. He truly suffers over being a burden to others."

The Reverend Kuzuhara lies in his bed surrounded by shelves of books, most of them theological texts. He became a minister in the Chicago area in 1943, when he founded what is now Lakeside Christian Church. His family followed him from the internment camp in Colorado.

"He's more Japanese than American," says his daughter. [The symbolic pattern on a wooden door in the apartment combines a cross and an oriental crest.] He loves America—he would do nothing to harm it—but he never wanted to give up his Japanese citizenship. On his hundredth birthday, Prime Minister Nakasone of Japan honored him here and sent him a silver wine container and a scroll."

He was born the son of a farmer in the mountainous country of southern Japan and went to agricultural college. But, as he says, "I didn't want to learn about farming. I liked better being a student." Later, he studied English in Tokyo and converted from Buddhism to Christianity. He graduated from the Bible School of the Oriental Missionary Society. In 1920 he, with his wife and five children (there would be 11 ultimately), came to Seattle. He studied at Asbury College in Kentucky and, while there, was called to help start a church in Los Angeles. He later founded 10 other churches.

When World War II came, he and his family were interned in a Colorado camp. "Ach, camp," he says and makes no further comment on the subject.

"*Isseis* [Japanese immigrants, as compared with *Niseis,* American-born children of Japanese parents] have a way of denying things, but they get away with it," says his son. "But Dad had stature as a minister in camp. People needed him. And it was a very pretty camp. Many of the people were Isseis, and they had labored so hard on the outside that camp was a relief. They were able to show others how to grow things in the desert."

"I didn't see the guards very much," says his daughter. "We got along in camp. We made our own modular furniture that folded and slid apart. Many people were gardening, and I enjoyed myself. Sometimes I feel bitter today. My sister was teaching in a Japanese school, so the FBI arrested her and put her in jail. There were the Japanese battalions who lost so many men to save the Texas battalion. . . . And then you come out and people think the Japanese are inferior. Why should we always have to be proving ourselves? I get angry now."

"I am a happy man," says Reverend Kuzuhara. "Wherever I go, the Lord has guided me. I didn't know how I was going. I didn't know where. It was always a good place . . . to do my work. Sometimes I have not a happy feeling. I can't go to the outside world. I can't be part of that now. I would like to go out and see."

"He still wishes he could be doing," says his son. "There is that Japanese thing about work. It has almost a spiritual connotation. So when you no longer have work, you're lost. But he is getting in touch with his inner self. He is beginning to meditate. A year ago last Christmas he got his sons together and asked their forgiveness for not being a better father all those years he had been so busy with his work. When I went through the country with him when I was younger, people would always tell me what a wonderful, warm man he was. I didn't know that side of him. In his very old age I am starting to see him as others saw him."

❧ "Why did I live so old? I don't know. God? I don't know why. I wholly believe I am going back to the Lord's place."

Do you have any fear?

"No. [He laughs.] I don't think I have. Where I am now is very quiet and peaceful. My soul is at peace."

Born: Pearl Gable, June 22, 1886, Cleveland, Ohio
Married: Charles Rombach, 1907; died, 1957
Children: (1) Severin
Principal occupations: housewife, artist
Current residence: Melbourne, Florida

Pearl Rombach

I sold two paintings today!" Pearl Rombach's living room is an art gallery of her and her friends' paintings. Some of them, like the many china plates, date to the early 1900s.

"I'm busy as a cat on a slate roof," she says. Her appointment calendar shows notations on most days for the next month. Once a week, she goes to an art class. Once a week, she plays bridge. She has a 39-year-old boyfriend who goes to breakfast with her on Sunday mornings and who brings her gifts.

"People probably talk about us, but we don't care."

She also has a woman friend who encourages her to wear make-up and take care of her health, and who admires her paintings.

On her recent work, she has been putting a "100" in a circle near her name. A watercolor she has just completed shows two thin, snaglike trees standing in the foreground. Greens, pinks, and white space pull the viewer's eye through the trees into an illusion of depth in the background. It is a striking painting. She knows her craft well.

"Most watercolor painters use too much paint. They're afraid to use water. You have to have some of it transparent to make it glow. Leaving some white helps too."

Her interest in art goes back to her childhood in Sequatchie, Tennessee. "I was brought up just like a wild animal in the woods. I was free as a woodland creature. When it got too hot we went down to the cave on the hillside. I can still remember the insides of the caves. Those days in Tennessee probably gave me my keen eyes and my visual memory."

But she supplemented her natural talent with art school, first Pryor Institute in Tennessee when she was 16, and with many teachers since then. When she married, she drifted away from her art for 20 years to help her husband in his jewelry business. Her only life's regret is leaving her art for so long.

Today little of the artist has been lost in her, not even her rich childhood memories. "I have fantastic visual dreams," she says. "I remember my dreams of those underground stones in Tennessee. And my paintings lately often come so easily. Just like I was writing a letter to somebody."

Painting and health are Pearl Rombach's main concerns. When it comes to health, a close woman friend is in the center of the picture.

"The thing that's strongest between us is our being health nuts. We are."

For nearly 35 years, they have been friends and have supported each other in their health care. They feel that doctors don't really concern themselves with nutrition for the aging. "I can't find a doctor to tell me how to eat properly for my digestion," says Pearl. "One prescription a doctor gave me depleted the potassium and caused severe nerve damage and circulation problems in my legs."

"So we read books on nutrition together," says Pearl's friend. Among others, Adelle Davis is one of their authorities. A well-worn copy of Biehler's *Food Is Your Best Medicine* lies conspicuously in the room.

"Our spirits are younger than our bodies. Really, it's not so much ourselves as our era we're fighting. We're stifled. We fight to keep our health and don't really feel the doctors are truly with us in our battle for health."

❦ "I've lived long because I was so mean," says Pearl. "I know what I want, I plan everything, and I go after it."

Pearl Rombach lives "health," partly because she has not always had a healthy life. As a child, she was overweight, pressing the scale to 155 pounds when she was 15. Today she has pernicious anemia and lost 40 pounds because of poor digestion. She has had surgery for both breast and colon cancer. But still she feels well enough to live a very active life.

"She's in such good health today because of diet," says her friend.

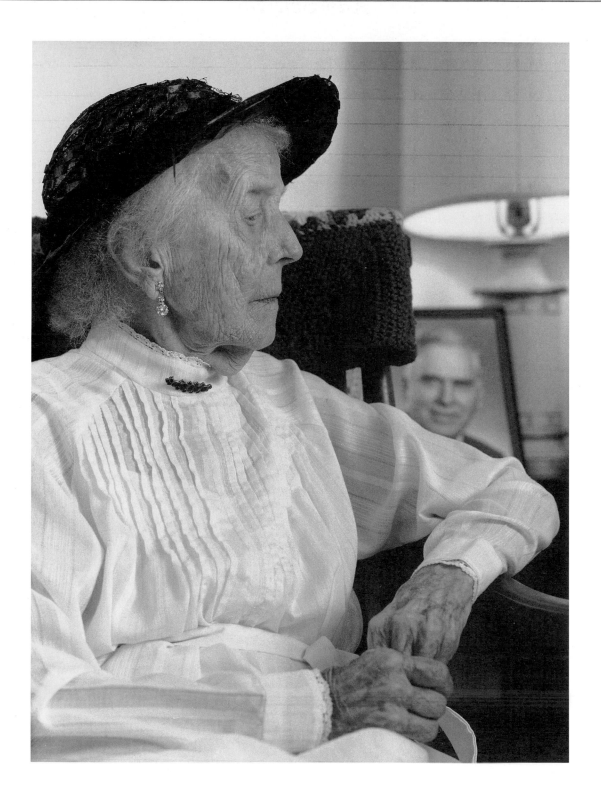

Born: Ann Haugan, May 5, 1887, Murray County, Minnesota
Married: James O. Berdahl, 1926; died, 1979
Children: none
Principal occupations: nurse, teacher, administrator
Current residence: Sioux Falls, South Dakota

Ann Berdahl

Ann Berdahl is a nurse with laurels. She tried to model her life on Florence Nightingale, who is regarded as the greatest woman of nursing history, and was evidently successful. Here is a quotation from one of the many published tributes to her:

"The Crimean War had Florence Nightingale—the Civil War had Clara Barton—World War I had Ann Haugan—and South Dakota has Ann Haugan Berdahl."

"I suppose she [Nightingale] was the biggest inspiration of my life," says Ann.

Today she lives in a nursing home, receiving the kind of treatment which for years she tried to give others.

"I'm just a pampered old lady," she says. "They go beyond the line of duty caring for me."

But, in fact, Ann is still working, teaching others to accept the aging process gracefully, consoling them to the adjustments of life in a nursing home. She has a copy of *When Love Gets Tough*, a guide for people thinking about nursing homes.

"She doesn't intimidate other nurses," says one staff member. "She is an inspiration."

"Adjustment hasn't been easy for me either," she says, "but having worked in the profession, I knew what to expect. Now I love it here. Life is still interesting anyway, even if I am old."

At 100 Ann Berdahl might well be resting on her laurels. She has numerous awards and plaques testifying to her significant contributions to the profession, including the Nurse of the Year Award from the American Red Cross in 1959, a building at Sioux Valley Hospital in Sioux Falls that is named in her honor, and the declaration by the mayor of Sioux Falls of Ann Berdahl Day.

Looking back over her life, Ann recalls that her mother, who died when Ann was young, was an early inspiration along with Florence Nightingale. She would take Ann with her when she went off to volunteer nursing care to typhoid patients. Ann says her early education was weak, but she was a precocious student. She taught for a few years before deciding on nursing and did not receive her nursing diploma until she was 30. But after serving in the Army Nursing Corps during World War I, she was given a fellowship to Columbia in 1919. After that, she served as a head nurse, a nursing instructor, a superintendent of nurses, and educational director at Sioux Valley School of Nursing in Sioux Falls, the place where she spent the most working years.

Although memories of her teaching years are her favorite ones, some of the most vivid are of her years immediately after receiving her diploma, when she cared for soldiers who were struck with the devastating influenza at Jefferson Barracks in St. Louis. This was the terrible flu (sometimes called Spanish influenza) that struck during World War I and that so many centenarians talk about.

"The flu would come on suddenly, often starting like a cold, then a very high temperature, and painful breathing," she recalls. "It often settled as pneumonia. But it acted differently in different people. When they died, it was usually from complications. Pneumonia. But they died quickly. It didn't last very many days. My worst job, really, was telling parents and hearing so many of them say, 'Why did you let my boy die?'"

No doubt Ann remembered that it was Florence Nightingale who helped change army hospital death rates from 40 percent to 2 percent. Later she would write a pageant honoring Florence Nightingale, entitled "The Saga of Nursing." The pageant with its cast of 60 characters was presented by her nursing students and traces the history of nursing from the Biblical apostolic deaconess Phoebe through World War I nurses. At the end, Florence Nightingale gets enthroned.

Besides her full career as a nurse and teacher, Ann has long made a hobby of flower arranging, writing, and bird-watching, which she still practices from her nursing-home window.

Looking back over all those years, do you have any regrets?

"Oh, I sometimes regret that I didn't have more time for housework."

❦ "How did I get so old? One word: moderation. I never smoked or drank. I eat everything that civilized people eat. My father and mother did not live to be old: he died at sixty-five and she at thirty-three."

Do you think your life of service to others gave you extra years of life?

"Yes."

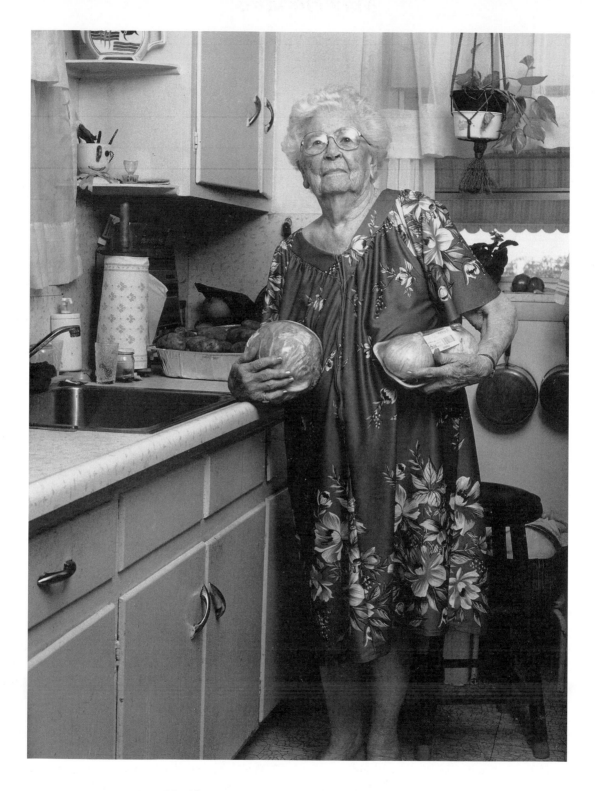

Born: May Flint, May 3, 1887, Clapham of Surrey County, England
Married: Stocton Horner Hopkins, 1908; died, 1941
Children: (4) Stockton, Myhill, Dorothy, Beryl
Principal occupations: homemaker, dressmaker
Current residence: Miami, Florida

May Hopkins

I've been living here alone, minding my own business. Nobody bothers me. I bother no one. Then when I'm one hundred, all of a sudden I'm the Belle of the Ball."

She maneuvers out of her small kitchen with the aluminum walker she calls her "go-mobile" and makes her way to her easy chair in the glassed-in lean-to of her house.

May lives in the house she and her husband moved into 47 years ago from New Jersey, where he had managed a drugstore. He died the next year. She has managed alone ever since. Neither May nor her simple surroundings show any signs of need. Grace and dignity touch every surface: lawn chairs cushioned with pillows are tastefully covered to become living room furniture, well-watered plants sit on sills and hang from the ceiling to fill her space with an air of opulence. Within arm's reach of her easy chair in one direction is a TV set; in other directions, equally reachable, are a light, a radio, her crocheting bag, and a Mr. Coffee machine, over which hangs one of the plants. Next to the Mr. Coffee machine and among the many plants sit jugs of water. Everything looks in place, and May looks like the epitome of independence in old age.

Even her speech carries a quiet confidence that all is well. Imagine the voice of a dignified Eve Arden, not the voice of "Our Miss Brooks" at her most strident, but a reflective, soft-spoken Eve Arden. She speaks with dignity, but also with the freedom to veer off into humor and laughter: "Someone decided to manicure my fingernails for me. Look at this—iridescent. I look like a call girl!

"I keep house here and live alone—and I have to make a path through it. A girl comes two hours a week to clean, but that doesn't take care of the house. And I have to eat besides. I put my soup in a thermos so that I can carry it on my 'go-mobile.' Once a week I fill the water jugs and carry them over near the plants so watering will be easier. This house isn't beautiful, but it's home, and it's mine.

"On a typical day, I get up, wash, clean my teeth, make my bed. I always have the same breakfast— two slices of toast, a glass of juice and coffee. I watch the "Today Show" from 7:00 to 9:00. Then I do what I have to do around the house. I do a lot of crocheting—shawls and afghans.

"I don't understand old people who say they are bored. When I'm finished with my work, I sit and think. I take one year at a time and go through it. Think of that: I have one hundred years of memories to entertain me! I remember little things, like my daughter—she had a speech impediment. When she was two, someone called her 'crooked tongue' and my daughter said, 'You tan dough do hell.'

"I never paid into Social Security and my husband only paid into it two years. My income is two hundred forty-six dollars a month and a supplementary one hundred fourteen dollars. My mother used to have different envelopes for different expenses, and I do that—seven dollars a month for the amplifier on the phone; seventy-five dollars every two weeks for water, garbage, and sewer; fifteen dollars to have the grass cut; two dollars a week for church—like that. I used to eat on one dollar a day; now it's twenty dollars a week. Then my mother used to keep one envelope marked, 'Do not use, so help me God.' That was for the unexpected expenses. But it's good that old people at least have an income.

"Oh, sometimes it's hard. You imagine yourself when you were forty, fifty, sixty—all those years—and then you look at yourself and think, 'God, do I look like that?' When I look in the mirror and see this white hair, this old face, it's hard to take.

"And on Sunday mornings, it's hard to get up. The pillow pulls. Some people say I should go to church, but I'm an Episcopalian, so I don't have to go to church unless I want to."

❦ "I really don't know how I got so old. I gave up men and cigarettes—which hasn't been hard since I've been a widow almost forty-seven years and I never smoked.

"Really, I don't know. When I came to this country, my mother went into nurse's training and put me in a boarding school on Long Island. It was just a play life and I didn't know anything about the world. When I got out of school, I had never seen a boy. I had never seen a horse. I had never seen a train. But it was just a happy life. Maybe that gave me a good start.

"After that, well, my body just never contracted diseases. I worked hard, but I'm a terrible worrywart. I'll lie awake at night worrying about anything, like planning a party. I eat what I want to, but I prefer fish. I hate turnips. I like whiskey sours. I just don't know."

Born: Amy Rymill, September 3, 1888, Homer, Nebraska
Married: William Hogan, 1907; died, 1969
Children: (2) Everett, Mary Drew
Principal occupations: teacher, homesteader, homemaker
Current residence: Denver, Colorado

Amy Hogan

"My vocal cords are worn out from scolding," says Amy Hogan. If her voice is getting a little weak, she's making up for it with reading, nothing less than *War and Peace*—in large-print volumes. She loves geography and regularly reads *National Geographic* and watches nature programs on TV.

She may have given her vocal cords their first test as a one-room schoolteacher in the hills near Homer, Nebraska. She had earned her certificate and started teaching when she was only 17. In her light-hearted recollections of those days, she reminds us that one of the benefits of living to be extremely old is that you can talk about almost anyone from your past without fear of hurting their feelings, because they're either dead or too old to care. She relaxes in this fact as she talks about her former students: "I had one pair of twins—they were the dullest two people who ever lived. There wasn't a brain between the two of them. And you wouldn't believe some of those eighth-grade boys—some of them were older than I was. Then I had one girl whose parents had named her Toilett. Her first name was Toilett! I found it hard to call on her without laughing."

Whatever laughs Amy Hogan had to hold back then, she unleashes now. But not all of her life is laughter. She hasn't been in the nursing home long and adjustment has not been easy for her. "Being cooped up in such small quarters is the hardest part," she says. But when she complains, it is with some sense of irony and humor. "There are sounds around here that I'd rather not hear, and I'm glad I don't hear too well. But sometimes I'm with blind people and I think they're better off—they don't have to look at all these old fogies."

But Amy is the well-balanced, pleasant person to whom anyone would be drawn. One thing that is attractive about her is that she seems so representative—she could be anyone's favorite aunt or grandmother. She accepts the bitter as bitter and the sweet as sweet. She could be any one of us in old age—at our best. And her bitter memories aren't even about people, they're about a place: Wyoming.

"My husband wanted to be a cowboy, so we went to Wyoming to homestead. The wind was terrible. There weren't any trees. There was nothing but prairie. The winters were awful. I didn't enjoy anything about it. I got very depressed.

"We were living in the midst of rattlesnake country. The first one I saw was outside, though I was in the house. I threw things at it through the window. First I threw a pan to try to get it to uncoil. Then I threw flatirons. It was well killed."

To make matters worse, the devastating influenza of 1918 struck her family while they were there. Amy took care of everyone else in the family, including her brothers, her mother, her husband, and her daughter. "We were all in a homestead shack," she says. "Very poor accommodations. We were all sick at once. We just had simple remedies—aspirin. People were dropping all over. My husband Everett got it, then his nurse who came to the house got it. Everett was a strong man, but when he stepped out of the car he just fainted."

They continued for a few more years in Wyoming, but finally, as Amy said, "We had enough of it." They left and her husband became a salesman in Iowa, Nebraska, and Minnesota. Her son was to become a pioneer in aviation, working as a pilot for Boeing. When his wife died, Amy and her husband raised their son's two children. In 1957 she moved to Denver and in 1968 started living with her daughter. Today, in the nursing home, she says her only real worry is the health of her daughter, who has severe arthritis.

❦ "I'm not sure how I've gotten so old. I've had good health. I've enjoyed all my children, my grandchildren, my great-grandchildren and great-great-grandchildren—I have five great-great-grandchildren. I've enjoyed watching them grow up and get educated. That has been a great enjoyment to me—one is graduating from Stanford this month.

"I can't say I'm a fussy eater—I eat what I like, including all the things that you're not supposed to eat. I guess I'm not much good on advice: I was always satisfied with my surroundings; I always enjoyed my home."

Her daughter adds: "She's adjusted to all the changes in her life—she even likes the nursing home now; she just didn't like Wyoming."

And, so it would seem, not liking Wyoming never killed anyone.

Born: May 27, 1884, Surprise, Nebraska
Never married
Principal occupation: farmer
Current residence: Stromsburg, Nebraska

Frank Flansburg

Cross the river from agribusiness Iowa into agribusiness Nebraska, and you'll find the flat world around you suddenly alters: more trees, more meadowlarks, more historical markers, and a much slower pace. At the end of one slow road sits Stromsburg. The world doesn't come to a standstill here, but it gets close. The rough brick road around the quiet town square seems to slow down both pedestrians and motorists. Doorways of a few stores emit some slow talk about beans and the weather, but not much else.

In the nursing home on the edge of town where Frank Flansburg now lives, things pick up a bit. The place is buzzing with activity and makes one wonder if the active people of Stromsburg have all graduated into old age. One of the fastest things in Stromsburg must be Flansburg's mind. Most of his life he has been a bachelor farmer, one of those Midwest departures from the norm that can make a person the butt of many a rural joke, but this man's flow of wit and humor must have meant that he was more often the source of jokes than the object of them.

"I've had a lot of fun and still do," he says. "This is home. Three of my relatives live here and we have a good time." He shows a picture of himself at a Halloween party when he was 101. He's wearing a wig and dressed like a woman. He laughs. "Wit is part of it and, you know, more corn grows in a crooked row than a straight row."

There's a bumper crop of wit in the contours of Frank's mind, wit and rhyme. "I never passed eighth-grade examinations, but I learned to read. I memorized things. Like this [he recites]:

My Josephine, / my kerosene, my gasoline, / my benzene, my vaseline, / I come from above my station, / without hesitation / or reservation / to ask you to become my relation / to increase the population / of this great nation.

"I got that one from *Peck's Boss Book*. It had lots of rhymes. I knew most of them."

He grew up near the small town of Surprise, not far from Stromsburg. Although he remembers "working like a dog," he is more inclined to talk about the playful excursions that delighted his mind. He says, "Surprise was a great show town. Used to go down to the Indian medicine show. The barker would go down into the crowd telling about this

medicine that would cure anything. Then he'd chant." Frank chants, fast, with gusto:

Umatilla Indian Hogah, / good for the liver kidney / stomach and blood, / loss of appetite, / sig-a-dig, nervousness, / indigestion or dyspepsia! / Who's the next wants / a package of wa-tanka!

So what would this concoction do for a body?
"Clean you out is what it did."

Frank tells an array of local jokes, then admits that reading has been his real obsession. He was and is an avid history buff, not only of U.S. history but of Greek and Roman history too. "I used to know size of armies, who was commanding each division, who was president, and for how long."

You ever think of getting married?
"Well, I kind of figured I was going to be like everybody else, but I had to give it up. Health is really the reason I never married. Dad said to me one time, 'I don't think you'll ever get married.' I was just down and out too much of the time."

When he was 19, he went with his brother to homestead in Alberta. Here his arthritis became so bad that he treated himself with vapor baths. "I've had arthritis my whole life and I've tried everything you've ever heard of."

By 1914 he returned to the family farm near Surprise where he combined dry-land farming with his dry wit. All told, he spent 85 years of his life there. For many years after that, he lived with long-time friends and had the chance to satisfy his curious mind more than ever by reading.

🐚 "I never had a belly full of beer, just a jigger of wine, and it made my head feel like it was four feet across. But I've been sick most of my life. Arthritis has been the worst. Had it my whole life. It's not so bad in my shoulders. But my knees, my fingers and thumbs, I've got arthritis in my face! I had bronchitis when I was seven. But that just meant smoking didn't work. I chewed plug tobacco until World War I, then started on snuff. I chewed eighty-one years, and I don't know how many gallons of that juice I swallowed." He laughs. "Well, it keeps the bugs away."

"My father and granddad lived past ninety, but the real reason I've lived so long is that I haven't died yet."

Born: Martha Koehring, March 19, 1887, Waukon, Iowa
Married: George Durr McShane, 1920; divorced, 1950 (?)
Children: (1) Georgine
Principal occupation: teacher
Current residence: Minneapolis, Minnesota

Martha McShane

I'm an inglorious Milton," said Martha McShane when doctors at Mayo Clinic asked her to introduce herself to a group of young interns. She was there to have her arthritis evaluated, but her literary allusion made it clear that she wanted to be recognized for her learning and wits more than her bodily ailments.

Her daughter says, "I'm so proud of my mother. We fought like heck when I was a teenager, but I admire her, that she strove so to attain a goal, going to school against all odds. I wish people knew how intelligent she is."

Martha McShane has been going against the grain of people's assumptions most of her life, asserting her independence as a child when she would take off her thick stockings on her way to school as soon as she was out of view of her mother.

"I was a dainty girl," she says. "You can't say that I ever worked hard."

This is evidently the image she wanted and wants to have of herself—someone who is different, whose life would be distinguished from the ordinary. But as a child she had to milk cows and help her father with other farm work. She also became an accomplished seamstress. "I knew how to do everything, even though I wanted to be a teacher."

She had to work before she could attend high school and didn't enter until her late 20s. She made beds in a hotel, but, she admits, "I didn't like it. I didn't stay there very long; I wanted something better."

Although her parents were not eager to have her go to high school, she says, "I didn't ask them. I knew what I wanted. And they knew if they crossed me, they'd get it back. My parents were very careful of me. My mother was kind to me. I think they thought I was special. They knew that I was different from others."

She was clearly a precocious person, playing the organ in church, excelling in her hobby of flower arranging. She was an avid gardener and amateur photographer who developed her own pictures. She also taught herself to play the harmonica which, even with her arthritic fingers, she still manages to do.

She went to Upper Iowa University to earn her teacher's certificate. She was voted best-dressed on campus—wearing clothes she'd made herself. She worked at the home of one of her professors for room and board.

She started teaching at a time when the country schools were all two miles apart. She lived with her parents and taught for $40 a month.

"My teaching days were the best time of my life. The children always liked their teacher. I was successful as a teacher. If you want to be a good teacher, you honor your students. I never forgot a teacher I had who slapped me. I called him cruel, but I had him for several years. I never did anything like that."

She met her husband at a dance. He was in uniform from World War I and she was in a red dress. "I think I fell in love with the uniform and he with the red dress."

It was not a good marriage, but the divorce didn't come until after their daughter was married. He was lenient, interested in playing cards, and not saving money. She hoarded money and liked to go to the theatre and concerts. "She really wanted to separate from him for years," says her daughter. "They argued a lot but stayed together for me. She divorced him. He admired her so much he would never have divorced her."

She has been living in the nursing home for more than 10 years. Until a few years ago, she read to kindergarten children in a school across from the nursing home. Today she can list very little as her daily activities: having breakfast, going to exercise therapy, maybe listening to the news. But something in her still strives to honor what she knows is special about herself. "I have a wonderful mind for memorization. I always loved to memorize poems, and I'm glad I did."

She recites Longfellow's "Village Blacksmith" very dramatically, almost weeping, as if she is transported through the poetry into a world where she would have preferred to spend most of her life.

❦ "I have no secret for old age," says Martha, "And if I did, I wouldn't give it to everybody. That's everybody's own business. Let them figure it out for themselves."

Born: Eva Tamar Wilbur, July 16, 1887, Chattanooga, Tennessee
Married: Carl F. Perzina, 1919; died, 1970
Children: none
Principal occupation: hotel owner and operator
Current residence: St. Petersburg, Florida

Eva Wilbur Perzina

How am I? I'm deaf, dumb, blind, and lame. Other than that, I'm fine. I have a good appetite."

Eva Perzina is gracious, funny, and confident. At 100 she acts like a woman who has had her own way and made her own way.

"I built the Carleve Hotel," she casually announces. It was a 48-room hostelry built in 1939 and got its name from a combination of her husband's (Carl) and her own name (Eva), though that is as much credit as she gives him for the enterprise. "My husband went fishing, and that was all right. This was my project."

She helped design the brick building, working with the architect and builders to make sure it had the features she admired, notably such things as large closets. The guests were seasonal, mostly upper middle-class retired people who, like so many today, came down to St. Petersburg for the winter. She planned the evening entertainment while her husband, who must have discovered that the fishing was not always good, managed the front desk.

The Carleve Hotel still stands in St. Petersburg, though today it is what Eva calls "a home for unwed fathers." It is a friary.

Eva Perzina grew up on the side of Lookout Mountain in Chattanooga, Tennessee. It was a youth of horseback riding and dreaming of faraway places. Geography was an early interest. "I remember reading geography books to our maid at the kitchen table," she says.

Her dreams of travel were not mere childhood fantasies. When she was 16, she read about teaching positions in Panama and wanted to go. Her parents wouldn't let her, but this did not discourage her interest in geography. While teaching geography in Chattanooga as a young woman, she had the chance to take a trip around the world with her uncle and aunt.

The same spirit that eventually would lead her to build the Carleve Hotel for seasonal adventurers prompted her to take that trip, and it is still one of the highlights of her life. The year was 1912. She remembers the shiny brass lettering on the *Titanic* at Southhampton shortly before it sailed. She remembers playing cricket on board her ship, throwing oranges to the natives while going through the Suez Canal. She remembers the tattooed faces of native New Zealanders, the well-dressed and polite Fijian prince, the ballet and Shakespearean performances in London. She remembers buying sapphires in Ceylon, cameos in Italy, and taffeta in England.

Back in America, she returned to teaching, met her husband, a slim and aristocratic man whose German family lost their piano factory when it was taken over by the government to make airplanes in World War I. She taught school while he sold pianos, though she would provide most of the financial support in their marriage.

Throughout her life, her travels would never be fully out of her mind. Anyone who knows Tennyson's *Ulysses* (1842) will remember it if they meet Eva Perzina, for she too might have said, "I cannot rest from travel" or "Much have I seen and known—cities of men / And manners, climates, councils, governments."

She takes much pleasure today remembering that trip, but the past also lives in such objects in her living room as the baby grand Perzina piano from her husband's family factory. The piano, inlaid with brass, is a magnificent instrument and piece of furniture that is older than she is. A maid lives in with her today in the lovely home where she and her husband moved in 1940 after she had run a successful tea room in Miami for five years. The house is surrounded by pine and palm trees and overlooks a small inlet of Tampa Bay. Inside Eva maintains an atmosphere of refinement. And independence. Every afternoon at five o'clock she has cocktails.

"Scotch on the rocks," she says.

Do you ever drink alone?

"If I have to."

❧ "I'm from good Scotch stock. There has been so little real sickness in my family."

So what keeps you well today?

"She keeps pushing her mind," her great-niece suggests. She still studies geography and still travels through her large-print world atlas, Tennyson again:

Though much is taken, much abides; and though
We are not now that strength which in old days
Moved earth and heaven, that which we are, we
 are—
One equal temper of heroic hearts,
Made weak by time and fate, but strong in will
To strive, to seek, to find, and not to yield.

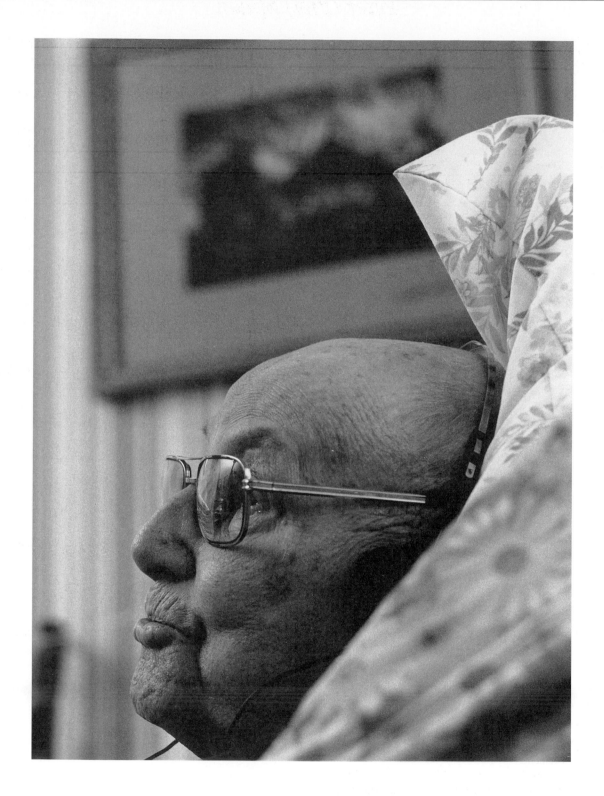

Born: May 31, 1886, Alkmaar, Holland
Married: Dieuw De Jong, 1908; died, 1982
Children: (2) Nellie, Marie
Principal occupation: dairy farmer
Current residence: Newport, Oregon

Peter (Piet) Spaan

W hat do I care what's going on—I have someone to care for me, plenty of sleep, plenty to eat."

There's a little bitterness in Piet Spaan's voice, but his moods swerve: A moment of darkness is often followed by a playful and resolute, "Oh, that's the way things are" or "Oh, you just don't know . . ." and he grins or laughs. While most people cheer themselves with optimistic talk, Piet seems to cheer himself with pessimistic talk. When he does laugh, there is nothing frivolous about it.

"What do I want out of life today? To get out of here. To be able to walk around a little bit—that's all."

Piet is bedridden and living in an adult foster home. Just a few months ago he was still walking. He has been a dairy farmer, sheet metal plant painter, fisherman, gardener, and he has always prided himself in his strength. He does not go down easily—not even at 101. But his back is deteriorating and he doesn't like it.

"My arms were very strong," he says, and flexes his muscles. As a young man in Holland, he was a gymnast. "I could whirl around fast as a windmill!" He demonstrates the speed with his hands. His arms look long rising from his 5-foot 6-inch body.

Piet Spaan still speaks with a Dutch accent.

My grandfather was from Holland. He said he came here for religious reasons. What about you?

"I came here for money."

Coming to America in the early 1900s, he found that economic bliss was not easy to come by. Friends had written him about the beautiful land of Oregon and its promise of prosperity, but when he arrived in Oregon as a young man, all of the government homesteading land was already gone. He went to work and saved his money. In less than a year he had saved $200, rented a farm, and bought his own stock.

"Immigrants were all poor," he says. "We had to be strong. I was very, very strong. But it's always a dollar sign," he says, referring to the hardships of his early years in America. "Everybody wants a dollar." And so did he. He built up his dairy stock and says he would have been able to buy the farm he was renting and become a rich man, "but the work was too hard. Lifting those milk cans was too much for me. I was strong, but I was small. Oh, that's the way things go."

When Piet's body started giving way under the farm work and his wife's health demanded special attention, he moved to Portland and became a painter in a sheet metal plant.

"I had to get off the dairy farm. Those big milk cans were one hundred pounds, too much for me. My wife's brothers were all big, like this. They could do that kind of work. You had to be big like that."

But they're all dead.

"Yes, of course, they're all dead."

Spray painting hardly sounds like work for a man who came to America for money, but Piet says, "I made a lot of money. I'd always work overtime if they needed it. They'd say, 'Piet, can you work tonight?' 'Oh, sure,' I'd say. I was the only one they could always count on."

He pauses a few moments. His large hairless brow furrows over his eyes, as if he were about to utter some words of worker's disgust. Instead, he says, "I had a really good life. You can say, 'I should have done this, I should have done that.' But that's the way it goes. You can do it only once, that's what I say. Do the best you can, and if it isn't good enough, nobody cares. Just satisfy yourself that you did the best you could anyway."

❦ *How did you get so old?*
"Just luck."

Dinner is on the stove as he talks, the aroma of fried chicken filling the house and reaching his room. He may not be able to walk to the dinner table, but he's ready to eat.

My grandfather used to say, "Beter lam als mislik" [Better be a cripple than have a bad stomach].

"Yah," says Piet, grinning. "I know what you mean."

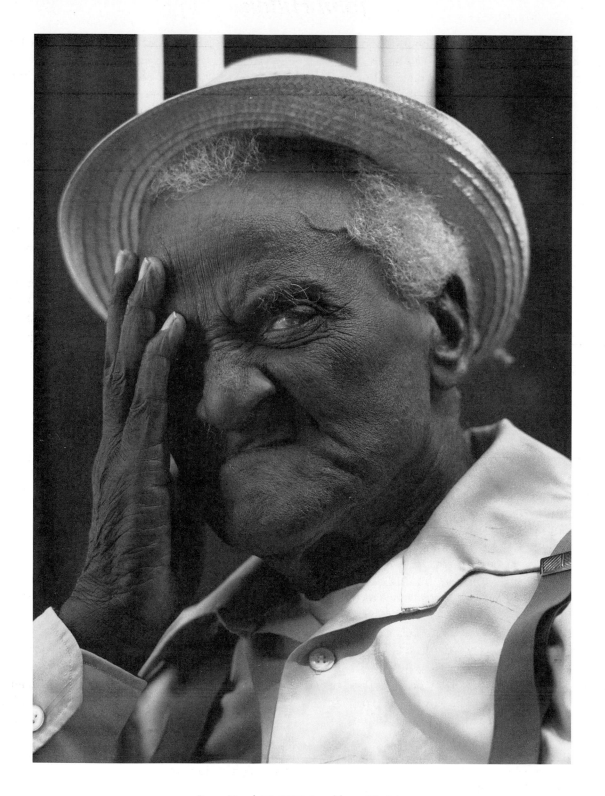

Born: March 18, 1884, Lynchburg, Virginia
Married: Emma Brown, (?); died (?)
Children: (3) Evelyn, two sons who died young
Principal occupation: railroad worker
Current residence: Ft. Lauderdale, Florida

John Hilton

John Hilton ran away from home as a boy of eight, partly because he did not like his stepfather. He traveled and became a self-taught survivor. When World War I began, he enlisted.

He walks out from his room to visit, smiling, dressed in a small straw hat, a blue, well-pressed shirt, blue-gray suspenders, and dark trousers which he has rolled up. There is hardly a wrinkle on his face.

The setting where John Hilton lives is quite a different scene from the famous Ft. Lauderdale beachfront, with its abundance of well-off young people whose shifting heads and eyes suggest they are all looking for action. In contrast to their freedom, the residents of the retirement center where John Hilton lives cannot see beyond the high wooden fence that surrounds the complex. The beach scene is out of sight and hearing, but it's only a few minutes from the locked front gate. Directly inside the gate, a large cement slab spreads out beneath a huge banyan tree. In its shade several old people sit in a horseshoe formation of lawn chairs, with their four-legged walkers standing obediently at their feet. A large TV set sits near the fence, but it is not plugged in. Some of the old people snooze in their chairs, their chins resting on their chests. Others look up at the sound of the admittance buzzer, but no one rises. Patients have worn a path just inside the fence that resembles the paths pet dogs wear into the grass just inside lawn fences.

The buildings in the complex are low, pink stucco structures, like inexpensive, one-story, flat-roofed motels. About 25 to 30 people live here. There are six employees. The owner/manager explains that this is a proprietary home, not a nonprofit, though some of the residents are taken in out of compassion at a relatively low fee. John Hilton is one of these. There are various levels of care. Most of the residents have Alzheimer's disease, with "ten-second memories." John Hilton is not one of them. He has a semiprivate room and is able to feed himself and live with relatively little assistance.

The buildings are furnished with old and inexpensive couches and chairs. The employees do not seem to be bothered by either the traffic noise or the relatively run-down facilities. They are, in fact, cheerful and responsive to everyone around them. One employee lives in with her seven-month-old child who crawls out into the hallways. Several residents stop to smile at or touch the baby. Even the most severe Alzheimer residents are cheered by the baby.

Doesn't all the traffic noise disturb the residents?

"No, it's good for them," says the owner. "Anything but silence. This is much better than isolation."

John Hilton sits down in a lawn chair near the fence. A woman paces frantically in front of him, but John does not seem to notice or mind.

How do you like it out here?

"It's all right," he says. "As long as everything feels right."

John Hilton grew up near Lynchburg, Virginia.

What do you remember of those days?

"All those hills," he says and makes a sweeping gesture toward the freeway. "All those nice hills."

He spent much of his life picking cotton and working on the railroad, driving spikes by day and sleeping on pillows that were laid out on floors at night.

Sounds like hard work.

"It was all right."

What do you do nowadays?

"Look at the girls."

"He likes to whistle at the girls," says a nurse.

"I like brandy. Like music," he says.

He starts to sing a few old tunes, but seems shy about it and sings so softly that the lyrics are inaudible against the freeway noise.

Doesn't all that traffic noise bother you?

"It's all right," he says.

All of the employees like John Hilton. They describe him as a "very nice little guy. He's easy to get along with."

❦ John Hilton keeps regular hours, getting up at about 7:00 or 7:30 and retiring at about the same time in the evening. He eats a big breakfast, a small lunch, and very little dinner. Taking it easy. Smiling. Watching a little TV, eating a few sweets, whistling at the women when they walk by. He looks self-contained, a survivor, whose old habits seem to be carrying him through.

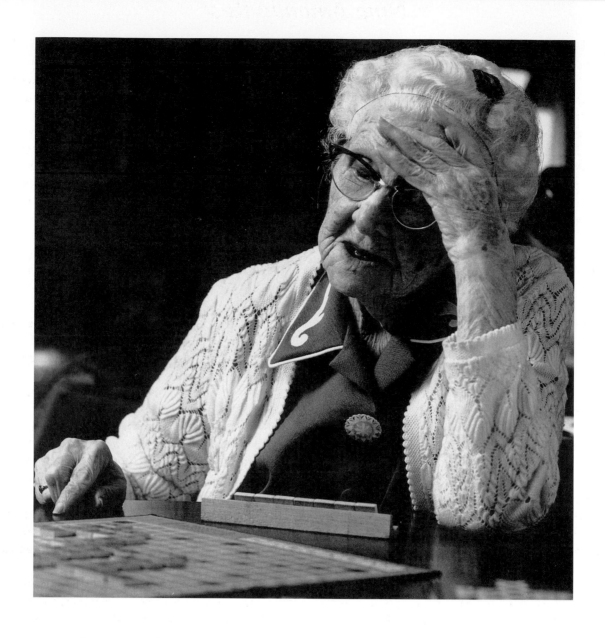

Born: Nina Amanda Billick, June 18, 1881, Hainsville, Nebraska
Married: Samuel Edward Rust, January 24, 1902; died, 1943
Children: (12) Eva, Ida, Floyd, George, David, Emma, Phyllis, Melvin (Budge), Clara, Meda, Willard,
Florence
Principal occupations: homemaker, seamstress
Current residence: Roseburg, Oregon

Nina Amanda Rust

Four of 106-year-old Nina Rust's children have had their 50th wedding anniversaries. All 12 of her children are still living. She has 36 grandchildren, 83 great-grandchildren, 51 great-great-grandchildren, and one great-great-great-grandchild.

She lives with her daughter in a mobile home in Roseburg, Oregon. In its early days, while settlers were displacing the Umpqua and Calapooya Indians from this beautiful bowllike valley, its main attraction was its suitability for raising stock and cultivating fruits and vegetables. Later it was to become a lumbering center. Today an inordinately large number of big-wheeled pickups rumble down the streets, which are lined with repair shops for motorized vehicles. And with mobile home parks. A bumper sticker on a parked car in the large park where Nina lives reads, "Women are veterans too!" In a place that feels mostly like a man's world, those words are not a bad introduction to the little woman whose living descendants could fill a small auditorium.

Nina is a celebrity in the area. She has been pictured on national television riding an elephant at the Oregon Wildlife Safari after she was 100, and her daughter has written a book about her that has been a hot item in local stores.*

Nina looks unassuming, crocheting a red, pink, and white afghan in her mobile home easy chair. Her cheek is healing from the second removal of skin cancer, but when she speaks, there is that slightly abnormal intensity in voice and gesture that warns you she is a tough one.

Her daughter's book confirms the impression. Nina was born in a sod hut on the Nebraska prairies. Near the sod house were buffalo wallows and "fairy rings," the name settlers gave to the verdant circle of prairie grass and flowers caused by water running off Indian teepees. The circle stood out from the rest of the prairie and was broken only where the teepee door had been. In this country which had only recently been explored by white men, Nina was a shy but daring tomboy, the kind of person who would sit in the tops of trees when her brothers cut them down so that she could have the thrill of falling with the tree and landing in the creek. Another time, she ran off to kill a rattlesnake for the pleasure of showing it to her friends. She pitched in on the hardest work, mixing mortar, milking cows, carrying buckets of river water to fight a prairie fire, gathering buffalo chips for fuel. Her memories could produce a handbook of folklore,

folk remedies, and folk art. Hers was the world of homemade willow whistles, baseballs made with unraveled socks, cornstalk fiddles, and tumbleweeds tied to string, which when driven by wind became tugging toy horses.

She raised 12 children and lived in near-poverty much of her life, conditions that often forced her to provide for the family by sewing. When her husband died after 40 years of marriage, she did other forms of labor as well, including hop picking after she moved west.

Didn't you lose sleep worrying about all your children?

"No, I figured that if something bad was going to happen, I had better get a good night's sleep so that I'd be better able to deal with it."

The picture of an indomitable woman comes through in Nina's personal history, but what does not show is the fact that she's a word-wizard.

"I like to play anagrams and Scrabble," she says.

Scrabble? Would you like to play a game?

"Yes. I don't take a back seat to anybody when it comes to that."

All of her moves are disconcertingly quick, maybe an average of a five-second pause. And behind the quickness is the kind of strategist who will take a low score on one word to keep the other player away from the double- and triple-word scores, and who will hoard the "U's" when she realizes the other player has the "Q." The score is high and close, but her opponent in this game is stuck with the "Q" and loses by about 20 points.

Call her a good sport, a daring old lady. Little seems to threaten or shake her. She took a motorcycle ride with her grandson shortly after she turned 106 just so she could say she had done it. She seems to be afraid of nothing. "I don't dread death," she says, "but if it's peaceful in heaven, I'll have to stir up something then."

If there's a Scrabble board up there, may the saints preserve them.

❧ Nina Rust does not mince moves in Scrabble, and she does not mince words in offering her formula for longevity: "Don't drink water. Stay away from doctors."

Dear Reader: 100 Years with Nina Rust, by Phyllis McMeekin, Graphic Dimensions, Roseburg, Oregon, 1984, 234 pp., $8.00 paper

Born: Marie Carrie LeCompte, June 25, 1882, Bourg, Louisiana
Married: Hayes Peter Hotard, 1902; died, 1928
Children: (6) Norman Joseph, Ruth M., Anne E., Theresa J., Leona M., Rosslyn P.
Principal occupation: homemaker
Current residence: New Orleans, Louisiana

Marie C. LeCompte Hotard

Marie LeCompte Hotard's father fought in the Civil War. After weeks fighting in the trenches, he had to walk home from Vicksburg. When he arrived, he had no shoes and his clothes were tattered.

"Nothing changed much in their hometown of Bourg after the Civil War," says her daughter. "So there wasn't much bitterness there. She didn't have a hard life in her early years. Maybe take in washing. The men worked. She had a simple but nice rural life."

Marie LeCompte Hotard grew up speaking Cajun French. After the war, her father had some land, which he worked. She couldn't speak much English when she got married, but her husband was a schoolteacher and could speak both English and French. Before his early death, she kept busy in the house, washing dishes and putting them back.

"My husband died when he was only 48. I miss him," says Marie. "But I still have good children. I must say that. That's real important to me. They're up in ages now too."

Like some of her fellow centenarians, Marie Hotard has had to worry about the health of aging children. After her husband died, she lived with her daughter, but a year ago, when Marie was 104, her daughter had a stroke and Marie had to move into the nursing home.

Her daughter is visiting her now, and while she talks, Marie sits quietly, nervously biting her fingernails until her daughter takes her hands and gently rubs them. Each seems to be comforting the other. "Really, I've been with her my whole life," says Marie's daughter. "My father died when I was sixteen, and I got my first job when I was seventeen. She's been with me ever since. When I married, my husband moved in with us. She had her own room and did a lot of the cooking. There's nobody can make oyster dressing like she does, and nobody can make shrimp stew like she does. When she got old, we took care of her like a baby."

Marie Hotard sits silently while her daughter talks and continues to touch and stroke her soothingly. The celebrity status that her extreme old age is giving her does not come easily for Marie. She seems uncomfortable and impatient with the attention she is getting, as if she has habitually lived quietly in the background. Several times she suggests that she would like to go back to her room now.

"She always did what she had to do," says her daughter. "I wouldn't say she had hobbies—sewing for the children, and she did a lot of needlepoint. She has never done anything to get into an argument, unless somebody did something to hurt her feelings. She's really a down-to-earth person. And while she was living with us, sometimes we wouldn't see her all day. She would play solitaire almost every night. She had few friends, but for no particular reason."

"Like old French people," says Marie's son-in-law, "all they really care a whole lot about are their families."

"That's enough now," says Marie, as the camera flashes. "Take me to my room."

❦ Marie's daughter says, "She's had every illness under the sun—a colostomy, a large abscess in her lower colon removed, her gallbladder removed, the worst case of hemorrhoids the doctors had ever seen, a broken hip, a tonsillectomy, and adhesions around her small intestine. It's easier to list what she didn't have. I really don't know what keeps her going. But she has the blood pressure and blood count of a forty-year-old."

She weighs 102 pounds and doesn't eat much, and she never has. "She just picked at her food, just didn't care for much, though she eats lots of salt."

But longevity runs in Marie Hotard's family. Several of her brothers lived into their 90s. Her mother lived to be 99, and two or three members of her father's family lived to be over 100.

"Now, come on, doggone it, that's enough," says Marie in a scolding voice. "Take me to my room."

Born: April 23, 1883, Florence, Alabama
Married: Ada Harding, 1904; died, 1924
Alice Garcia, 1925; divorced, 1936
Velma Vaughn, 1946; died, 1971
Children: (12) Herbert (Buddy), Vera, Robert, Ollie, Velma, Mary, Leroy,
Velora, Herman, three children who died at childbirth
Principal occupations: farmer, smelter kiln-tender
Current residence: Chimacum, Washington

Russell Williams

Russell ("Papa") Williams had his last child when he was 72 years old, but was joking about finding another wife only five years ago. At 104 he's calmed down a little, into an easy-chair life in the home of his son and daughter-in-law on a cleared hill just off Egg and I Road (named after Betty MacDonald's popular 1940s comic novel).

Papa Williams has been in the Northwest for only the past seven years. Although he's been around the country, including 31 years in Kansas, he is a Southerner by birth. He was among the post–Civil War Black people who were born into the ambiguous freedom of sharecropping on their one-time owners' land. His mother had been a slave before the Emancipation Proclamation, and his father was born on the Williams plantation. This was in Alabama.

As a boy he went out into the cotton fields with the whole family—"pickin' cotton, choppin' cotton, leavin' two stalks far enough apart so's they could grow out." He remembers mornings so cold that his bare feet left footprints in the frost. The work was from dawn to dark, or, as he puts it, "from can to cain't."

"I'm just a common man," he says. "Common as common. Never got no schooling, but I liked to work."

As a young man he became a deckhand on a government-owned steamboat. Later he went off to lay railroad tracks, dig sewer ditches, work in a cotton mill, and clear land by hand. Finally, he started his own farm in Oklahoma, where, with the help of his large family, he built up a herd of stock.

What did you do for a good time?

"The best I could and that wasn't much." He smiles. "Squirrels. Those red-haired fox squirrels would be a pretty good meal—there was meat on them. We'd cut down any kind of tree—maple, cottonwood, and oaks—that was big enough to make good lumber. Others would pick up the lumber for wood, but I was after what was in that good lumber."

You'd cut down a tree to get the squirrel?

"Yeah."

Farming the fields in Oklahoma gave him a glimpse of prosperity. "I had cows, I had a milking machine, I had a cream separator." He joined the Masons, could afford whole boxes of cigars, and people on the street called him "Mr. Williams."

But droughts came and in 1926 he moved with his family to Coffeeville, Kansas, where he farmed for a short time, but then he began working at a smelter for Sherman Williams. It was hot, smoky work where he once was severely burned and once broke his jaw, but he stuck with it for 31 years before retiring. Still, he has no regrets—"I always liked to work," he says. "I liked every job I had."

☙ If hard work could open the doors to the Kingdom of Longevity, Papa Williams would be St. Peter. But his daughter-in-law says that it's more than work that has kept him around so long: "Good booze, good cigars, good food, and a lot of love."

At 2:00 P.M. she brings him an afternoon snack: cookies, cheese, and a four-ounce glass of vodka flavored with cherry syrup.

Well, do you think your eating habits have been different from other people's?

"I know my eating was different from other people's because I knew I wasn't getting any. Not much of anything most of the time. That's different."

His favorite foods are greens and salt pork. He smokes cigars and has for as long as he can remember. "I wouldn't give a penny for a cigarette of no kind. Cigars," he says, holding his out. "Cigars."

What about the drinking?

His son and daughter-in-law laugh. For a while since his 100th birthday he had been drinking a half gallon of vodka in four or five days, but they've cut him back some now. His real fondness is for Jack Daniels, though vodka has recently become his regular drink. Of Jack Daniels he says, "I ain't no ways down on it; I'm reachin' up on it all the time."

What's your secret, really?

"Oh, the good Lord just overlooked me, just like He always done."

Born: Onie Wilkins, March 26, 1889, farm near Elkton, Kentucky
Married: James Grisham, 1907; died (?)
Children: (6, all deceased) Paul, Edith, Esther, Goodwin (other names not given)
Principal occupations: farm worker, homemaker
Current residence: Denver, Colorado

Onie Grisham

Onie Grisham's first words to her visitors are "What are we doing? I'm not doing anything new."

She is tiny and wiry, and grabs a handful of butterscotch candy before leaving her nursing-home room to come out and visit. "I wish I'd stayed in Kentucky," she says. "Everything's better in Kentucky. They treat you better. They treat everybody like they was home folks."

The nurses seem a little nervous as Onie starts talking. "I haven't had a really good time since I was in Kentucky. When I was a little girl I was workin' in the fields just like a man. We raised everything: corn and tobacco and wheat and oats and anything you wanted to plant, and I was workin' there too in it. At five, I could drop corn in the checks where they checked it off to plant, and I could drop tobacco plants and then when the tobacco come up I could pull the worms and suckers off. You see, after you topped the tobacco, the suckers would come out between the leaves and the stalk. I'd kill worms and pull the suckers off."

You said you had a good time in Kentucky. That sounds like work.

"For fun we'd have these play-parties. My dad wouldn't ever let us go to square dances, so we had to make it up as a play-party, you know. Then when we got there we'd dance. Everybody kept their mouth shut. That is one thing we did do that wasn't exactly right, but I guess anybody'd a done it if they was young. It would turn into a square dance. We had music there—fiddle and banjo. I had some of the old songs but I lost everything when I left Kentucky."

Onie rubs her arms which have large dark spots on them, the color of bruises.

"Those were good times. Worked in the fields after marriage too. I'd put the kids in a tub or in a playpen or something in the shade, give 'em things to play with and things to eat on, and I'd work in the field. I didn't beat 'em up all the time, but I taught 'em to mind. I done everything. Cookin' too. I never cooked chitlins, I didn't like them. We raised everything there. My husband was a good farmer. If you knowed how to work, you was a good farmer."

But her oldest son developed a lung illness. The doctor recommended that they move to Colorado for his health. "He died here just exactly as he would have done in Kentucky, maybe sooner by changing climates, you see. Always will think if they'd let him stay in Kentucky he'd have lived longer than he did by making all that trip. *You* couldn't stand it either if *you* was laying on your back flat, being pounded around all over the country.

"When we got here, for a long time we had to go on welfare, they called it. And that didn't suit me a bit when I'd worked hard all my life, to think we had to have somebody help us, give us something to eat. In Kentucky we wasn't rich—we was just common farmers is what we called ourselves. We could always eat everything."

Lunch is being served in the cafeteria next to the visiting room. Onie says she isn't hungry and reaches in her pocket for a butterscotch candy. She doesn't offer any to her visitors.

"I wish they'd never brought us here. If we'd bring the boy here they'd cure him. Well, he died here sooner than he would have in Kentucky—by changing climates. I always will say if they had let us stay there he'd have lived longer. Darn doctors was the cause of it too. Darn doctors, I call them something else. Some of 'em's pretty good and some of 'em's mean as the devil. I don't know if He'd have 'em. He'd give 'em a certain little bad place in H E double L and tell 'em to stay there."

Have you been a religious woman?

"Well, I wasn't mean, if that's what you mean."

Onie complains of a chill in the room and says she's about ready for her nap.

"Everything is better in Kentucky than here. It ain't so cold. We don't have any real cold weather back there in Kentucky and Tennessee and Alabama and all them southern states. Nice weather most all the time. Rain and hail and thunder and lightnin' and that's about the worst part of it. Well, we got flies, yes, about as many flies as anywhere else. The people was nicer to me. I think people know how to do everything better in Kentucky."

❧ "It's hard work got me here. I was the oldest one in the family so I was the one who had to do the work and I'm the only one that's living. Hard work never killed anybody. Hard work toughens you so you can take it. By the time the younger ones was big enough to work, the farm was paid for and they didn't have to. But I did. I had to work to help pay for it. But it still let me live longer anyway. I worked from the time I was five. I worked hard and I ate good. That's all there's to it. Because all the younger ones than me was dead long before I was. And I still ain't dead."

Born: February 27, 1883, Cleveland, Minnesota
Married: Grace Inez Myers, 1908; died, 1956
Myrtle Gailey, 1960; died, 1967
Children: (2) Doris, Audrey
Principal occupations: horse trader, wheat and apple farmer
Current residence: Port Angeles, Washington

Redden Lee Couch

At 104, Redden Couch decided to stop living with his daughter and move into the small house where he now lives by himself. He is nearly deaf and totally blind.

From the outside, his new home looks like one of those little places for young couples that realtors call "starter houses," but the inside has the surprising component of numerous ropes draped from door to door and room to room to help him find his way around. He is sitting in an easy chair dressed in blue sweat shirt and pants that make him appear as if he were about to go jogging. He looks like a starter, and, in fact, the ropes do serve as exercise aids, which he follows around the house on long daily walks.

But it is really his mind, not his body, that he puts through the most rigorous aerobic routines. Sometimes he practices the multiplication tables over and over. Other times he silently tells himself old stories he's read, or he recites Bible verses. One of his favorite mental games is calculating statistics about his life.

"I've eaten over one hundred eighty dozen eggs since I was one hundred. I've collected over fourteen thousand dollars in Social Security since I was one hundred."

He figures the Social Security payments are an especially good deal. He had been a farmer and had not paid into the program. He learned that he could receive benefits if he paid in for six quarters, so at 72 he went to work for a fruit processing plant to build up the necessary credit—but didn't stop working until he was 85.

The mentally and physically agile Redden Couch of today is not a surprising departure from his life story. At age 15, he set off with his family on an immigrant train from Minnesota, getting off in Ritzville, a small town in eastern Washington. He was the quintessential hearty young Westerner, possessed with wide-eyed ambition, drive, and daring. He apparently had a natural eye for good breeding in wild Cayuse horses and was a successful horse trader in his teens, no doubt calculating faster than a would-be buyer. At 24 he rented a 700-acre farm. With the cooperation of the weather, he produced a first-year bumper crop. This gave him enough cash to pay off his debts and then some.

"With crops like that, I figured in a couple years I'd be a millionaire. Have an early retirement."

He bought a half section of land, but the weather did not follow his calculations. The dry winds of drought withered the crops and his hopes. Redden laughs. "I went broke."

In the following years, he worked a number of physically rigorous jobs—on the railroad, hauling coal, and shoveling gravel. In 1918 he started his own apple orchard, and it was in the apple growing business that he spent many of his working years. During economically difficult times, he trucked his own apples into the cities and sold them directly to customers.

But here another side of Redden comes out. He seems to have been less interested in calculating apple money than apple taste. "The best tasting apple in the world is the common delicious. That and winesaps is all we used to grow. The red and golden delicious came later. But that common delicious was the best. The best ever," he says and seems to relish the memory.

🍎 Alone and lively at 104.

"Health and longevity are a family tradition," he says. Except for a twin brother who died at childbirth, all of Redden's siblings have lived to be old, and he is one of three who have lived past 100. His younger brother George is over 100 now and living in California.

Besides the benefit of family genes, Redden has a health-minded daughter who owns a reputable health establishment that provides a number of personal care services, including steam baths and massages. She comes by daily now and prepares his meals. The lunch she leaves for him on the table today includes an alfalfa sprout and meat sandwich, three prunes, a few tortilla chips, and a dish of raspberries.

"He eats like a longshoreman," she says.

"Yes, I have a good appetite. That's why I'm afraid I won't die for quite a while yet."

The offhand comment about death sounds out of character, but, in fact, few people could hope to be as fully at peace with their own mortality as Redden.

"I look forward to death because of all the things I've done that I can't do now," he told a reporter four years ago when he was 100. Today he speaks of death with the same easy anticipation. "I don't have any fear of death at all. If I were to die right now, it would be just fine. I'm ready any time."

He pauses, and grins. "Except now. I'd like to sit around and wait for your book. I'd like to listen to that. That book will sell a million copies, you know."

Born: Mattie Sarah Richards, January 8, 1886, Mississippi City, Mississippi
Married: Charles Edward Clark, 1903; died, 1970
Children: (6) Rufus Aldean, Lillian, Charles E., Jr., Ruth, Alvah, Eugene
Principal occupation: homemaker
Current residence: Ocean Springs, Mississippi

Mattie Sarah Clark

Mattie Clark is a true Daughter of the Confederacy. Her father was Benjamin Amman Richards, private, Company E, 20th Regiment of the Mississippi Infantry. He enlisted July 6, 1861, was shot in the shoulder during the Battle of Atlanta in 1863, spent some time in a hospital, and walked home. Her uncle died in the Civil War in 1864.

She's a descendent of the Acadians who were driven from Nova Scotia in the 1700s. Her family roots go back to France, then Canada, then Maryland, then Louisiana and Mississippi. Her family is interested in family roots, and she is interested in her family. They are her life now and seem always to have been.

"My husband, Charlie—boy, was he good. We had the happiest marriage you ever saw. Anything I'd do he was satisfied. He'd come home and say, 'Come on, Honey-bun,' and he'd pour the money out and say, 'There. You know what to do with it.' We just really loved each other."

Not only did she rear her own children but she had a hand in raising many of her grandchildren too. "When my daughter's husband was killed in World War II, she said, 'I don't know what I'm going to do.' I said, 'Well, bring them to me.' So she did, and I raised them."

What Mattie gave to her family in her earlier years is returning to her in old age. For years her son and daughter-in-law lived next to her small house, a convenient few steps away. Now she lives with another daughter in the large and lovely home surrounded by pecan trees that bend heavy with nuts. There are palm trees, long-leaf pine, centuries-old live oaks, the soft warm air from the Gulf of Mexico, and Mattie Clark smiling where she sits in her pink dress, her fingernails bright with fresh pink polish. All that's missing are the mint juleps.

"I have the most wonderful family," she says. Several of her immediate family are in the room. Everyone's attention is focused on Mattie. Even that of Tuffie, the dog. "He's part of the family," says Mattie.

"We're proud of her," says her daughter. "She's not any trouble. I mean that from the bottom of my heart."

"I know what side my bread is buttered on," says Mattie.

"The family looks to her," says her son. "They imitate her ways and let her know they are following in her footsteps. The grandchildren haven't forgotten what she did for them either."

Mattie's tendency to look after her family is a habit that started young—she was the one who ran all the errands for her parents. She likes talking about her childhood in Biloxi. Walking home from school, she'd slip off into the Gulf to catch soft-shell crabs. The blue crab sheds its shell and for a few hours is immobilized before it starts to form a new shell.

"I was a little rascal. I tried to wade when they wasn't nobody around. They'd come catch me out there and take me in if they saw me. When you'd pick up them soft crab they'd be twice the size of their shell. You'd cut the legs off and the rest you'd clean and roll it in cornmeal and drop it in hot cooking oil, and, oh, that was good."

It seems that food and family have always gone hand in hand for Mattie: "I'd come home from school and I'd go to the stove, and my grandmother would have a good fire in there and she'd have it filled with sweet potatoes. I'd get me two of them sweet potatoes, and she had always milked the cow and had made butter, and I'd get me a knife and a spoon, and I'd get me a chunk of that butter, and I'd cut my potato and I'd smear that butter all through it and go under that chinaberry tree with that sweet potato and, oh, I wish I had some of it now. . . ."

The chinaberry tree refuge is also where she pieced quilts. She had five of them made by the time she married. And her association of food with a happy home life carried over into her married years—in her case, Creole Cajun cooking. "I made *Court Bouillon** (baked red fish from the Gulf with tomato sauce), gumbo, and puddings: tapioca, bread pudding, and lemon pie."

Today her favorite times are when her daughter takes her riding in the evenings. "I like that good fresh air." And she still likes food. "I like pancakes and fresh homemade syrup. I have a sweet tooth."

❦ "I don't know what the secret is," says Mattie, "whether it was what I did when I was young."

"You said you always rested ten minutes every afternoon," says her daughter.

"Yes. I just lay down and rested, then I was ready to get up and go again. I never worried about nothing. I didn't have nothing to worry about. They told me what to do and I did it, or maybe I would have worried."

Her daughter adds, "The doctor says the attention she gets from her family is what is keeping her going."

**Court Bouillon* as opposed to *coubien*. "What Cajuns in Louisiana called it."

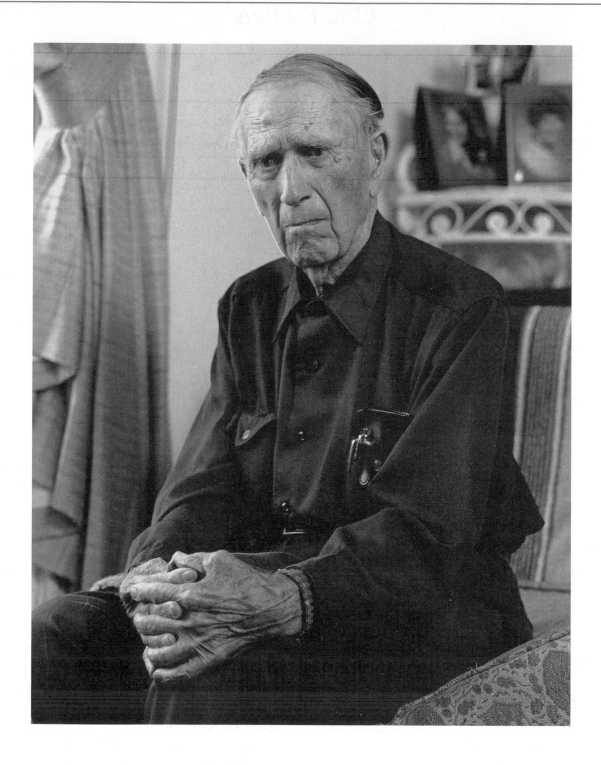

Born: November 4, 1888, Minneota, Minnesota
Married: Mary Ree, 1915; died, 1975
Children: (4) Irene, Carolyn, Harry, Conrad (died a baby)
Principal occupation: farmer
Current residence: Granite Falls, Minnesota

Otto Burthus

Otto's is a sort of good-luck story of a hard-luck guy. "I was a farmer my whole life," he says. "I didn't want to be a farmer. I wasn't a very good one.

"Oh, yes, I have regrets. I should have bought oats once—I could have borrowed the money—for twenty-four cents a bushel. I didn't do it. Then by harvest time they were up to a dollar. I should have bought. That was dumb, dumb. And I had a chance to buy a farm once for five hundred dollars—they wanted that much a year—but I didn't do it. I should have done hybrid hog raising—that's where the money was—but I didn't do that. I never got rich. I wanted to, but I didn't know how."

His father was a Norwegian immigrant, his mother from Iceland, and they lived in a prairie dugout when he was a child. He was never more than a tenant farmer, but he did milk 50 cows at one time and ended his career on a 4-acre retirement farm, the same site where one of his daughters later ran a nursery. Hunting birds and fishing for catfish have left him with more pleasant memories than farming.

"I had a revolver. I could shoot rabbits with that. Sometimes I hunted on horseback, caught up with them, and shot them on the run. I could shoot anything with that."

But he regrets the hunting a little: "I wish I'd had a camera. I would have taken their picture instead. All those beautiful geese. The area was thick with wild game then."

Do you wish you had done something other than farming?

"Yes, I wish I had gone to school instead. I was a really good student."

What would you have studied?

"Agriculture."

The good luck part of his story is that he is alive at 100 and happy about it. He consoles and encourages his oldest daughter, with whom he lives and who recently lost her husband.

"I don't want to die," he tells her.

He is an avid reader and has news magazines and newspapers stacked next to his easy chair. "I read all the time. I read too much."

He loathes TV—"so much advertising and all that crap," he says.

His mind and memory are clear, and he most enjoys having his children come over, which gives him the chance to talk, one of his favorite and most accomplished crafts. Although his children say he was an incredibly hard worker, they also know he was and is a great storyteller.

"When we were kids, we would rather listen to Dad tell stories than listen to the radio," says his daughter.

Within the man who feels he never succeeded as a farmer is a tender and gentle person whose real regrets are not about not making money, but regrets of the heart. His most painful memory is of trying to save a horse that had fallen into a ditch, and whose head was twisted and wedged against the embankment. He chopped at the embankment with a pickax, trying to free the animal so that it could straighten its head. When he failed, he had to shoot the horse.

"That was the hardest thing I ever did."

❦ "I never been sick to speak of my whole life and never been hardly to the doctor. Done nothing but work hard and chew snoose.

And you still have your own teeth?

"All my own teeth."

"And he's finicky about them," says his daughter. "He'll stand in front of the mirror and admire himself for a long time. He's like a young schoolgirl."

No childhood disease?

"Not a one. My brother did. It must have been the snoose kept the worms away. Or I must have been too tough or something. I started using snuff when I was about twelve years old. I wanted to be like the grown-ups. Stupid. I stopped all that."

When?

"Oh, last year or so."

Did you take vitamins?

"The only thing I took was a good shot of whiskey once in a while—and not very often. I guess I was just lucky."

"He's definitely not a worrier," says his daughter, "and he eats everything. He still likes his eggs and bacon. He's a meat and potatoes man, and does not prefer fruit or vegetables, though he'll eat them if he's served them. He's a hearty eater."

Otto's real health secret may lie in his good luck: both of his parents lived past 100.

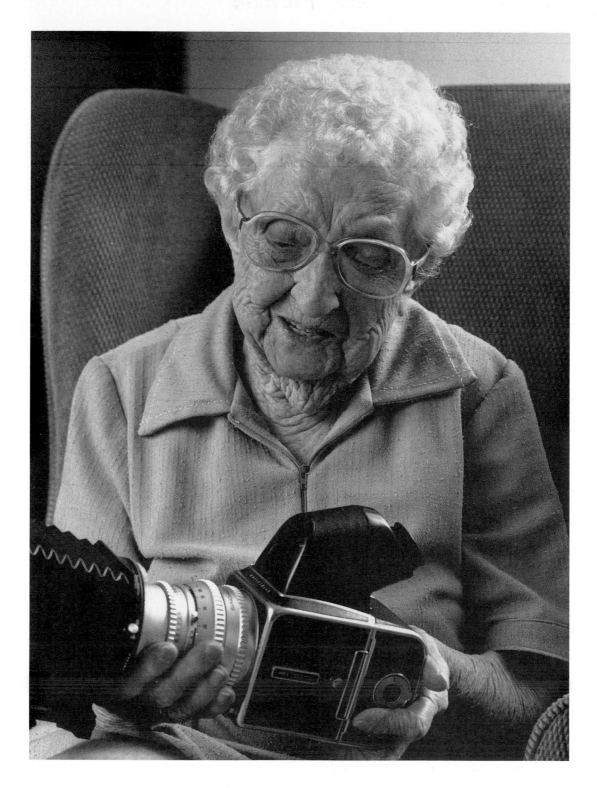

Born: Susie Morris, April 3, 1884, Marble Valley, Alabama
Married: James Rankin Pittman, 1913; died, 1939
Children: (2) Lyda Bell, James Morris
Principal occupations: horse and buggy photographer, homemaker
Current residence: Repton, Alabama

Susie Pittman

I moved down here seven years ago so she could take care of me," says Susie Pittman's daughter.

It's one of those family jokes that tells some truth, a bit like smoke that tells you there's fire. Behind the joke is a steady torch of a woman. A picture shows her riding a self-propelled lawn mower when she was 100, and her daughter tells of the time when Susie was in her 90s, she landscaped the yard after a big rain, using a shovel, propelling herself and shovelfuls of dirt.

"I was so embarrassed," says her daughter. "I thought, 'What will the neighbors think, letting such an old lady do that kind of work?'"

The mother and daughter live in houses next to each other in an area not far from Andrew Jackson's Trail, where Jackson used to change his horses. Susie has, in fact, moved in with her daughter.

But she is still very active, getting up at 6:30 in the morning, reading, washing dishes, watching TV, and sometimes memorizing poems. She is a woman inclined toward constant activity, even though an early childhood accident gave her a lifelong handicap that is still apparent in her indented knuckles and abnormally curved fingers.

"My father picked me up by my hands and I screamed. My arms swelled up. They just thought my wrists were sprained and we didn't know until I was in school how bad they were."

Her father had evidently jerked her fingers from their sockets and they never developed normally.

"It made it hard for me to pick cotton. I tried so hard to pick one hundred pounds a day. I'd get a whole dollar for one hundred pounds. And I wanted to play piano. My sister could reach an octave, but I couldn't with my crooked fingers. These fingers are why I could never play piano. That wasn't for me."

What was for her was photography. As a young woman, she became a horse-and-buggy photographer, going out into the country to take pictures, then coming home to a darkroom her cousin had helped build.

"I had an old 8 x 10 view camera with a tripod. I'd go out and shoot weddings and things like that, but I liked to take pictures when people weren't expecting it." She still has candid shots of two children and a pig, one child pulling on the ears,

another pulling on the tail.

"What was most interesting for me was when somebody else took the picture and I finished them. I loved to be in the darkroom and see that picture come on when I didn't know what was on it." Her injured fingers never stood in the way of the precise darkroom work, but her photography career ended when she married a building contractor and chose to follow him and his work.

"My husband was more important," she says.

He died nearly 50 years ago and she has been living on a marginal income ever since, often making a living as a babysitter. "I like children. I never did grow up," she says.

Her own childhood had few luxuries. "I was raised on a farm where you get up and get at it, and it comes natural for me to get up and what I've got to do, I'm going to do it, and then I'm ready for pleasure."

So you do know how to have fun?

"I don't know what fun is. But I know what happiness is. It's love and peace. I've had a hard life but always happy. A hard road but a good road."

☙ Susie Pittman says her diet and taking pride in caring for her body are her secrets to longevity. She weighs little more than 100 pounds. Here is what she eats:

Breakfast: 1 slice of toast
1 egg, scrambled
3 ounces of orange juice
coffee
Lunch: 1 vegetable serving (4 tablespoons)
4 ounces of meat (3 times a week)
(4 times a week, vegetable only)
1 cookie or small slice of cake
Dinner: 1 glass of milk
1 small slice of cake

A high estimate of her caloric intake would put her at about 800 calories a day four days a week, and 1,200 calories three days a week for a total of about 6,800 calories a week.

"I eat when I'm ready to eat and when I'm finished, I'm right ready to get up and take my place at the dishpan. My parents taught me to get up and do."

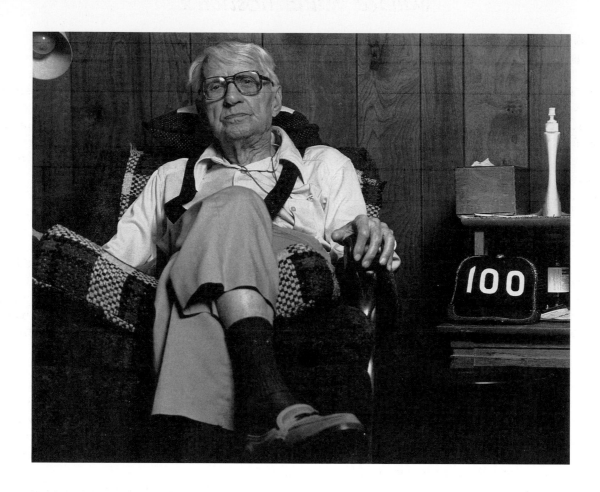

Born: September 26, 1886, Atlanta, Ohio
Married: Rosa Holloway, 1909; died, 1950 (?)
Imogene (?), (?); died, 1970
Children: (1) Wallace L.
Principal occupation: stationary engineer
Current residence: Fullerton, California

Wallace Walter Bostwick

I liked Ohio better than California," he says, "but beggars can't be choosers."

Before breaking his leg at age 95, Wallace Bostwick lived alone in his home in Chillicothe, Ohio, where he spent most of his life. Now he lives with his daughter-in-law and son in their large home in an attractive housing tract in Fullerton, California. A TV set sits a few feet from his easy chair, a hat-tree blooms with a large collection of caps that people have given him, and the historical novel *The Eagle Has Landed* lies near his chair. "Boppy," as his family calls him, sits comfortably slumped in his easy chair, his suspenders sliding off his shoulders to his elbows. His speech and movements are measured and slow.

"He's always been a very slow, calm, and quiet person," says his daughter-in-law.

A wind chime outside sounds its gentle soporific music. Only three minutes away are the waterfall sounds of continuous commuter traffic and the louder seasonal avalanche of tourists descending on Knott's Berry Farm and Disneyland.

"It never rains here. I liked Ohio better, even if we did have zero weather," says Boppy.

The possibility of his quiet life in the midst of the urban busyness is one of the minor miracles of southern California—these little oases of silence in the midst of it all. Cut off the sound, and the warm, quiet sun still shines. In his calm way, Boppy contends with the weather by watering the yard just outside the sliding glass doors of his room. The zero temperatures may not be here, but Boppy's habits are those of one accustomed to long winters: he naps frequently and lives a quiet life in easy contrast to the sunstruck insomnia just out of view. Boppy likes occasional trips out to restaurants, but most of the time he is alone, doing his own cooking, reading, and watching television. He seldom laughs or smiles. He won't even watch comic Westerns on TV, only the serious ones.

Boppy grew up helping his father in the blacksmith shop that stood next to their house in Chillicothe. He did not follow his father into the blacksmith trade, but he did turn toward machinery. He studied books on steam engines and became a self-taught steam engineer. He first worked on self-propelled steam engines, the kind that could move slowly from one farm to another, where they were needed to drive separators for such crops as timothy grass.

"Little could go wrong with the old thirty-horsepower machines," he says. "Just keep the steam up, make sure there was plenty of coal, make sure the water level wasn't too low."

It does not sound like work that would be out of character for the Boppy of today. Neither does his next job as a stationary engineer, tending the large steam engines used in the plant that provided electricity for Chillicothe's streetcars and streetlights. In 1930, after a short term in a civil service position for the Industrial Commission of Ohio, he returned to work as a steam engineer, this time on the newer steam turbines, a job he held for the rest of his working years. He really never swerved from the calm life. Once when he turned to the potentially more eventful work as a policeman, he quit almost immediately when he realized that giving tickets to people brought conflict.

Today Boppy carries with him only one conspicuous mark of momentary disruption in a long, quiet life—a missing thumb cut off in the mechanisms of one of the turbines. He holds out his hand with no apparent regret about the lost thumb.

"It didn't hurt a bit," he says. "Glad it wasn't my hand."

What about hobbies? Have you had any hobbies?

He thinks for a moment, then makes the satisfied announcement, "I am the only engineer who ever took a steam turbine completely apart and put it back together."

❦ "I don't have no magic formula or eat anything special. I just went to work, done my job best I could, come home and eat and sleep and go back the next morning. The years just piled up."

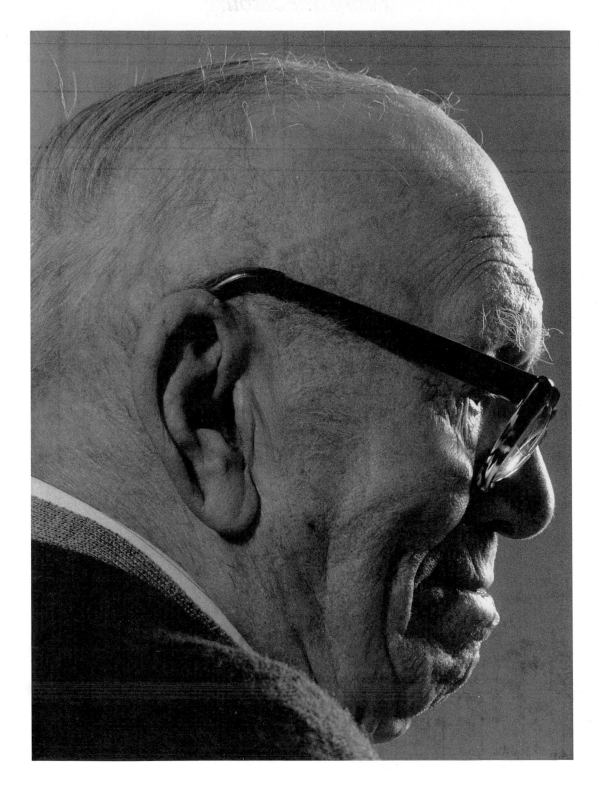

Born: April 27, 1885, Cannon Falls, Minnesota
Married: Lillian Branzell, November 7, 1916; died, 1978
Children: (2) Robert, Virginia
Principal occupation: department store floor manager
Current residence: Seattle, Washington

Philip S. Eastburg

I have been thinking about angels because they will soon be my hosts."

Philip Eastburg is dictating an article to his daughter that will be published in a newsletter, "Voice of the Seniors." He speaks hesitantly during conversations, but his voice changes and flows with lucid prose as he writes through his daughter's hand: "Angels are with us now, though our eyes are blinded. They are around and watching intensely."

Philip Eastburg believes in angels, and he believes in miracles. A "heart leakage" at 19 was supposed to kill him. He dropped out of college and went home to the family farm in Minnesota, but he was so weak that his parents wouldn't let him do any work more strenuous than riding the plow behind the horses. One day in the fields, he suddenly recovered. He remembers the moment, a feeling of instantaneous transformation. "I knew I was better," he says. "It was a miracle."

The miracle of recovery has followed him for over 80 years. Today, dressed in a bright red sweater, he looks healthy. "The only trouble I have is with my legs. Otherwise, I feel fine."

He lives in a large Seattle retirement complex that was once a sanitarium. The place looks more like a small private college campus today—tall, old trees, well-manicured grass, and bushes clipped into perfect little domes. But vehicles of another world park near the buildings: a large van equipped with a wheelchair lift and a delivery truck with oxygen tanks to refill those used by some of the residents.

The atmosphere inside the unit where Philip Eastburg lives is like a hospital—or the nursing wing of a hospital. His small room allows for only minimal furnishings and has little room for guests. It is a peculiarly contained setting for a man who has always worried about everything from money to health and has worked most of his life in the stressful job of floor manager for department stores. Writing has long been a pastime—mainly editorials for the religion page of newspapers.

"He has always known what he wanted and worked until he got it," says his daughter. "They used to call him Demander in Chief."

In spite of his quiet manner, he loves being around people. He loves holidays. He not only writes editorials, but also letters to mayors, governors, and presidents with his complaints. He is quiet but decisive, a thinker and a doer.

He seems like a gentle, passive man today, sitting in his wheelchair, his mouth somber and drawn below his large dark-rimmed glasses. With a life of miracles, worries, and determination behind him, there is something inscrutable about him.

❦ A big box of chocolates sits on a shelf in Mr. Eastburg's room. He eats the last piece, a chocolate-covered caramel, savoring each bite.

"His mother died at age fifty-seven from diabetes," his daughter says. "Diabetes runs in the family, but he's always had his sweets."

"God helped me," says Philip Eastburg. "I believe in guardian angels. They have watched over me and kept me alive."

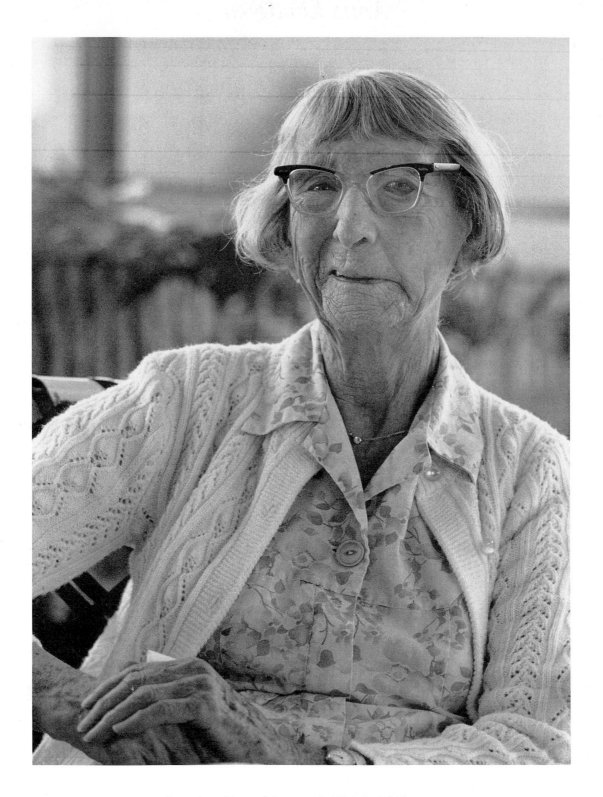

Born: Anna Megaard, January 10, 1886, Opdal, Norway
Married: William J. Lundgren, 1911; died, 1950
Children: (2) Louise, Berna
Principal occupation: homemaker
Current residence: Englewood, Florida

Anna Lundgren

Dear Mr. Heynen,
 This is Anna Lundgren writing, nothing great, but the best I can do. My health is good, and I love life. My walking is shaky, but I take things easy. I walk and enjoy life, for how long, who knows?

 Anna Lundgren

I feel different from most old people. I think young all the time and stay away from old people. Some people like to be old, and I like to be young. I don't feel any older in the inside than I did when I was sixteen."

What about the world around you? Don't you feel that it's changed?

"Yes, the rocks in the road have gotten bigger."

The care center room is small, and Anna's roommate lies just a few feet away, her elbow on her bed, her face resting on her hand as she faces away from Anna toward the wall and her TV set.

"Back in Norway where I was a little girl, when people got to be fifty-five or sixty-five, they just sat. I never felt that old. *That's* old. I don't feel that old today."

Anna's roommate turns up the volume. It's a quiz show. "I feel free here," says Anna. "I have all the clothes I need and they prepare three meals a day. The young people here who are taking care of us—well, I feel we're looking out for them. If you're one hundred years old, things should be good. I feel like I'm living in clover. What could be nicer?"

The volume of Bob Barker's voice rises over all sounds in the room.

Is there perhaps another space where it would be easier for the photographer to take pictures?

With a little assistance, Anna makes her way down the corridors of the care center and away from the carnival sounds of her room.

"I have a gift of gab and that's what gets me where I want to go."

She sits down in the quiet sun room, a good setting to reminisce.

She arrived in Duluth, Minnesota, from Norway via Quebec in her late teens, and soon met the familiar immigrant woman's welcome of housework at $10 a month for a "nasty woman" who made her mop floors in rooms that were so cold that the water froze as she mopped. She had typhoid fever in 1907, learned English by studying the Bible, then married a switchman on the railroad in iron ore country of Biwabik. Her life consisted of children, an "ordinary home," bridge games with the girls, bread baking, Sunday school for the kids, dancing with hubby on weekends, then, as a widow, living near one of her daughters in Massachusetts. She worked until age 91.

"It's foolishness to say anything about me. I'm just a common old lady."

The quilt of Anna Lundgren's life is rather gray. But the bright thread is her mind, her quick stitches of wit piercing the fabric.

She looks at the camera, smirking. "If there's something here you like, just take it."

All right, what's your best side?

"The front side."

Anna, you say you are living in clover, but what do you do all day?

"Play solitaire. It keeps my mind in working condition."

❦ "I just made up my mind that if people try to get over things, there wouldn't be so much sickness. Why worry about this and that? Eat and drink and be happy. Oh, I've been sick a few times, but I get over it. If people just did it their own way and tried to get over things, they wouldn't have so many surgeries. I think it's in your head—what's in your body. So if you just think, and shove it away, then you'll be all right. That's my philosophy. I've lived that way and it's worked for me."

Born: December 11, 1886, Pizzoferrato, Italy
Married: Pasqua Casciato, 1909; died, 1949
Children: none
Principal occupation: boilermaker
Current residence: Portland, Oregon

Donato DiMatteo

Donato DiMatteo has nothing bad to say about anything. Not his work, not the government, not his family.

"He's always been like this. Always cheerful," says his niece.

Weren't there any bad times in your life?

"Never," says Donato. "I never had a bad time in my life. I had a good time all the time."

Donato DiMatteo lives in a modest ranch-style house with his niece and her husband. His territory is defined by an assortment of music stands and accordions in the living room. He smiles and offers to play several tunes on the instrument that has been his pastime since his boyhood in Italy. He taps his foot and continues to smile as he plays. The man emanates good will and is unassuming and gregarious. The mood of everyone around him floats like a buoy on the wave of his friendliness.

For 35 years, Donato DiMatteo was a boilermaker for the Union Pacific Railroad. The job, repairing flues, separators, and boilers on locomotives, does not sound like work befitting this congenial man. Twenty-five boilermakers worked with him among 500 more workers in the large roundhouse. It was a sledgehammer and chisel world: steel clanking on steel, grease, grime, and locomotive smoke. And often he had to put in seven-day weeks. The work sounds awful, grueling, exhausting. The drink, the *boilermaker*—a shot of whiskey followed by a beer chaser—must have been named in honor of this job.

It sounds like terrible work.

"No," he says. "It wasn't so bad."

He says his earlier days were always good too, especially when he was old enough to dance and court women.

"He's always had an eye for women," says his niece. On his last visit to Italy at 96, he disappeared several times, only to be found visiting a woman down the street.

A good time all the time. He is evidently telling the truth. His niece testifies that he has always been free from cares and worries, working hard by day, gardening and playing the accordion in his free time. He never fought with his wife, never showed bitterness over the fact that their marriage was childless, though they both loved children and poured their affection on their nephews and nieces.

"Kids are attracted to him like a magnet," she says. "They climb all over him."

He has never been fanatical about anything, never hostile toward anyone. It does not sound like ecstasy. It doesn't even sound like optimism. It is more that relaxed state that many people try to reach through entertainment, exercise, or artificial relaxants like alcohol. Donato seems to come by this state naturally, accepting what he has and demanding little from the world around him.

In his life today, he keeps a regular schedule, getting up at 8:30 and going to bed at 10:30. He walks back and forth through the house for the exercise he does get and regularly watches quiz shows on television. And he plays his accordion, but he also practices his math and penmanship.

"I just want to keep in practice," he says. The tablets on which he has been writing show that he is doing more than practicing penmanship: he is playing with words. The pages are covered with words that have close sound associations: "plan, planet, planetary, plane, plant, etc." There is a musical quality in the parade of words across the page, a kind of simple poetry. His love of music has gone beyond the accordion. Maybe that is his secret formula for perpetual happiness—finding music in everything he does. Maybe he even found it in his life as a boilermaker—a percussive symphony of sledgehammers and steel.

❦ Longevity does not run in Donato DiMatteo's family.

His niece says that he has grown old because he never drove a car, never had any kids, never worried, and knows how to tune you out.

"Just work hard, take whatever is coming," says Donato. "I never thought about age much."

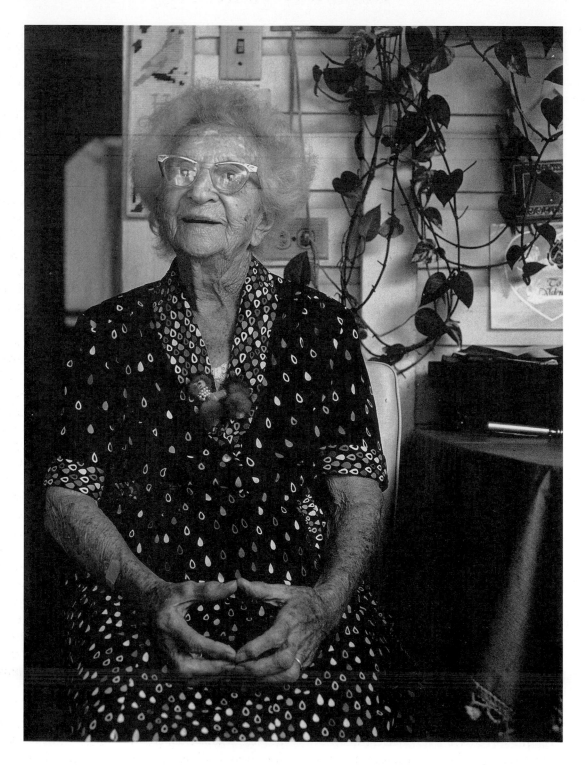

Born: Martha Miller, November 6, 1886, Bremen, Germany
Married: Fred Waldvogel, 1908; died, 1949
Harry Lester, 1952; died, 1965
Children: none
Principal occupation: servant girl/maid
Current residence: St. Petersburg, Florida

Martha H. Lester

She's efficient, tidy, and independent. Meeting her, you'd guess that she's had a few hard knocks in her life and learned how to take care of herself. She *has* had the knocks and she has learned to make do—with considerable grace.

She lives alone in her small St. Petersburg house. Mockingbirds sing outside in the grapefruit trees of her yard. Inside, the furnishings are modest, many things are old, but she has what she needs: a simple, good life.

Two husbands, a series of bakery stores in New York and New Jersey, 22 years of living alone are behind her, but her memories of coming to America are more exact and vivid than most people's memories of yesterday's drive to the grocery store.

"There were four classes of people on the ship. I was on the 'swishen deck'—the lowest class. Pigs in Germany had it better than they had it." Martha Lester was 18 and heading for America, looking for something better than the $10 a year she was paid as a servant girl in Germany.

But arriving on Ellis Island as a poor immigrant was its own horror story. Her memories of that experience stand out more distinctly than her first view of the Statue of Liberty. Opened in 1892, the Ellis Island center processed up to 15,000 incoming aliens a day in the early 1900s. The facilities were crude and overcrowded, the procedures impersonal and sometimes abusive. Martha grimaces when she remembers it. "So dirty where the water fountain was—there they peed. And the way they looked at you to see if you had disease! They kept me in a wire cage until my cousin picked me up."

Her first job was with an old Hamburg family, cleaning and cooking. "They treated me good. That was the first time I got to sit at the table with the family I worked for. In Germany, you couldn't even walk with people you worked for. You had to walk behind them."

But the Hamburg couple were old and soon died. She then got a job with the wealthy Tench family in White Plains. She was given the address and instructions on how to get there. After she boarded the train, a man tried to take her suitcase: "He grabbed it and I said, 'No! No!' The conductor came and asked where I was going. I showed him my card—36 Greenwich Ave.—I'll never forget that, and the conductor told me to sit down until he told me when to get out. When I got out, that man tried to take my suitcase again, but I grabbed it. Outside were all these two-wheeled buggies with a pony. The guy who had tried to take my suitcase went to one driver, who then said to me, 'Get in.' I had never been in one of those things and to me it was something wonderful.

"So he drove me and drove me and drove me. There got to be less and less houses. There was woods. I was told by the Tench man that it would only be ten minutes. And I said, 'Where you take me to?' We drove another couple of minutes and he said, 'Here it is.'

"The house was back from the road. And I looked at it and all I saw was '36' but there was no name of the street. It was all by itself. I rang the bell and who came to the door? A colored woman and, oh!, I bless her to this day yet! A little white bonnet, a little white apron. She looked on that card I gave her and all of a sudden she said, 'Go on! Go on!,' and pushed me out the door. I didn't know what was wrong.

"But now I know where I was—I was in a whorehouse where they had white slaves, where they take white girls—I found that out later from Mr. Tench."

Martha gives the details of the rest of the story: sitting down on her suitcase along the road, weeping; walking the entire day; seeing two boys in a cart who would not help her; and finally arriving late at night at the Tench home. " 'So this is America,' I thought."

In a few years she would meet her German-born first husband at a dance and they would begin their series of bakeries. They retired to Florida in 1949, but he died the same year. She married an old friend in 1952, but he died in 1965. She has lived alone ever since.

Her world today echoes her past: old furniture, not fashionable antiques, but simple, plain items that give her house the feel of a European cottage. The signs of tidiness and frugality—simple, economical, clean.

"I stick with my stuff," she says, pointing to a 1905 sewing machine. She looks happy and in control, as if these may be some of the best days she has ever known.

🍃 "The secret is to keep going. Keep moving. Do work, whatever you can. I worked hard and nothing gets stiff. Another thing is your eats. I eat very little fried stuff. For breakfast I have a donut and a piece of cake. For lunch, a big soup like we did in Germany. Or I like to put stuff in the blender—carrots, lettuce, raw eggs, apples, bananas—anything—maybe with a little bit of ginger ale. I have a glass of wine now and then. No cigarettes. And I found that a little bit of Southern Comfort helps me get to sleep."

Born: August 23, 1885, Atchison, Kansas
Married: Mamie Louise Talbott, 1917; died, 1973
Children: (5) Cathryn, John, Carl, Jr., Talbot, Carol
Principal occupation: horse seller
Current residence: Port Townsend, Washington

Carl David Corder

It's easy to like a man whose favorite memory is the time he slept all night on the back of a "big wide horse" in a boxcar traveling from Omaha, Nebraska, to Atchison, Kansas.

"I think I'm the only person who ever rode a horse two hundred and forty miles in one night," he says. "When I woke up, I heard them talking about Atchison, Kansas, so I got off the horse and walked home."

He was 12 years old then and a runaway returning home from his own brand of Huck Finn shenanigans that had taken him as far as New York City and into a life of dishwashing for survival money and eating soup—bone soup with bums along the tracks. It was 1897. Wasn't that a time of low-life thugs, horse thieves, child exploiters, traveling gamblers, and nomadic perverts? Not on Carl Corder's journey. He tells only of a friendly and receptive America, where people always fed him when he knocked on their back doors to ask for food, where the bums he sometimes ate with were either out of work or out to see the country like himself. Whatever their situation, he found them all congenial. Not one moment of danger? Not one moment of fear? Carl says, "None." If there had been milk cartons in those days, his picture would not have appeared on the side with the caption, "Have you seen me?"

But what a way to end a boyhood adventure! What kind of dreams would a boy have, curled up on the back of that wide horse? There must have been the horse's body heat to comfort him and the swaying of the boxcar and the swaying of the horse Was it like being rocked in a cradle? Maybe he just learned to trust horses, or learned that horses trusted him: later in life, while living in Great Falls, Montana, he made a living by buying and breaking horses for the U.S. Cavalry.

"They had to be gentle before I could sell them," he says. He was successful at the work and liked doing it. Somewhere in the horse-breaking and selling career, there must have been the memory of that warm ride home.

Before selling horses, he worked delivering messages for Western Union. After retiring from selling horses, he and his wife moved to California and he invested in real estate, which provided him with enough income to allow them to live several years in a large retirement community on Seal Beach.

"I worked hard and had a good life," he says. "Wonderful family. Wonderful wife."

Today, at 101, he lives most of the time in a state-licensed adult family home not far from where his daughter lives. A few years ago when his daughter was no longer able to attend to him full-time, he chose this innovative alternative over a nursing home. He still spends some time with his daughter, but the family home has become his main residence. It's modeled after foster homes and is meant to provide the warmth of a home environment.

The woman who owns the home is licensed to have up to four people living with her at one time.

Carl is a favorite in the house, and it's no wonder. He is handsome and charismatic and has a smile that is so attractive it affects everyone. He gets plenty of attention.

"I was never bathed by a woman until I got here," he says, and smiles.

"At first he was very shy," says the foster home owner. "Now he likes it."

❦ *When people ask you what your secret is, what do you tell them?*

"I just can't tell them. To tell the truth, I just don't know. I got no advice for nobody."

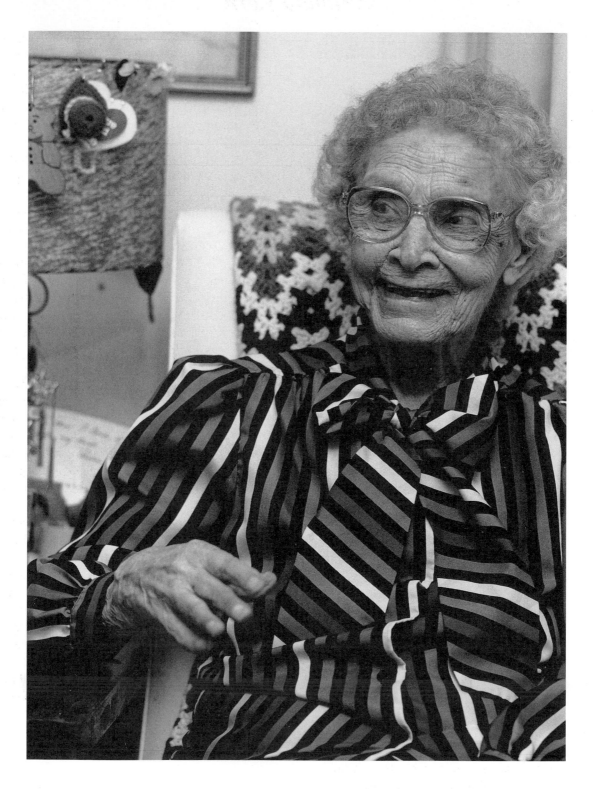

Born: Amanda Weisbrod, February 22, 1885, Palo Alto County, Iowa
Married: Carl Kern, 1906; died, 1953
Children: (5) Ruth, Melvin, Derwood, Lloyd, Helen
Principal occupation: farmwife
Current residence: Armstrong, Iowa

Amanda Kern

Amanda Kern has lived so much of her life in the middle of Iowa cornfields that they haunt her dreams even today, recently helping to give her a black eye. She lives in a nursing home now, but she dreamt of the olden days when farmers burned corncobs in their cookstoves. In her dream she was carrying a basket of corncobs. When she started to wake up with the dream still playing in her mind, she thought to herself, "If I'm strong enough to carry that basket of cobs, I'm strong enough to go to the bathroom by myself." The dream lied. She fell on her face and got the bad bruise.

"But this is my home now," she says with an air of surprising contentment. She credits the nursing-home staff and fellow residents for her adjustment, but perhaps the familiar farm scenes and smells have given their own kind of friendly support. What you can't see from the small-town nursing home of the Iowa springtime, you can smell: herbicides, feedlots, and processing plants whose odors have followed the gentle breezes into town. As if to emphasize the familiar—like paintings of ships inside ships—a miniature farm complete with miniature goats has been built across the street from the nursing home.

Amanda grew up on an Iowa farm and later married a farmer. The Iowa of her childhood memories includes many of the same farm animals that are staples of Iowa farms today, but at a time before stainless-steel teat-cups replaced the warmth of palms and strength of fingers.

"Sure, I had to milk cows," she says. "Starting when I was about ten or twelve."

But she also remembers the time before every square-inch of Iowa topsoil sustained cash or feed crops. When she was four, one of the worst prairie fires swept across the landscape. She probably remembers the fire well enough to dream about it: "There were quite a few fires, but this was the worst one. It came from the northwest and up and down the hills, and there was a little gutter just north of our place, and they thought this would stop it. Well, it did a little bit, then jumped right over it. Mother was out there with a scoop shovel. Whenever she saw a blade of grass flaming, she'd scoop it out. Dad plowed around the place about three furrows—oh, I know that so well. There was water in some of the low places and that kind of

stopped it. We could see the smoke and the fire. At times it blazed, you know, and then if it got in a low gutter, it would kind of stop there. The smoke was blowing right along with it. It was gray and dark. Whenever it hit a wet spot, it got dark. You see, when the fire got to water, it got black. When we saw that black smoke we knew it had hit a wet spot."

She remembers the long days in which her father would rise at 4:30 A.M., the days of no electricity, no running water, no indoor plumbing, pancakes for breakfast, and going out with her father to "shock oats or to husk corn" with two-thumbed mittens.

"Sure, I was a tomboy," she says. "I'm not ashamed of it." But as a young woman she turned toward the traditional work of women, learning to sew and going around to homes doing seamstress work. She'd use the sewing machine that was in the home she visited. "Many girls were doing this," she says. She does confess that she and other girls got together and discussed how much they would charge, an interesting case of early price-fixing.

Her parents did want her to have an education, and she attended college for a year in Charles City before marrying. "I was a farm wife until we retired to Fenton, Iowa, in 1952." Although she had left the farm, the farm had not left her. She kept a large flower garden and did lots of canning. When her husband died one year after their retirement, she lived alone until she was 99. She crocheted, sewed, embroidered, and quilted, making a quilt a year for 30 years.

❧ "I was never careful about what I ate. I didn't like squash. I ate too much once in a while. I was a worrier once in a while. There were times I lost sleep worrying about the children. My family was Methodist and we didn't smoke or drink, but my brothers and sisters didn't live to be old."

The Iowa landscape where she has managed to achieve her extreme longevity seems to have few secrets. Does she?

"No. No. I have no secret."

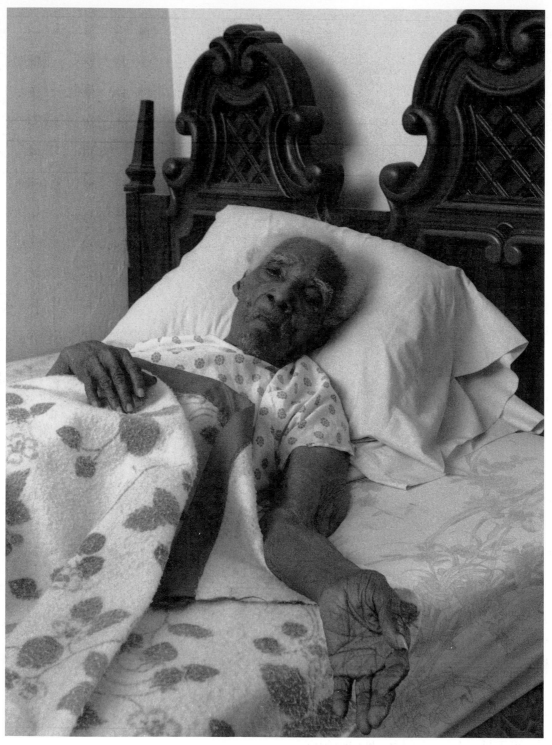

Born: Dora (?), May 1, 1880, Milledgeville, Georgia
Married: (?)
Children: (12) Arizona, Annie, Duval, Thomas, Paris, Mary, Roger, Arthur, Mark (three not named who
died at childbirth)
Principal occupations: homemaker, day laborer
Current residence: Miami, Florida

Dora Davis

It is the eve of Dora Davis's 107th birthday. In the living room of her daughter's house hang pictures of children and grandchildren, many of them in military uniforms, along with a cameolike portrait of John F. Kennedy. In the bedroom where Dora lies, a large fan circulates the warm air. Dora is in terrible pain.

"Oh, help me, help me," she cries out.

Should we leave?

"No," says her daughter. "She wants to see you."

Dora Davis moans and sits straight up, her hand clutching her side.

"She gets up like that when she gets to hurtin' so bad. Her stomach swells and then it gets to hurtin'. None of the doctors tells me why this stomach swells and how come it swells. One doctor think it's her bowels. Other one don't know."

"Oh, help me, help me, help me, Jesus," she cries out, then gradually lies back down as the pain subsides.

"I will be one hundred seven years old at four o'clock," she says. "Can you understand me?"

Yes. Do you want to talk? Do you want to tell me what you did as a little girl?

"Yes. I plowed behind the mule. A nice mule, named Helen. She was our pet. Plowed corn, cotton, peanuts, collard greens. I plowed. With a Dixie plow. That was my plow. Papa and Mama were slaves."

What did they get later, when slavery was over?

"They didn't get nothin'. They didn't care. I remember three of them men who owned the farm. The ones they belonged to as slaves. One was a Peacock. Another one was a Rose. The other one I forgot. I ain't never had no arguments. I ain't never had no trouble with nobody."

"She was always a calm, easy-going person—as long as you didn't bother her children," her daughter says. "She was born after slavery, but I knew her Papa. He always talked about 'Old Boss this and Old Boss the other.' "

Dora begins to moan again as the pain tightens her midsection. "Oh Jesus, Jesus, Jesus, Jesus. Oh Lord, Oh Lord."

She bolts up holding her side again, then lies back, quietly. She holds out her hand for comfort.

"She was a working woman her whole life," says her daughter. "She worked for Judge Gould, then for his children, then for his grandchildren. She worked until she was almost one hundred. Then she went to a senior citizen house where you don't have to pay very much money. Then she came to live with me.

"My daddy worked for Judge Gould too. He moved houses. Then I worked for Judge Gould's daughter. When the bus broke down, Mama would always walk home. Mrs. Gould would say, 'Arizona, why don't you walk home like your Mama?' Well, I didn't. I was very average. But Mama was strict. We couldn't go anywhere without asking her. Back in 1918 when we come here, we first worked on a tomato farm for a white man. We all worked on the farm. Before that I think she was just taking care of the children. My daddy was working, doing all different kinds of work."

"I want a mouthful of something to eat," whispers Dora.

"Now what are you going to eat, my darling? I should get you some cake for your birthday.

"Her dad and mama were on the farm. He was a good old man. He lived to be an old, old man. But my daddy was a raccoon. He'd go away and stay away for months, wouldn't tell nobody where he was. She never asked him where he was. She would always be glad to see him. She always took him back. She'd tell you today he was the sweetest man. We'd never find out where he was—off with some woman, that's where he was."

What did she do for a good time?

"Nothin'. She ain't never had no good time."

What made her happy?

"Looking at us, I guess. You know, she's had her ninety-first Mother's Day?"

❦ "Everybody always asking me what she did to get so old, what did she eat and all those questions. Well, she worked hard, but she just ate like the rest of us. She loves canned Spam."

Arizona sits on the edge of the bed, stroking her mother's forehead. "She didn't die because she loved her children too much."

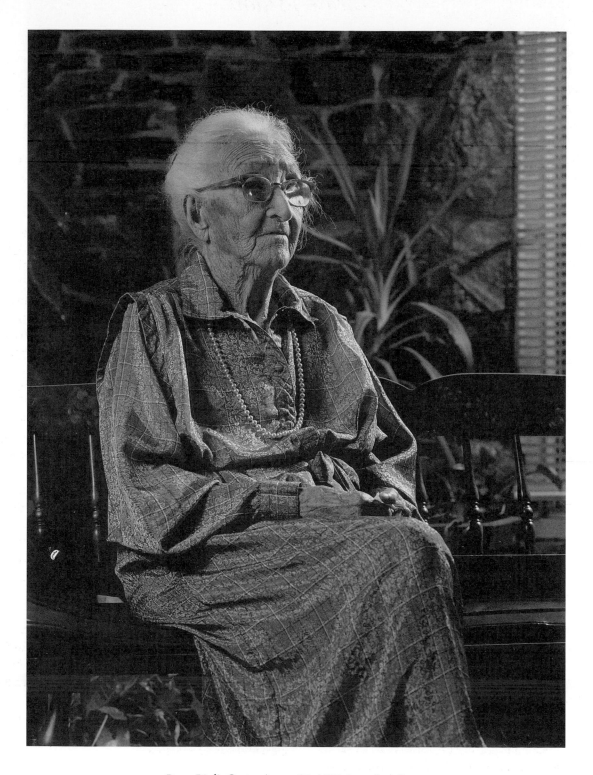

Born: Birdie Carter, August 26, 1887, Lone Star, Texas
Married: Lee Coan, 1907; (deserted), 1908
Jesse McNary Jordon, 1921; died, 1950
Children: (4) Myrle Arminta (Coan), Jackson Clifton, Hugh McNary, Gracie Lynn
Principal occupation: cotton mill worker
Current residence: Corsicanna, Texas

Birdie Jordan

*H*ow *much snuff do you use?*

"I don't know. I never did count it." Her answer is only partly a joke. Dipping snuff has been a habit of this old Texas woman since she was a girl. But, in a sense, Birdie is only half of her story. She had an identical twin named Myrtie who died only a few weeks before their 100th birthday. The party had already been planned, the announcements prepared. Birdie doesn't realize her twin has died. When you look at Birdie's picture, imagine a mirror image beside her. They were identical twins, and they were meant to share these pages.

"We decided not to tell Birdie," says her daughter. "Why upset her at this point?"

Myrtie was the older of the two by a few minutes and was thought to be the stronger and healthier one right up to the time of her death. She died with little warning that anything was wrong.

In their younger years, Birdie and Myrtie had often acted in the good old-fashioned tradition of identical twins—fooling boyfriends, fooling strangers, but distinguishing themselves from each other by developing polar personalities: Birdie became the proverbial thinker, the quiet one, the homebody; Myrtie was feistier, talkative and social, the one who won the arguments, the one who loved to travel.

"We was always together," says Birdie, "that is, when she wasn't pushing me off. Mama said if I didn't learn to stand up to my twin sister she was going to give me a good whippin'. As a little girl I felt heavy in here [holding her heart], because I wasn't worth much. Birdie was the one always goin' out."

In spite of their personality differences, their lives paralleled each other in odd ways: both worked many years in the cotton and woolen mills; both had bad first marriages which ended with the husband deserting; both had a son who died from cancer; and both dipped snuff. Always, when the going got tough, as during World War I or the Depression, they turned to each other, and they both stuck with Texas.

They grew up in a tradition that embraced the anomaly of feminine propriety combined with raw individuality: tough nice girls. Birdie is a person whose father chaperoned her on dates but who, when the wrong boy tried to kiss her, took the horse whip to him. She played the church organ for Sunday singing but also has been "dippin' snuff" since she was a young girl.

"I plowed many a row of corn and many a row of cotton," says Birdie as she begins to recall her childhood. "Myrtie had her horse and I had mine. My horse was kind of wild. Myrtie always thought that Jim was her horse. . . . And I picked a lot of cotton too. I'll never forget the first time I picked a hundred pounds. I fainted. I couldn't believe I picked that much. Myrtie couldn't pick that much."

They were young girls at the time Teddy Roosevelt and his Rough Riders were passing through Texas on the I&GN Railroad that ran through their farm. Roosevelt rode the train back and forth trying to recruit soldiers, and the twins threw fruit and vegetables to the men on the train as it passed by. The engineer would slow down and the men would have their hats ready. At night, though, the family locked the doors of the house to protect themselves against them.

"Teddy Roosevelt stopped at our house and my mother introduced me. He was wearing a blue striped suit. I dipped snuff while he was there. I said to him, 'I dip snuff,' and he said, 'Well, my mother did too.' "

("I'm not sure Roosevelt actually stopped there," her daughter says later.)

The farm where they lived when they were little girls was destroyed by a flood. A few moves after that, they stopped their formal schooling and by 1900 went to work in the cotton mills. Later, after both twins' marriages went awry, they returned to work together in the cotton mills. Birdie worked her way up to the position of inspector.

Today Birdie lives in a nursing-home room with a roommate. She likes bright colors and has colorful pinups on her walls. Before she broke her hip a few years ago, she had rarely seen a doctor.

What do you enjoy doing today?

"I enjoy life. I believe everything has a purpose."

Her daughter says, "I don't believe I've ever heard my mother complain. I don't think I've ever seen her mad. It's really strange. She never did gossip either. But she still dips snuff. In the old days, when doctors didn't think you were going to live, they'd tell you to dip snuff. The idea was that when you spit it out you spit out the disease with it."

❦ "Mother taught us about good food," says Birdie. "We always had a vegetable and meat and either stewed or fresh fruit."

Birdie Jordan has a small can of Garret snuff in a drawer next to her bed.

"I believe it's good for you," she says. "It kills germs."

Born: Irene Du Bray, May 29, 1887
Married: Ed Livermont, 1920; died, 1976
Children: (1) Mamie Fern
Principal occupations: homemaker, ranch worker
Current residence: Pine Ridge, South Dakota

Irene Livermont

For the past 22 years, Irene Livermont has lived in the village of Pine Ridge, the major trade center on what is now the second largest Indian reservation in the United States.

Has the reservation changed much in those years?

"It's noisier now," she says.

Irene's birth date is not certain. She was enrolled at the Indian agency office in 1890, but was considerably older than a newborn. As was the custom with Indian children at the time, the day of her birth was chosen for the season in which she was born. Her grandnephew says she was a baby at the Wounded Knee massacre and that her sister carried her away across a fence.

Her mother was a Sioux born in the Fort Laramie area of Colorado. Her father was Irish. She attended a Bureau of Indian Affairs grade school in La Creek and started working on ranches when she was quite young, following a tradition of Indian women going to work early. Before she married, she worked as a cook at a ranch and took care of a physically handicapped brother.

"I worked both in the fields and as a cook."

Sounds like you've been good to people.

"They were good to me."

The combination of housework and field work was to follow her into adulthood. As deeply as Irene Livermont's life is fixed in Indian history and traditions, she did not live the conventional Indian life many non-Indians might imagine. She rarely attended powwows and even today has few Indian relics or mementoes in her home on the reservation. She married at a Catholic Church in Rapid City, South Dakota, in a double wedding ceremony with her nephew and his bride. Most of her adult life she spent with her husband on a big ranch, always in the Pine Ridge area.

When she married, she still had her allotment, granted to Native Americans by the government, and she worked on it for some time before selling it and moving with her husband to his allotment. They ranched until he became blind, and then moved to Pine Ridge where she has lived ever since with her adopted daughter.

"They were mostly homebodies," says her grandnephew. "They appreciated home and livestock. Her husband never drove a car, so she would chauffeur. She's the same today as when I was a kid," he says. "She would be an aunt that everybody would want to have: you were always welcome at their house. She and her husband led good lives, plain old country people who got along with everybody. Everybody said they were the best neighbors anybody could have. Some of their friends were white, some Indian. It never made any difference to them."

Irene looks contemplative as her relatives talk about her. She is a very tall, big-boned and regal woman with large brown eyes, but she is shy and reserved. She listens to every word they say, smiles, but says little. And when she does speak, she holds her hand over her mouth.

Although she is shy about speaking to strangers, she loves to read the papers and spends hours every day talking with relatives on the phone and seeing visitors, whose approach to her front door is announced by her highly vociferous poodles that her relatives call "her ears."

Her hobby has always been sewing, and she crocheted and made quilts until recently. She says that she had to quit sewing because she was having trouble threading the needle. Instead of sewing, she plays word-circle puzzles, using a ruler, so that she has the words blocked off in perfect rectangles, words isolated with lines that are straight as a well-sewn hem.

What's life like at one hundred?

"Oh, it's all right, I guess," she says, smiles, and covers her mouth.

❦ "I eat pretty good. Nothing special," says Irene. "She eats anything," says her daughter.

Behind the modesty is a good clean life. No smoking, no drinking, just hard work. She and her husband raised most of their own food, canned it, and put it away for the winter.

Does living to be old run in the family?

"My father never would tell his age, but people said he must have been about a hundred. My mother was sixty when she died."

Her grandnephew says, "I think she has lived so long because she knew we couldn't get along without her."

Born: December 25, 1866, Hawkinsville, Georgia
Never married
Children: none
Principal occupations: mail handler, career military
Current residence: confidential

Jackson Pollard

Jackson Pollard's birth date is, of course, startling. He has always been very positive about the date, circumstances, and location of his birth. He was one of 13 children and grew up on a plantation. Both of his parents were slaves, and the children were raised by a Black woman named Mrs. Barnes while his parents were working. Although there can probably be no absolute validation of his birth date, state social services records say that in 1870 he was a child in the home of his birth—information which supports the age he gives. In the same report, the Social Security Office gives his birth date as December 25, 1869, although no one says how they arrived at this date. The National Personnel Record Center did not have sufficient information from his military record to deny or confirm his birth date. He has no known living relatives.

He tells about leaving home at a young age (about 12) and going to work as a mail and baggage handler on the railroad. He says he did this for many years before joining the army. His main identity even today is as a soldier. He wears black socks and army-colored khaki pants and shirt. The nurse says he always dresses like this and prefers to stay in his room.

He is a bit guarded at first, but in a few minutes is laughing and reminiscing. Once he trusts someone, he is wonderfully warm and congenial.

So you were in the army. Did you fight?

"Sure did!" he says. He is excited by the topic.

Where?

"Cuba!"

He becomes very animated, recalling direct confrontations with the enemy. He no doubt did fight in the Spanish–American War. Although he is not able to give specific information about names of generals or ships, he was probably in one of the 18 regiments of infantry that left Tampa in June of 1898, and he probably saw combat near Santiago in July. He knows it was Cuba where he fought and that he saw people die. He would have been quite old even for the Spanish–American War—31 in July of 1898. But, as he says, his decision to join the army came after "many years" of working for the railroad.

Jackson Pollard likes his privacy and protects it. He often hides his most valued possessions in fear that others might steal them. Friends recently gave him a new pipe, a bigger one than his old standby, so that he will not spill so much of the two cans of Prince Albert tobacco that he smokes every day. But to him the new pipe is too precious to have out in the open where someone might steal it.

It would have been about 1880 that he left home to work for the railroad. He does not remember the exact age he joined the army, but he enlisted and still thinks of himself as a career army man. He was in the army when the *Titanic* sank, but this was close to the end of his military service.

"I was one of the oldest guys in the trenches," he says. Several times while talking about his army life, he clearly imagines or remembers moments of hand-to-hand combat or of firing at approaching enemies, but the place of battle is never quite clear. At one point he speaks of Indians having guns and burying them underground. Did he also fight the Indians, and, if so, was it before or after the Spanish–American War?

After his military service, he went back to work for the railroad, but he is essentially still a soldier. A very, very old soldier, sitting in his easy chair smoking his pipe and wearing his army-colored clothes.

"I wish I was in the army now," he says.

❦ Jackson Pollard has always loved buttermilk. It's still one of the staples in his diet. Codfish, cookies, and buttermilk are his favorite foods.

He is a large man and appears to be a bit overweight, though he is a light eater, judging from his response to the lunch that is served. He takes one look and says, "Oh, I ain't got nothin' again." He eats a few bites and puts the tray aside.

What's your secret? How did you get so old?

"Trust in the Lord, and don't drink alcohol—it ruins your system. And I sweat. Sweating will do you good. Work is good for you."

What about the pipe?

He laughs, "I always smoked a pipe." As a boy, he smoked "rabbit-tobacco"—a native grass that rabbits ate. Now it's two cans of Prince Albert a day. On Fridays he gets five cans to last him through the weekend. The tobacco is important to him. He hoards it. Bottoms of several cans glisten behind some clothes on a shelf where he has hidden them.

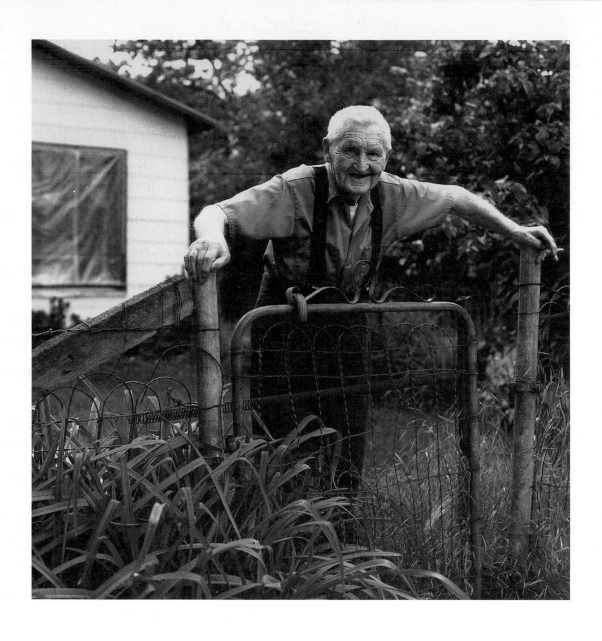

Born: July 20, 1886, Great Falls, Montana
Married: Kate (?) , 1911; died, 1919 (?)
Children: (6) names not given; all deceased
Principal occupation: camp cook
Current residence: Boise, Idaho

Jack Goodenough

Jack Goodenough smokes a couple of cartons of unfiltered cigarettes a week. He's had a few strokes, wheezes and coughs quite a bit, but he lives alone in his small house on a quiet street in Boise, Idaho. Once a week, health workers stop by to mop his floors and help him bathe, but he gets around with his walker and cooks his own meals. Someone from a social services office telephones him every day to see if he is all right.

"I get along pretty good," he says, "but I can't do what I used to do."

Evidence of what he used to do is all around his house: mostly the remains of a leather-working hobby. And although the long grass in his front yard looks like unruly hair, out back there's still a fussed-over garden with evenly mounded rows of vegetables. Two fully supplied bird feeders hang on wires from the gabled canopy over his front door, and songbirds sing and flutter their sounds against the blaring of a TV baseball game playing just inside the screen door. He seems to be more involved in the game right now than anything else and is a bit reluctant to turn off the set. But he does.

"The birds come and sing when I turn on the TV," he slurs, then settles back in his easy chair.

A small secretary-desk sits next to his chair. Stacked on it are a six-carton supply of unfiltered cigarettes, along with a plastic container filled with disposable butane lighters. Within arm's reach lies an ashtray with a fistful of loose cigarettes, and next to his knees sits a large galvanized bucket where discarded cigarette butts float in 4 inches of water that looks like the contents of a barroom spittoon. He holds up an issue of *Philip Morris Magazine* which has a feature story about him.

"There's my whole story," he says. "Mind if I smoke?"

The magazine article does not tell Jack Goodenough's whole story, which can easily be lost in the cloud of smoke that surrounds him. He looks like a sultry old cowboy, a legendary chain-smoking, two-fisted drinker who might be your stereotypical sidekick in some TV Western serial. He even comes complete with cowboy hat and wind-furrowed face.

Much of his biography supports this image. He watched as his daddy was gunned down by cattle rustlers on a Montana ranch when he was only six, learned to ride horses and roll his own Bull Durham cigarettes by the time he was 10, and, as a young married man, rode with the Second Idaho Regiment chasing Pancho Villa across Mexico. After World War I, he was still a military man, working for the U.S. Forest Service. To carry the tough-guy image into the present, until a few years ago, he always kept a keg of beer in his house.

But the rugged Westerner myth has more smoke than fire. The other Jack Goodenough is not just the watcher of birds and TV baseball games. He was in the military, all right, but as a trail cook, not a fighter. And those years working for the U.S. Forest Service? He was setting up tree-planting, trail-clearing, and fire-fighting programs for young people. As a veteran, he wasn't brandishing weapons in parades or telling tall tales in VFW halls—he was starting a veterans' service agency in the VA Hospital. His backyard garden is the biggest giveaway: it's his personal Abundant Foods program. He donates produce to any hungry person who wants it.

"Jack is amazing," says a social worker and admirer. "He's the kindest man on earth. He loves baseball, he loves birds, and he loves to give things to people."

There's also the Jack Goodenough of unspoken tragedies. The death of his father was only the beginning. On his return from the Mexican military mission, his wife and two of his children drowned when their car plunged into San Francisco Bay. Two more of his children died in World War II. All of his immediate family are dead. He starts to talk about them, then stops, says, "Please don't ask me to talk about my family, I'll just cry."

❦ Jack walks across his kitchen to look for an old kitchen utensil he used as a camp cook. His kitchen shelves are well stocked with canned fruits and vegetables, V-8 juice, canned pork and beans, and as many boxes of instant breakfast as he has cartons of cigarettes in his living room.

"I made some mistakes, but I always ate right," he says. "When young people ask me for advice, I tell them to get in touch with the Lord. Forget all that monkeyshine, forget all about beer drinking. I wouldn't do that again. I'd still smoke cigarettes. After one hundred years, why shouldn't I?"

List of Interview Dates

Carl Corder	February 9, 1987	Bess Foster Smith May 15, 1987

Carl CorderFebruary 9, 1987

Ruth AustinFebruary 25, 1987

Donato DiMatteo..........................February 25, 1987

Nina RustFebruary 26, 1987

Al Holmgren..............................February 27, 1987

Philip Eastburg...........................March 6, 1987

Bessie HubbardMarch 7, 1987

Henry Neligan.............................March 7, 1987

Della ZieskeMarch 11, 1987

Russell WilliamsMarch 20, 1987

Peter SpaanMarch 24, 1987

Charles BicknerMarch 25, 1987

Julia PrestonMarch 26, 1987

Geraldine PringleMarch 26, 1987

Mary AnnandMarch 28, 1987

Sarah SilversMarch 29, 1987

Wallace BostwickMarch 30, 1987

Juliet Rothschild.........................March 30, 1987

Esther Henrickson.........................March 31, 1987

Royal PullenMarch 31, 1987

Redden Couch..............................April 22, 1987

Max Schoenfeld............................April 23, 1987

Charlie Rainsbury.........................April 27, 1987

Willie Mae BrockApril 28, 1987

Guyon John CarterApril 28, 1987

Martha H. LesterApril 28, 1987

Anna Lundgren.............................April 29, 1987

Eva Wilbur PerzinaApril 29, 1987

Dora Davis................................April 30, 1987

May Hopkins...............................April 30, 1987

David KaneApril 30, 1987

John Hilton...............................May 1, 1987

Mary WallaceMay 1, 1987

Jacob Kirchmer............................May 2, 1987

Pearl RombachMay 2, 1987

Alice ThomasMay 2, 1987

Lona C. DonicaMay 3, 1987

Oscar WilliamsMay 4, 1987

Jackson Pollard...........................May 4, 1987

Cora Lee and Oliver GlennMay 5, 1987

Grace KrotzerMay 5, 1987

Patrick J. Carmichael.....................May 6, 1987

Lula Bell MackMay 6, 1987

Susie PittmanMay 6, 1987

Beatrice EnrightMay 8, 1987

Louise House..............................May 14, 1987

Harry WanderMay 14, 1987

Mae WolfeMay 14, 1987

Eva BreshearsMay 15, 1987

Bess Foster SmithMay 15, 1987

Jack Goodenough...........................May 15, 1987

Ann BerdahlJune 22, 1987

Karen BrendeJune 22, 1987

Maria BramaJune 23, 1987

Martha McShaneJune 23, 1987

Amanda Kern...............................June 24, 1987

Linda MessersmithJune 24, 1987

Ciel BoyleJune 25, 1987

Johanna PedersenJune 25, 1987

Mabel TaylorJune 25, 1987

Frank FlansburgJune 26, 1987

Fred LindenJune 26, 1987

Stella Harriss............................June 27, 1987

Philip Thomas McGoughJune 27, 1987

Albert Starr..............................June 29, 1987

Clare AxtellJune 30, 1987

Leo RonccoJune 30, 1987

Daisy HolmesJuly 15, 1987

Martha A. BoxdorferJuly 15, 1987

Katherine MichelJuly 16, 1987

Brother Adelard BeaudetJuly 16, 1987

Ernest M. WheatleyJuly 17, 1987

Cyrus LeachJuly 17, 1987

Faith Linsley.............................July 18, 1987

Bertha O. Normano.........................July 18, 1987

Birdie JordanAugust 13, 1987

Marie LeCompte Hotard.....................August 14, 1987

Mary WhiteAugust 15, 1987

Mattie ClarkAugust 16, 1987

Anna Michelson............................August 17, 1987

Frank HersmanAugust 18, 1987

Frank MorimitsuAugust 19, 1987

Sadaichi KuzuharaAugust 20, 1987

Frank and Palmina Canovi..................March 31, 1989

Jesse Haas................................March 31, 1989

Otto Burthus..............................June 8, 1989

James Holy Eagle..........................June 9, 1989

Irene LivermontJune 9, 1989

Paul FloresJune 10, 1989

Onie Grisham..............................June 10, 1989

Amy HoganJune 10, 1989

Prisciliana SalazarJune 11, 1989

Jim Garrison..............................June 12, 1989

Kisa IseriJune 14, 1989

John Lord.................................July 31, 1989

Ethel NoelAugust 1, 1989

Netta Snartt..............................August 1, 1989

Edna Olson................................August 2, 1989

Jim Heynen, left; Paul Boyer, right

Jim Heynen is the author of several critically acclaimed books,
including *You Know What Is Right*, *The Man Who Kept Cigars in His Cap*,
and *A Suitable Church*. He is currently writer-in-residence
at Lewis & Clark College in Portland, Oregon.

Paul Boyer, a commercial photographer, has had his photographs
published in various magazines, including *Prevention*, *Bicycling*, *Natural History*
and *Entrepreneur*. He makes his home in Washington State
and likes to camp and bicycle in his spare time.